SINCE
1854

MECHANICS' INSTITUTE

LIBRARY & CHESS ROOM

57 Post Street, San Francisco, CA 94104
(415) 393-0101

My Avant-Garde Education

Also by Bernard Cooper

The Bill from My Father

Guess Again

Truth Serum

A Year of Rhymes

Maps to Anywhere

My

Avant-Garde

Education

A MEMOIR

Bernard Cooper

W. W. NORTON & COMPANY
NEW YORK | LONDON

Copyright © 2015 by Bernard Cooper

For information about permission to reproduce selctions from this book,
wirte to Permissions, W. W. Norton & Company, Inc.,
500 Fifth Avenue, New York, NY 10110

For information about special discounts for bulk purchases, please contact
W. W. Norton Special Sales at specialsales@wwnorton.com or 800-233-4830

Manufacturing by R R Donnelley, Harrisonburg
Book design by Fearn Cutler de Vicq
Production managers: Devon Zahn, Ruth Toda

Library of Congress Cataloging-in-Publication Data

Cooper, Bernard, 1951–
My avant-garde education : a memoir / Bernard Cooper. — First Edition.
pages cm
Includes bibliographical references.
ISBN 978-0-393-24071-9 (hardcover)
1. Cooper, Bernard, 1951- 2. Authors, American—20th century—Biography.
3. Art students—United States—Biography. 4. Gay men—United
States—Biography. I. Title.
PS3553.O5798Z46 2015
813'.54—dc23
[B]

2014032976

W. W. Norton & Company, Inc., 500 Fifth Avenue, New York, N.Y. 10110
www.wwnorton.com
W. W. Norton & Company Ltd., Castle House, 75/76 Wells Street,
London W1T 3QT

1 2 3 4 5 6 7 8 9 0

Contents

Sections of this book have previously appeared in the following publications:

Granta, Los Angeles Magazine, Graywolf Forum 2003, *The Best American Essays of 2008,* and *The Best American Essays of 1997*

"Blank Canvas"—*The Mid-American Review* and *Harper's Magazine*

"Labyrinthine"—*The Paris Review*

"The Insomniac Manifesto"—*The Santa Monica Review*

"Uses of the Ghoulish"—*Los Angeles Magazine*

"A Thousand Drops" (adapted from "Something from Nothing")—*New York Times Magazine*

I am for an art that is political-erotical-mystical, that does something other than sit on its ass in a museum. I am for an art that grows up not knowing it is art at all....

—CLAES OLDENBURG

Like art, sex ... was a shudder of hypotheses, a debate between being and nonbeing, between affirmation and denial.

—ANATOLE BROYARD

Art always changes. The avant-garde stays the same.

—MAX STEELE

My Avant-Garde Education

1. Teaching a Plant the Alphabet

The windowless room is dark except for static sputtering on a video monitor. Beside the monitor, on one of the institute's stackable chairs, sits Jim, a gaunt young man who stares at his knees and pounds them again and again with his fists. His assault is as unrelenting as the static. *That must be the point*, I think, but my conviction quickly fades. I shift in my seat and look around to see if anyone appears to understand what's happening. Postures of contemplation emerge from the gloom: chins propped on hands, jaws grinding gum. Several students lean forward, mesmerized by the granulated light and the steady thwacks of impact. Our instructor, the conceptual artist John Baldessari, stands in a corner. A bulky six-footer with shaggy white hair and beard, his expression is, as always, inscrutable, his hands buried in the pockets of his jeans. He knows that the aesthetic value of any object or activity can not be measured hastily; the history of the avant-garde is the history of critics who rushed to judgment, whom time proved foolish. Here

at the California Institute of the Arts, one must inch toward, rather than jump to, conclusions.

Jim continues to pummel himself and no one speaks. Words would be brutish and premature. No snickering or glancing at one's watch. Even coughs and throat clearings are kept to a minimum. And so we stare in a kind of numb reverence until a secretary from Admissions barrels into the dark room to deliver a phone message. She squints against the gloom and plunks herself into a chair beside Jim, holding out a folded note. "Your mother wants . . ."

He shushes her, punishes his knees.

She straightens her skirt and waits a moment. "Jim," she says, "I haven't got all day. You mother wants you to . . ."

His fists stop midair and he looks up from his lap. "I'm doing a performance," he hisses. Just as the secretary turns and finally sees a roomful of students staring back at her, Jim lurches to his feet and hits the monitor's Off switch. Static evaporates. "Your mother," she continues in utter darkness, "wants you to phone her after class."

Jim opens the door and stomps into the hall, the secretary hurrying behind him and wagging the message in her outstretched hand. Darkness again when the door slams shut. The rustlings and murmurs of my classmates. I begin to wonder if the secretary's intrusion was planned, like a certain performance in the Ice Capades that thrilled me as a child, the skater's phony falls and failing props eliciting gasps from the audience. Maybe Jim's temperamental exit was part of his performance, a comment on the fragility of artists' egos. I can hear the instructor's huge hands patting the cinder-block wall, groping for the light switch. Outside, sunlight is shining on the freeways, gas

stations, fast-food chains, and tract homes surrounding the campus; whether or not Jim finishes his piece, the world will plod on. I can't admit this to anyone (to do so would be considered retrograde and bourgeois) but I find myself longing for ordinary, unselfconscious acts—scratching an itch, swatting a fly—acts without the aftertaste of art.

The room revives in a shuddering flood of fluorescent light. Mr. Baldessari considers what to do now that Jim has left in a huff. He touches a finger to his lips, thinking. The "post-studio" seminar is barely half over. Since the monitor is already here, he decides to show one of his own videos and mumbles something about how the piece, *Teaching a Plant the Alphabet*, caused quite a stir when it was shown at his gallery in Milan. He rummages through his dilapidated briefcase and slides a cassette into the console.

The camera's viewpoint is stationary and the performance, thanks to films like Andy Warhol's eight-hour-long *Sleep*, unfolds in "real time." And herein lies the phenomenon I remember most about graduate school: real time sagging in seminars, in the vast cafeteria, in the ultramodern library, and especially in the labyrinth of long white hallways as I searched among hundreds of identical rooms for classes in Earth-Works, The Happening, Movement as Anti-Dance, The Death of Painting in the Seventies, The End of Art.

If reticent in class, Mr. Baldessari is quite enthused in his video. He stands facing a small potted plant and holds up, one by one, twenty-six flashcards. The leaves are so pert they seem to pay attention. He croons, chants, sounds out each letter with loving persistence. At first, the futility is funny—that poor dumb flora! But I begin to lose interest at about *F* or *G*, and

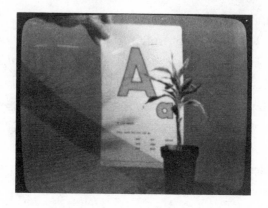

think how odd it was that the secretary had walked into a pitch-dark room where a young man, apparently alone, sat in a chair while beating his knees to the sound of static, the sight of which didn't alarm her in the least, didn't so much as give her pause. Had everyone at CalArts become so inured to the avant-garde that no behavior, regardless how bizarre, could shake our composure or quicken our pulse? Had the "cutting edge" grown dull at last? Did I have, or want, a future in the arts?

. . .

My awakening to the world of avant-garde art had taken place ten years earlier in my junior high school library. Diagonal shafts of light slanted through the Venetian blinds. Rotary fans turned overhead, stirring currents of warm air. Every now and then the librarian shushed talkative children as she silently rolled a cart through the stacks. These details come back readily because, in a lifetime of generally sluggish and imperceptible change, there followed a moment of such abrupt friction between who I was and who I would become, it's a wonder I didn't erupt with sparks. Instead of looking up the

major exports of Alaska for my geography report, I slouched in a chair and leafed through an issue of *Life* magazine. A bold-face headline caught my attention: "You Bought It, Now Live with It." The article profiled the handful of New York art collectors who were among the first to buy the work of Pop artists. Although Pop art was routinely savaged by critics for exalting the banal—billboards, supermarkets, Hollywood movies— this "new breed of collector" didn't care.

"All that other stuff," grumbled a collector named Leon Kraushar, referring to the sum total of art history before Pop, "it's old, it's antique. Renoir? I hate him. Cézanne? Bedroom pictures. They'll never kill Pop, they'll just be caught with their pants down." *They*, Kraushar seemed to imply, were a bunch of stuffed shirts, scoffers and doubters, the self-appointed enemies of fun. Kraushar was shown in his Long Island house, lounging on the couch next to a stack of Andy Warhol's Brillo boxes. Behind him stood a life-size plaster jazz trio by sculptor

George Segal. The musicians held real instruments, their bodies frozen into a white glacier of improvisation.

Collector Harry Abrams, publisher of coffee table books on art, watched the real television set that was embedded in Tom Wesselmann's painting *Still Life with TV*.

"Whether it's on or off," marveled Abrams, smiling from his recliner, "the painting is different every time I look at it." Cleo Johnson, the Abramses' maid, appeared undaunted by modern art; she took a bemused, sidelong glance at the clock in a huge, messy painting by Robert Rauschenberg. According to the caption, the clock worked. So did Cleo, who wore a starched uniform and carried a plate of corn bread.

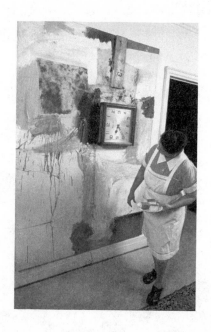

Robert and Ethel Scull were perhaps the most avid collectors. Pictured in their immense Manhattan apartment, Mr.

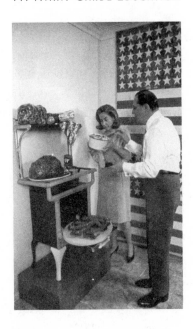

Scull, a taxicab magnate, watched his wife dust the plump enameled ham that sat atop Claes Oldenburg's *Stove with Meats.* "Ethel thought I was crazy when the stove arrived," Scull said, "but now she calls it 'my emerald' and won't let anyone else touch it." On the next page, clearly a convert to Pop, Mrs. Scull beamed while standing in front of the portrait she'd commissioned from Andy Warhol—innumerable, mugging, multicolored Ethels.

As I turned the pages and stared at the photographs, it was difficult to tell the difference between a kitchen and a painting of a kitchen, or a man opening a door and a sculpture of a man opening a door. Reality was up for grabs, and my sudden unknowing made me giddy. I'd always thought that art sat mutely in a museum, but if televisions and clocks were part of these paintings, then art blared commercials, told the time,

and had to be plugged into an electrical socket like an ordinary appliance. And yet the word "ordinary" didn't apply; a soup can, a panel from a comic strip, an American flag were more mesmerizing than I ever thought possible. Even the advertisements in the magazine that featured, in full color, a Sealy Golden Sleep mattress or a Swanson's Fried Chicken Dinner, seemed otherworldly, lit from within.

Up until that day in the library, I hadn't known or cared much about fine art. What little I knew, I gleaned from the art in my parents' house. I liked the Parisian street scene in our hallway; the pedestrians, with a few deft strokes, were reflected in the rain-soaked pavement. In our tropical-themed den, a reproduction of a painting by Diego Rivera hung above a bamboo bar. It showed a woman strapping to a man's back a basket so huge and laden with flowers, he bends beneath it like an animal. My father had bought it as a gift for my mother, the two of them calling it "wonderful," "exotic," seemingly unaware that

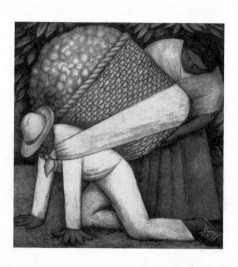

the man had to lug the basket to town; for him those flowers were weight and labor.

But the most unsettling painting in my parents' collection was a portrait by my older brother Ron of our eldest brother, Bob. The portrait had been hanging in the living room since Bob's death from Hodgkin's disease four years earlier. Ron painted as a hobby, the bedroom he'd once shared with Bob redolent of turpentine and linseed oil. A rickety easel was stationed by his bed, ready, I used to think, should he jump up inspired in the middle of the night.

Despite Ron's limited technical skills, his portrait of Bob perfectly, if inadvertently, captured the physical essence of our brother's illness; something in the thinness of the pigment, as grim as watery soup, never failed to remind me how chemotherapy had turned Bob's skin translucent, as if he were stripped of all protection layer by layer, his ailing insides harder to ignore. My parents had hung the portrait in a heavy gold frame, and

even back then I understood that this was their way of forever containing Bob's memory, of paying him homage. In that sense, the frame was like a headstone, strangely funereal for a portrait in which a twenty-one-year-old boy with a flattop is dressed in a dapper shirt and tie, his eyes conveying the hope that he's handsome. But none of these qualities in themselves accounted for what turned out to be the painting's revelation.

One afternoon, I was sprawled on the living room couch, steeped in the idleness that, at the age of nine, I regarded as a calling. Light from the bay window struck the portrait at an odd angle, and I noticed that the dots running vertically down the center of Bob's tie were more than decorative daubs of white paint. I rose and walked closer, and as I did, the dots resolved into tiny letters. *Oh Bob,* Ron had written on the tie. *Poor Bob.*

Ron had moved away from home to attend law school shortly after Bob's death, leaving me, the late child, to grow up alone. Now he had his own car and apartment and full-time

job—triumphs that exempted most young men from unhappiness, or so I believed. Yet there it was in the afternoon light: the keening of one brother for another, a grief so precise, so carefully encoded, you had to look long and hard before you noticed. I stood inches from the surface and couldn't move. The power of art to startle and compel had come into focus like the writing on the tie. What other secret messages were embedded in the world? Could they be decoded by the act of looking?

A reclusive boy, especially now that my older brother had left home, I began to spend hours drawing with the pastels Ron had given me as a birthday gift, fascinated by the greasy lines, the hues blended by smudging the page. The nature of the medium—sticks of pigment as dense as clay—lent itself to landscape. Jon Gnagy, the exuberant art teacher on the TV show *Learn to Draw*, set up his easel every Saturday morning and, accompanied by the theme music of Strauss's "Artist's Life," gave lessons on how to render "majestic" mountains, "fleecy" clouds, and "babbling" brooks.

The smock and beret he wore on the first episode were thereafter retired in favor of a not-too-woodsy plaid shirt that became his sartorial trademark and added a note of gravity to an artsy panache that, by today's standards of public behavior, wouldn't qualify as the least bit unorthodox. Gnagy sported relatively long hair for the day, along with a Vandyke goatee so pointy that anyone who harbored doubts about art might have found it a tad satanic. Years later, when I first saw Marcel Duchamp's *L.H.O.O.Q.*, a mustachioed and goateed reproduction of the *Mona Lisa* (pronounced in French, the letters form a sentence that means: *She has a hot ass*), it was Jon Gnagy who sprang to mind.

Dubbed "America's First Art Teacher," Gnagy revealed a nearly fatal weakness for puns by naming episodes "Where There's Still Life, There's Hope" or "How to Get a Head [*sic*] While Going in Circles," and so on. During the show, he sketched and painted each landscape as though in a race against time, which, since the show only lasted about twenty minutes not counting commercials, he was. While drawing along with Gnagy—or, rather, while trying to keep up with him—I seemed to float above the paper, a disembodied observer looking down into a world I could gradually enter as it achieved depth and detail. The successful replication of a tree or a barn filled me with the thrill of omniscience. But for all the satisfaction in making those landscapes, they were, in the end, someone else's idea of beauty, little more than quaint imitations.

Not until I came upon the article in *Life* magazine did I see that art's subject matter could be gleaned from the city, from my very own home. Even better, paintings by Pop artists presented a point of view entirely different from Ron's mournful portrait of Bob; Pop was enamored of a world in which all that's lost or obsolete is simply replaced by a newer model. Pop was based on unjudgmental wonder, without a trace of the suffering I was too young to know we all must bear, griefs as abundant and burdensome as Diego Rivera's flowers.

Once I was sure the librarian was distracted in the stacks, I quietly tore out the article in *Life* and folded it into my shirt pocket. I hadn't so much as stolen a candy bar before that day. I'd been taught never to write in the pages of a book from the library or to tear out the pages from a magazine in a waiting room. My mother demonstrated the concept of respect for others' property one day in the dentist's office when she found

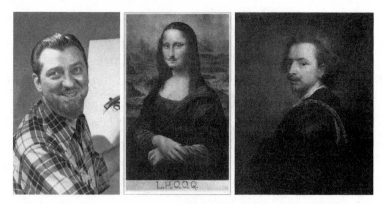

Jon Gnagy/Duchamp's *Mona Lisa*/Sir Anthony van Dyck

that a recipe she wanted to tear out of *Good Housekeeping* had already been torn out. "Don't do this," she said, showing me the ragged strip that was left. Despite the admonition, I kept the stolen pages of *Life* in the nightstand next to my bed and furtively eyed the article every night, the saturated color raising my pulse, the effect of Pop art nearly pornographic.

2. Just What Is It That Makes Today's Home So Different, So Appealing?

Eager for more to read, I searched through the art section of Pickwick Bookstore on Hollywood Boulevard (it was here that musical comedy star Ann Miller was reputed to have asked for ten yards of yellow books to match her living-room walls). Newly published, *Pop Art* (1965) by John Rublowsky was one of the first American publications to document the phenomenon of Pop. The frontispiece was dominated by a photograph of artists Claes Oldenburg, Tom Wesselmann, Roy Lichten-

stein, James Rosenquist, and Andy Warhol posed at a group exhibition of their work. The wan fashion model Jean Shrimpton stands among them, mascaraed and miniskirted, her hair molded into the stiff, symmetrical curls of a "flip." In another photo of the show, art patrons wander among a roomful of Warhol's Brillo boxes, a few looking somewhat bewildered, as if they'd accidentally stumbled into an industrial warehouse.

Rublowsky's book was prescient in that it treated these five artists as the celebrities they were to become, capturing for posterity their every brushstroke and contemplative pause. Each of them was given his own chapter and shown mixing paint or hefting rolls of canvas, hard at work in their cavernous studios. Each of them, that is, except for Andy Warhol, who sprawled on a couch, relaxing like a sultan while two handsome assistants in T-shirts and tight jeans dragged a squeegee across his silkscreen of Elizabeth Taylor. In the background, dozens of other paintings by Warhol leaned against a wall—Elvis Presleys, electric chairs—each image repeated over and over. The text claimed that the detractors of Pop found Warhol's multiple images numbing, but they dazzled me like the stutter of TV channels when I twisted the dial, or the brand names and logos and slogans that bombarded me every day like the sun's ultraviolet rays—Duz, Malt-O-Meal, Dippity-Do. As far as I was concerned, the glut of words and images comprised a fine, intoxicating nonsense. Andy's art was fun. I "got it," with a wallop.

Though I believed that Warhol made, or had his assistants make, great paintings, I was mystified by the man himself. In every photograph he lacked expression, the skin of his face as tight and shiny as a marionette's. He claimed that his fondest wish was to be a machine, and referred to his studio in Chelsea,

whose interior had been painted silver, as the Factory. The place looked as echoey and reflective as the inside of a tin can. One photograph showed Warhol dressed in a suit and sitting atop the Factory's silver toilet. Though there was hardly a glimmer of natural light in the room, he wore a pair of sunglasses, the flash-bulb reflected in his dark lenses like two bright but empty eyes.

The chapter told how the Factory attracted a gaggle of mis-fits on whom Warhol lavished his blank gaze. These were the "superstars" who slept, chain-smoked, or rambled aimlessly in his movies. At that point, I hadn't actually seen a Warhol film, but they sounded like an avant-garde version of one of my favor-ite television show, *Candid Camera*, where the host, Allen Funt, "caught people in the act of being themselves." I thought of the Factory as the home of an eccentric family for whom Warhol, with his ghostly pallor and silver hair, was a kindly albino uncle. High art and low, the significant and the trivial—Uncle Andy made no such distinctions. Though I couldn't have put it into words back then, there was something appealing in his neutral viewpoint. I liked his painting of Chicken Noodle Soup better than his painting of Navy Bean Soup because I thought it was a better flavor, though not necessarily a better painting. For what other reason could I have preferred one over the other? They were virtually the same painting but with different labels. The absurdity of this judgment, or lack of judgment, was not lost on me, nor was its shock value. When I brought Rublowsky's book to my mother and showed her the paintings of Campbell's Soup, she looked at me askance and patted the spongy rollers in her hair. My mother was a woman who shopped avidly and often, maneuvering her cart down grocery-store aisles with the instinct of a tigress hunting for prey; she seemed to sense rid-

icule, rather than celebration, in Warhol's oeuvre. "Da Vinci," she said, "he isn't."

In some ways, it's surprising that my mother couldn't appreciate the bounty of commercial subject matter that typified a work by Warhol. Both of my parents were second-generation Jews whose families had immigrated to the United States from eastern Europe. Growing up in Chicago tenements, they'd heard their parents bemoan in Yiddish all the comforts and conveniences they lacked. Now that my parents had moved to the Golden State and my father was solvent in his law practice, they were thrilled to be able to buy luxury items like five-speed blenders and portable TVs. They'd open these purchases with great ceremony, intone the instructions like Talmudic texts— "Make sure switch is in *off* position!"—and unfailingly mail in the warranties. It was a point of pride that they stocked our Spanish house in Hollywood with brand-name rather than discount products. "Why buy crap," my father would ask, "when you get something good for a few pennies extra?"

Yet those ancient days of scarcity had bred in them the habit of hoarding. They'd secret away even the smallest objects, stray odds and ends that others might have discarded without a second thought. My mother reused sheets of tinfoil and kept a sizeable bird's nest of rubber bands in a kitchen drawer. Claiming she needed them when she cleaned, she stuffed the utility closet with rags, shreds of the clothes and bed sheets she couldn't bear to part with. She'd stock our pantry with, say, two dozen cans of cling peaches if they happened to be on sale, and that flaccid, pale, syrupy fruit garnished our plates for weeks on end. So crammed were our cupboards that, during the Cuban Missile Crisis, I remember being certain that we'd "duck and cover"

when the bomb was dropped, then sit in the rubble and feast like kings.

My father also hoarded the flotsam of our prosperous life. On the shelves of his workshop in the garage, rows of used jelly jars (Mother had rinsed them with scalding water) held screws, washers, eye-hooks, nails of all sizes and degrees of straightness, fuses, thumb tacks, and stray springs whose origins were a mystery. Should the need for one of these odds and ends arise, he'd pluck it from a jar and go about his chores, as if it were a small but crucial detail he'd recalled while telling a story. "It's *meshuganah*," he'd always say, "but you never know what'll come in handy." Cash in hand, my parents assimilated into American life, but with the persistent suspicion that their prosperity would one day come to an end. No matter how much money my father earned, no matter how often my mother shopped, no matter what they crammed into cupboards or kept in glass jars, their belongings were borrowed, meager things, the privations of the tenement only a reminiscence away. We lived, I was given to understand, in a house full of fine but tenuous possessions.

Pop art was a movement tailor-made for the son of first-generation Americans, a boy who'd been weaned on the promise of plenty. Pop wanted me to have art that was push-button, wide-screen, charcoal-filtered, ready-to-eat, disposable, and one-size-fits-all. Pop wanted me to enjoy things while they lasted and didn't sneer at the world just because it was fleeting and gaudy. "Pop art represents our particular moment," wrote Rublowsky, "reflecting this particular civilization in its acceptance of the mechanized and mass-produced. These artists face the now, the today. Tomorrow they leave to the future." I loved

the martial tone of those lines, and had never thought of *today* as a noun, a thing I might possess as well as live through.

. . .

One chapter in *Pop Art* contained photographs from *The American Supermarket*, a 1964 exhibit at the Bianchini Gallery in New York City. The gallery was divided into aisles featuring bread, fruits, and vegetables. Chrome apples by Robert Watts could be purchased individually or by the dozen. Andy Warhol signed real Campbell's Soup cans that were stacked into a pyramid and labeled TODAY'S SPECIAL.

Inspired, I insisted on accompanying my mother on her visits to the Safeway Market. She interpreted this as helpfulness on my part, a healthy interest in domestic chores, but I'd often wander the aisles alone, dazed by the orange vortex of a Tide detergent box or the bright-green cellophane grass that grew beneath the avocados. Every package and label and display was designed to wrest my attention and fill me with longing, which is exactly what happened. The overhead lights flickered at the perfect frequency for a trance, reflections of the neon tubes shimmering in the polished floor. Muzak seeped from the very air, homogenizing popular songs into an endless, buoyant melody with plenty of gratuitous flourishes. I was too awed to care if I looked foolish gawking at a vacu-formed plastic Butterball turkey or a fat, inflatable Dole pineapple that hung from the ceiling on a string. What a thrill when I realized that, apart from permanent fixtures such as meat cases and cash registers, the supermarket was sent promotional items that were always changing. I could visit the Safeway every week and always see something new.

On one visit to the supermarket, my mother finally noticed

my fascination with packaging. We were standing together in the checkout line. While she browsed through the magazine rack, I became transfixed by a pack of Wrigley's gum. In the Wrigley's ads that adorned bus benches all over Hollywood, working people chewed a stick and, according to their thought balloons, water-skied, danced at a ball, or imagined some other antidote to drudgery. Life is like a dream, I thought. Sound had stopped. A foil rectangle gleamed in my palm, emblazoned with slender letters. The cashier's fingers were poised above the keys as she patiently waited for my reverie to end. "Are you all right?" my mother asked. She must have looked up from *Good Housekeeping* to catch me staring at a pack of gum as if it were an ingot of some rare ore.

If it sounds as if I were a budding consumer instead of a junior aesthete, let me add that it was of no consequence whether my mother actually bought the things I admired. Purchases were beside the point. I wanted only the luxury of looking, a total saturation of the senses.

Supermarkets weren't my only source of inspiration. I went into raptures over used-car lots, coffee shops, telephone booths, freeway overpasses, and especially crowded downtown intersections. Whiffs of bitter exhaust, vendors hawking stuffed animals and hot pretzels, store-window mannequins whose limbs were flung into ludicrous poses—whenever I stepped off the bus to visit my father's office on Spring Street, the city stretched before me like a man-made forest. A native Angelino, I'd never seen snow or autumn leaves firsthand, but I'd seen, on the billboard facing my father's office, a pat of creamy yellow butter melting into an Everest of peas.

Every Saturday on Channel 5, Jon Gnagy continued to

churn out a seemingly inexhaustible array of majestic, fleecy, and babbling subject matter, and yet I began to view his art through the lens of irony. He made bad art that was good because it was bad. Posing before his spindly easel, he played the role of eccentric-artist-as-celebrity. Gnagy, in short, was an unwitting Warhol.

By the time I was fourteen, the few assumptions I had about beauty were turning inside out. Art didn't have to be somber and lofty; it could be as laughable and blunt as a pratfall. All the "serious" art I'd seen in reproduction—*Mona Lisa*, *Blue Boy*, *The Thinker*—rankled with its piety and made me impatient. Sure, these might have been masterpieces in their time, but to honor them and ignore the world around us seemed a kind of hopeless nostalgia. The amber light of Renaissance landscapes, the still life's cascade of flawless grapes—such antiquated themes barely roused my interest. Besides, printed on T-shirts and coffee mugs and place mats, masterpieces were as common as weeds. Eschewing all claims to greatness, turning its back on posterity, Pop won me over by being unpretentious. Pop was the hick cousin who shows up at a black-tie affair in a checkered suit, loud yet guileless, a breath of fresh air. Trash Can school, the New Vulgarians—when epithets were hurled at Pop, my devotion only deepened.

There were nights when contemplating the democracy of Pop art left me too agitated to sleep and I would throw off the covers, fevered with the need to draw. Pastels had come to seem crude, and so I sketched with a sharp lead pencil. Using newspaper and magazine advertisements as models, I drew TV dinners, vacuum cleaners, and frosty mugs of A&W Root Beer. We lived in the foothills a few blocks north of Hollywood Bou-

levard, and whenever I stopped drawing long enough to look out my window, I saw the glow of city lights rising from the L.A. Basin, obscuring all but the brightest stars.

On a few occasions, insomnia stirred me to compose rambling manifestos, a word I'd learned from Rublowsky's book. In one manifesto, dated 1966, I scrawled in the loopy cursive of my teens: "Taking something that means nothing and making it art just by CALLING it art is something we have taken too long to do! It is glorifing [*sic*] the ordinary—producing excitement from dull [*sic*]—purpose from purposeless [*sic*]—IT IS ART! IT IS <u>MORE</u> THAN ART!!!" I'd caught the spirit of hyperbole, which resulted in the Royal We, underlined words, and rampant exclamation marks.

If I decided to read in bed before I fell asleep, it was usually a book or magazine article about Pop art. One work in particular fascinated me: a 1956 collage by the British artist Richard Hamilton. The collage was seminal in the history of Pop, which originated simultaneously in Great Britain and the

United States, so I came across it again and again. In a newly furnished, shag-carpeted interior, a body builder lifts a gigantic Tootsie Pop (according to one art historian, this was how the movement got its name), his thighs and biceps bulging. On the couch across from him sits a woman who wears nothing but a lampshade on her head and pasties over her nipples. A large canned ham sits on the coffee table between them. *"Just what is it,"* asked Hamilton's title, *"that makes today's homes so different, so appealing?"*

The answer, as far as I was concerned, was the man's physique. He looked a little like Mr. Rippey, my swaggering gym teacher. Whenever Mr. Rippey barked orders, which was just about always, spittle flew from his lips and tendons bulged in his neck. While we ran the requisite ten laps at the beginning of gym class, Mr. Rippey stood on the sidelines and ridiculed boys who

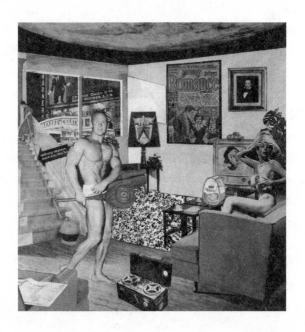

lagged behind. "Are your shoelaces tied together, Mr. Hasagawa? Mr. Leggit, are you a slug? Put some sweat into it!" He called us "mister," it seems to me now, in order to highlight how ill fitting the appellation sounded when applied to a bunch of gangly kids, whereas "mister" fit our gym teacher as snugly as his regulation T-shirt. No doubt he wore his T-shirts tight in order to invite admiration, but back then I worried that the strength of my longing overrode the rules of physics and somehow caused the cotton to cling, the words "Physical Education" stretched taut across his pectoral. "Today's topic is homos," he once bellowed at the beginning of a health class, stunning the assembled boys into silence. "Any questions? No? Good."

Pop art, it seems to me in retrospect, was the perfect guise for my nascent homosexuality. Pop scoffed at convention. Pop defied the prevailing aesthetic by not only tolerating, but reveling in, the "unnatural." Pop found a place in art for everything that society devalued. If there existed a precocious, self-congratulatory aspect of my devotion to Pop art, a willfulness to set myself apart and cultivate my youthful iconoclasm, that devotion also felt helpless, inexplicable, and driven.

In any case, the bodybuilder appealed to me more than the woman on the couch, no matter how hard I tried to make myself believe otherwise. Weighing and evaluating my response to those different forms of flesh, my eyes darted back and forth, back and forth, pausing at that can of meat in the middle—*Just open, heat, and serve!*

. . .

Claes Oldenburg was an alchemist. He transformed the rock-hard trio of bathtub, toilet, and pedestal sink into sculptures as

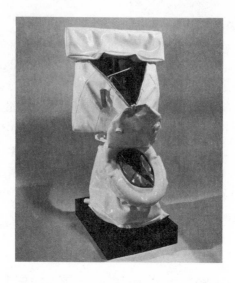

soft and pliant as pillows. Sewn from bolts of white vinyl and
stuffed with kapok, the fixtures sagged and swooned at odd
angles, tempting the viewer to touch, squeeze, and rearrange
them, to do anything but remain a passive observer. This phys-
ical shift from aloof solidity to wanton softness emphasized the
tactile, erotic nature of the bathroom. In the sea-green echo
chamber of my own bathroom, I scrutinized my skin, gazed into
my mouth, and marveled at the sight of my excrement. With
its frosted window and a door that locked, the room seemed
designed to protect and sequester the secrets of the body, all
embarrassing traces of which could be washed away. It was here
that I masturbated while imagining Mr. Rippey. In fantasy, he'd
swagger close, fidget with his whistle, and invite me to reach
beneath his shirt.

As I shuddered toward orgasm, the room around me would
soften and yield. The tiles could have been waves of green water,

the porcelain fixtures made of mist. During my adolescence I had become so guarded, so determined not to succumb to, or betray, the least hint of my sexual nature, that my plunges into fantasy made that small, glistening room seem momentarily boundless and liquid.

It was jarring to sense, even subconsciously, hints of my private sexual surrender in Claes Oldenburg's soft bathroom fixtures, which I had come across in an issue of *Art News*. But it wasn't until a visit to the Los Angeles County Museum of Art, in the summer between junior high and high school, that I actually saw one of his sculptures in person: an oversized egg beater suspended from the ceiling. With its flaccid handle and two limp whisks, the sculpture looked like a giant penis. At that point, I wasn't certain whether Oldenburg's work purposely evoked such overt sexual associations, so I didn't allow myself to dwell on the comparison for more than a second. Still, the Do Not Touch sign only encouraged furtive contact. When the guard in the corner looked the other way, I took a chance and reached out my hand. I was almost gone by the time he turned around, but the whisks still wagged suspiciously.

Also on exhibit was the artist's hamburger sandwich. Molded from plaster and displayed on a fake plate, the sculpture was slathered with shiny, dripping enamel paint, as tantalizing as ketchup and mustard. Standing before it, I felt a strange craving, as if I were an infant who learned about art by stuffing sculpture into his mouth.

To face my desires head-on was too stark and painful a prospect, and because of this, my burgeoning sense of the erotic was channeled into everything but the act of sex itself. The oblique

seductions of Oldenburg's work felt somehow familiar; he took heretofore neutral objects—a pink eraser, a smooth scoop of ice cream—and enriched them with innuendo.

In Rublowsky's book, the bald and hulking Oldenburg was the most antic among the Pop artists. He'd posed for one picture wearing a huge pair of plastic ears, in another an Alpine hat with a long, jaunty feather protruding from the brim. Dwarfed by his own sculptures, he appeared as impulsive and kinetic as a ten-year-old kid. But the artist possessed a thoughtful, almost melancholy presence when I actually met him in 1966. I'd taken the bus from Hollywood to a show of Pop art at the Pasadena Museum of Art. What I didn't know until I arrived was that the show was actually a preview for an afternoon auction. Men in khaki suits and women in summer dresses surveyed the paintings, sipping Champagne and murmuring in small, sedate groups. I loitered by the drinking fountain, feeling out of place and waiting for someone to ask me to leave, when I saw Oldenburg standing on the sidelines with his wife, Pat, whom I also recognized from Rublowsky's book. The artist looked groggy and anomalous in the crowd of art patrons. Dressed in baggy trousers and a faded shirt, he huddled close to Pat, whose limp brown hair and heavy mascara lent her an equally forlorn, bohemian air. I barreled toward them and heard myself stammer something inadequate about how much I loved his work. Pleasure slowly claimed his face. Without saying a word, he put one arm around me and the other around his wife. Before I knew it, the three of us were touring the room in a tight and silent trio, stopping to admire Andy Warhol's hot-pink hibiscus on a field of black grass, or a painting by James Rosenquist that read

SIGHT SEEING in big block letters, SIGHT written in roses and SEEING in shards of broken glass.

I was too stunned and self-conscious to fully appreciate what had happened—embraced by a Pop artist!—until Oldenburg lifted his arm from my shoulder. A bell had chimed and the double-doors to the room where the auction would take place were flung open in front of us. People began to jostle and swarm by. Pat was carried with them like a leaf in a stream, whereas Oldenburg and I dodged the oncoming throng of art collectors by stepping to one side of the door and standing beside a folding table. Perhaps the artist's ill-fitting clothes or sadly observant expression made him seem like an outsider; a gentleman with silver hair handed the artist his Champagne glass, assuming, as did every man and woman after him, that Oldenburg was a servant manning his station.

At first I bristled; didn't these people know who he was? Many had come to bid on his work! As Oldenburg reached for glass after glass, I saw that he was lost in concentration, and not at all offended by his role as impromptu glass-stacker. His bushy eyebrows arched in amusement. I felt certain he'd refuse any offer of help. Quick yet cautious, he grasped the slender glasses by the stems and seemed to take note of their slight variations: lipstick stains, damp and clinging cocktail napkins, cigarette butts floating in the golden dregs of flat Champagne. He never paused long enough to look into the eyes of the people filing past, who in turn took no notice of him. Once the surface of the table was crammed with glasses, he began to stack them in a second tier, then a third, a fourth.

After the patrons had drained through the door, men in jumpsuits raced into the room and began to lift the paintings off

the wall. Works of art were herded away. When I turned around the artist was gone, and a bartender, eager to leave the museum and call it a day, was busy dismantling the pyramid of glasses.

3. Be the Green!

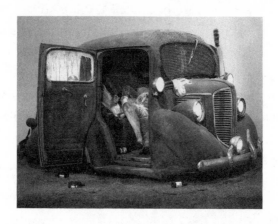

Entering the Ahmanson Building at the Los Angeles County Museum of Art (LACMA), one had to take a concrete walkway through the La Brea Tar Pits, which bubbled and stank with prehistoric ooze, fiberglass sloths and mastodons lurking at their edges. I took the elevator directly to the twentieth century, located on the fifth and uppermost floor, and skipped the floors that contained the old art. To see modern art was to rise above anything out of date, leaving it behind to sink in the pitch.

One summer I stumbled into the museum's Edward Kienholz retrospective shortly after it had opened, and before the vociferous city councilman Robert Dornan (later a US senator) began a campaign to make the exhibit off-limits to minors. The piece

that most enraged him—for weeks it was impossible to turn on the television without seeing him rail against the immorality of modern art—was entitled *Back Seat Dodge*. In a dark exhibit bay, the squat blue Dodge sat on a patch of plastic grass littered with empty beer bottles, its red taillights blinking like a distress signal, its windows filmy with grime. One of the car's rear doors had been flung open, and through it I could hear staticky pop songs wafting from the car's interior. The brash curiosity with which I usually approached a work of art was tempered, in this case, with caution.

Two figures grappled on the backseat. A chicken-wire man lay atop a plaster woman, slipping his hand beneath her skirt. In contrast to the weighty, earthbound woman, the man was transparent and ill defined, his passion a jumble of form without substance. The shabby, desperate rites of sex—I was riveted by the aura of menace, though too uneasy to look for long.

Also on display was another notorious tableau by Kienholz: *Barney's Beanery*. A nearly full-scale replica of a bar on Santa Monica Boulevard in West Hollywood, the gay area of Los Angeles, the Beanery was inhabited by patrons whose faces were stopped clocks, and whose bodies had been basted in amber shellac, as if the artist had made a futile attempt to preserve their flesh. A tape loop of drunken chatter and a chemical replicating the smell of stale beer added to the stifling atmosphere. What had the greatest effect on me, however, was a misspelled sign above the bar: FAGOTS STAY OUT! When I overheard a docent tell a group of tourists that the same sign hung outside the real beanery, I felt myself grow hot with shame; in those days I was so convinced that my desire for men was unforgivable, I never considered the possibility that Kienholz may have included the sign to indict the drunks who drooped from barstools, or to comment on the peck-

ing order in a roost of losers. Instead, I pictured myself despised in the future, banished from even unsavory places.

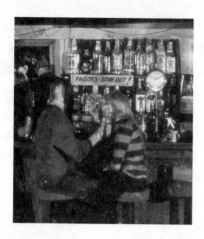

For weeks afterward, I mulled over the Kienholz exhibit, wondering what his work could tell me about the world. More than anything else in my life, art's provocations, whether pleasant or unsettling, engaged and sustained me. Even back then I was aware of the dual citizenship of an artistic life, how I lived within the actual world as well as within its internal reflection.

After the unnerving worldliness of the Kienholz show, LACMA's collection of abstract expressionism was a welcome relief. I spent the better part of an afternoon lost in Jackson Pollock's drips and Mark Rothko's foggy oblongs, surfacing from my ruminations only when I heard people huff and click their tongues before launching into some harangue about how a child or chimpanzee could paint the same picture. More than once, I was tempted to echo one of my parents' favorite admonitions: "You're letting yourself get upset over nothing." But of course "nothing" was precisely what upset them: They couldn't say what the paintings were of.

Although I preferred the banalities of Pop, its imagery recognizable in a split second, I believed it my duty to stand there and fume on abstraction's behalf. The splashes of paint were really pretty.

It would be years before I read about the psychic inwardness, the emotional turbulence that often fueled abstract expressionism. That afternoon at the museum, I'd studied paintings by Franz Kline and Jackson Pollock without understanding the physical strain, the grim exhilaration that went into them. And so I retrieved my brother Ron's rickety easel from a closet and set it up in our backyard. It was a sunny afternoon, which must be why I took my equipment outdoors as if I were a landscape painter instead of the abstract expressionist I intended to be. I worked on a piece of panel board about two feet square (clearly, the monumental scale of abstract expressionism hadn't sunk in) and used a tube of phthalo green paint—a sort of tart, electrified lime that caused the retinal equivalent of puckered lips. I squeezed the color straight from the tube. I made a few strokes across the white surface, then began to gingerly poke at the pigment till little globs of it peaked like frosting. Hoping to open myself to inspiration, to let some creative force move through me—*Be the green!*—I tightly gripped the brush in my fist. The easel began to rock back and forth from my ever-more-blunt, impassioned blows. From deep within this fit of inspiration, I heard my mother knocking on a window, and I turned to see her, eyes wide, peering out at me from the kitchen window.

. . .

My phase of artistic apprenticeship continued throughout junior high school. One Saturday I bought a small primed and pre-stretched canvas at the local art-supply store and set out

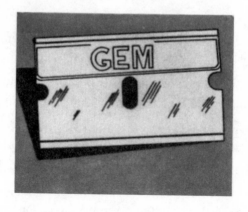

to paint something in the hard-edged manner of Roy Lichtenstein. I looked around the house for a suitably mundane subject and chose one of my father's razor blades. The blade was blunt on one side, with the brand name, Gem, embossed along the edge. In some vague way I was intrigued by the incongruity between the name and the object, but mostly I figured that, being a simple rectangle, it would be an easy subject to render. Woozy from paint fumes, swept away by the glee of completion, I ran downstairs and showed the painting to my parents, holding the canvas from behind by its stretcher bars and waiting for murmurs of appreciation. That my parents might react with a kind of mute incredulity to their teenage son having painted a huge razor blade didn't so much as cross my mind, and when I lowered the canvas from in front of my face, I saw that they were wearing suspiciously wide smiles, like mouths that had been cut from toothpaste ads and stuck to their otherwise troubled faces.

"What's it called?" my mother asked, ever diplomatic.

"*Gem,*" I said.

My father grunted, "Hmm."

"And you plan to hang it where?" asked my mother.

"I guess in my room."

They looked at each other and exhaled with relief.

I dismissed their lack of enthusiasm as precisely the kind of misunderstanding my artist-heroes must endure every day. In fact, my parents' bemusement turned out to be far more gratifying than their approval ever could have been: I found their disbelief more refreshing than an ice-cold Coke.

With each passing month it seemed that the chasm between me and my parents opened wider. Mystified by my passion for art, they never asked a question or ventured a comment, afraid to betray any sign of ignorance about the culture they strived to blend in to. My immersion in the avant-garde must have reminded them that the country in which they'd worked so hard to find a stable place was rapidly changing: color TV, area codes, Strip-O-Grams, passenger jets. Even their son was becoming a stranger. Still, their parenting had been based not only on the liberal wisdom of Dr. Spock but on a Jewish ethos that honors intellectual investigation of all kinds; as a result, they left me pretty much to my own devices. I prided myself on being in touch with, if not ahead of, the times. My parents remained on the shores of the Old World, with its bland cooking and Yiddishisms, while I eagerly departed for the new.

. . .

One day, an unusually subdued Mr. Rippey met his class of fifteen boys at the locker-room entrance. He told us we wouldn't be changing into our gym clothes and led us to a stand of bleachers on the far end of the playing field. "Men," he said, without a hint of the usual sarcasm, "please be seated." He folded his arms across his impressive chest. "President John Fitzgerald Ken-

nedy was shot while riding in his motorcade in Dallas, Texas. He passed away at eleven fourteen this morning. You will sit here in respectful silence. It is a time of national mourning. Is that understood?" Most of us nodded, not only dumbstruck by the news but afraid to so much as mumble *Yes*. Mr. Rippey spun on his heel and swaggered across the asphalt toward his gymnasium office, where a newscaster's urgent but indecipherable voice crackled from a radio.

Once Mr. Rippey was out of sight, we looked into one another's bewildered faces as if to find a clue about how to feel or what to do next. I'm sure I wasn't alone in wondering why Mr. Rippey kept us at a distance from the news reports. In order to spare us the details? Because we were just a bunch of boys? Few of us had ever experienced a tragedy like this, touching all of us at once. Five minutes passed. Ten. It was odd to remain stationary during PE and we quickly grew restless. Allen Hasagawa opened his lunch bag and bit into a limp bologna sandwich, chewing as though it were homework. Lawson Leggit bent forward and cupped a hand to his ear, catching snippets of the news and daring to whisper to the rest of us what he'd heard, or thought he'd heard. "The FBI caught a Russian spy! They're going to freeze JFK's body!"

This was the first time I'd heard the word "motorcade," which reminded me of "Ice Capades." It was also the first time I'd seen Mr. Rippey express an emotion other than disgust at our athletic inadequacies. The drastic change in his demeanor made me think of my father standing in the hospital corridor a few days before my brother died; one minute he was flagging down a nurse, and the next he buckled inward, a sob caught in his throat. My mother and Ron and I stood and stared for a moment, none of us making a move to comfort him, so sudden

and uncharacteristic was his outburst. It was as if the three of us had stumbled upon an animal whose leg had been snagged in a trap, a species we couldn't identify and were too afraid to touch.

Years had passed since my brother's death, but I could still smell the ammoniac air of his hospital room and feel myself confined within its walls. I sometimes stared at my sleeping brother's bed for so long, I imagined he'd arranged his pillows beneath the sheet, a decoy in the shape of his body. Then I'd notice the rise and fall of his breathing and my vigil would resume.

I was jarred back to the present when Allen Hasagawa shouted, "Hey, Lawson. Did you know that your name backwards is Tiggel Noswal?" A titter rippled through the bleachers. Lawson was the scrappiest boy in class, and simply by reversing the letters of his name, Allen had cast a spell that made him harmless.

Lawson's back stiffened. He stood up and turned around. Surprised at the fury in Lawson's eyes, Allen stopped chewing his sandwich. "Hey, Hasagawa," Lawson shouted. "Did you know that your name backwards is Asshole Assholegawa?"

Our gym teacher must have looked out his window just as Lawson began to shout obscenities. In no time flat, Mr. Rippey (now might be the time to mention that his nickname was "The Ripper") flew from his office door and careened up to Lawson from behind, grabbing the boy's collar and lifting him entirely off the ground with one muscled arm. It was as if Lawson's shirt had suddenly flown upward, dragging its wearer along for the ride. Lawson flailed. He blanched as white as a glass of milk. Mr. Rippey carried the dangling transgressor into his office and slammed the door behind them with his foot.

Whenever we got out of line, Mr. Rippey reminded us that he'd drilled holes into the wooden paddle hanging in his office.

"Diminished wind-resistance" allowed the paddle to travel faster and hurt more. Three stark reports confirmed the holes were working.

Moments later, Lawson emerged from the office door. He blinked against the sunlight and limped back to the bleachers, his pride and feistiness "knocked into the next county," as he himself phrased many a threat. If he'd been a raucous, unbearable boy before the paddling, he was far worse now—slow and insensible and broken. He faced us for the entire walk but looked right through us, seeming not to know who we were. The sight of him filled me with a wordless apprehension: after the world doles out its blows, who do we become?

Two years later, at the Ferus Gallery on La Cienega Boulevard, I saw Andy Warhol's multiple silkscreen portraits of Jackie Kennedy in her mourning veil. Some of the images had

registered more densely than others, the widow's face either bold or ghostlike, depending on the pressure.

4. Ready-Made

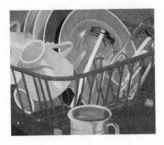

Dishes—James Rosenquist, 1964, 50" x 50"

By the eleventh grade, I refused to let trivialities like homework and what my mother called "a boy's basic need for fresh air and exercise," get in the way of making art. My grades in liberal arts courses were fair, while those in math and science plummeted. This, combined with my propensity to stare at a bottle cap or dish rack and ruminate over its physical properties, was especially alarming to my mother, who'd begun to wonder about my eligibility for college, not to mention my mental health. It was not unusual for my mother to find me fishing an empty box of Kraft Macaroni & Cheese out of the trash can, or collecting lint from the dryer because I had a hunch I could "use it for something." My drive to hoard useless things was no more odd or inexplicable than hers, and yet, all these years later, when I picture my mother dressed in her housecoat and looking at me wistfully, I understand at last how perplexed she must have been.

In the presence of her friends, my mother minimized her worry by dubbing art my "nutty hobby," which made it seem like an eccentric aside to her son's otherwise normal preoccupations. By 1968, however, "normal" was considered an insult, not only by me but also by most of the kids I knew. "Freak" was the term for anyone scruffy and unconventional enough to merit the admiration of his peers. I first heard the term while smoking pot in the back of Brenda Komensky's van during lunch period. Draped in a shawl she'd knitted herself, Brenda took a hit and rasped, "My lover, Jasper, is such a freak. The guy sleeps naked and grows his own dope."

The walls of Brenda's van were covered with paisley and rainbow posters for bands like the Jefferson Airplane and Strawberry Alarm Clock, the psychedelic text melting into illegibility. With my shoulder-length hair and wire-rimmed glasses, I fit the hippie image to a T, allied with the times in most respects—except for aesthetics; psychedelia repelled me with its florid distortions, its airless excess. Psychedelic art borrowed heavily from art nouveau and stressed the undulations of nature, the decorative tendril and flowering bud, whereas I was excited by the repetitions of mass production, the bold graphics of advertising. My circle of friends, with their back-to-nature aspirations, found Pop art shallow, as corrupt and impersonal as modern American society itself. They were as baffled as my mother by the art I revered. "Pop is so plastic," one friend remarked, meaning, it took me a moment to realize, "plastic" in the pejorative.

Lovers of psychedelia, my high school friends possessed an endless tolerance for hallucinogens. I'd dropped acid a couple of times, but found the experience overwrought and ugly. One

Saturday morning, right as we were peaking, Brenda and I went to eat at a restaurant next to the La Brea Tar Pits. The patrons (I realized later they were senior citizens who'd jammed the place to take advantage of a cheap breakfast buffet) looked stiff and mineral, like fossils dredged from the ooze and resurrected, and this, along with the granules of salt breathing in the shaker, caused me to lose what little appetite I had. We spent the drive back to Brenda's house, which seemed to take several days and involved unexpected detours through foreign countries, trying to remember if we'd left the waitress a tip, paid the check, or went inside the restaurant at all. My consciousness felt expunged rather than expanded, and it made sense that if I disliked the psychedelic aesthetic, I'd dislike the drug from which it sprang.

. . .

In the twentieth century, the museum and gallery have assumed an almost religious authority when it comes to ratifying vanguard art; renegade and previously unacceptable objects are sanctified within those walls. Marcel Duchamp, whose found objects, or "ready-mades," I'd read about in high school, understood this earlier than any modern artist. By mounting exhibitions of his work that included a bottle rack, a snow shovel, and, in the most notorious instance, a urinal, he not only gave these objects the imprimatur of art but suggested that choosing an object is tantamount to creating one. Ready-mades embody his aesthetic every bit as pointedly as objects crafted by hand.

Although I may have possessed a precocious sympathy for such ideas back then, they were inarticulate inklings at best, dim apprehensions. A thrilling paralysis, a churning in my solar

plexus; these were (and to a large extent have remained) my sole criteria for judging art.

In any case, my longest exposure to the transformative white environment of high art came when I was in the eleventh grade. At this point, a one-man show seemed the only way to prove to my parents, and to myself, that a life in art was the right decision. And so I spent a summer afternoon tromping into galleries and asking dealers to take a look at the Polaroid snapshots I had taken of my paintings of razor blades and towel racks. In lieu of a portfolio, I'd pasted the Polaroids into the pages of an empty family album I'd found in the basement. "Family Album" in fact, was written across the cover in fancy gold script, befitting the fierce, paternal pride I felt about my work.

The north end of La Cienega Boulevard was almost entirely taken up by small, thriving galleries. Everything from moonlit seascapes reminiscent of Jon Gnagy's to glossy, monochromatic slabs by Los Angeles artist John McCracken filled the display windows facing the street. Because the galleries were located in West Hollywood, antique shops also flaunted their stock of French provincial chairs and brocade drapery. Elegantly ghettoized, the north end of the boulevard was redolent

of a pampered, old-fashioned homosexuality—an atmosphere that simultaneously threatened me and made me feel safe.

Despite the district's bustling outward appearance, I was consistently surprised to find the galleries silent and empty except for the dealers, mostly well-dressed middle-aged men who sat behind enormous desks. Not one of them was charmed by an overeager high school kid thrusting in front of their faces his family album, and since they seemed to be doing nothing more than stewing in a vacuum, they couldn't, with much conviction anyway, blame their lack of interest on an urgent phone call or a demanding collector. They dismissed me with a flick of the hand, a condescending smile. I'd imagined an enterprise as frenzied as the stock market; could the commerce of art be as impenetrable and lonely as it seemed?

By the time I entered the Horizon Gallery, I'd pretty much given up on the idea of a one-man exhibit and wondered how I could earn extra cash for art supplies. I didn't bother to show the gallerist my portfolio, which I'd tucked under one arm, nor did I look at the prints on her walls. Instead, in a last stab at audacity, I marched up and asked if she needed an assistant. After sizing me up and asking a few questions, she hired me on the spot.

And so, three days a week, I unlocked the gallery at noon, dusted the desk, vacuumed the architectural carpeting, Windexed the enormous plate-glass windows, climbed a stepladder to change burnt-out lightbulbs, and watered the potted palms. I became—you'll forgive the Duchampian pun—a kind of "ready-maid," keeping the context of art pristine.

My employer arrived at work with the tailored, quaffed, and moisturized look of a woman of means. Gail remained unfailingly buoyant during the long hours in which there was little to

do except sip coffee, open mail, and straighten the Chagalls and Picassos in the print cabinet. She performed these tasks with attentiveness and pleasure. More art arrived at the place than ever left it, and because the realm of personal finance was still a mystery to me, I spent a great many of those idle hours wondering how she made money. Though always kind, Gail wasn't a particularly forthcoming woman, and it was largely by eavesdropping on her private telephone conversations that I gleaned the story of her divorce from a corporate executive who'd left her for a younger woman and, in a pang of guilt, agreed to support her gallery until it got off the ground. "It just may take me the next ten years," I once heard her boast to a friend on the phone, "to show so much as an itty-bitty profit."

During her lengthy lunches (from which she returned humming and flushed from wine), I sat in the swivel chair behind the desk, alphabetizing files and signing for deliveries. In the rare instances when someone asked to see a print, I wanted him or her to think I was an art-world prodigy. Before sliding open a drawer, I had to don a pair of white cotton gloves that made me feel as formidable as a surgeon. I wasn't especially interested in the artists whose work we sold, but I soon discovered that, when showing a print, a noncommittal attitude was the most aggressive sales tactic of all. Should I sense that someone was intimidated by having to stand there and stare at a lithograph, I might, after a good long while, break the tension by saying something like, "He's very free," in the case of Picasso, or "Those floating lovers," in the case of Chagall. I quickly learned that the most obvious tidbit of commentary could sound so knowledgeable, so cleverly epigrammatic, in the velvet setting of another's silence.

In those days I was only partially aware of how badly I wanted to belong to some kind of group or movement, to posterity itself. As deeply as I believed in the challenging spirit of the avant-garde, and especially in the playful effrontery of Pop, I still craved some form of normalcy and acceptance; all the more so since I feared that my sexuality might lead to a life of ostracism: Fagots Stay Out!

Manhattan was the geographical focus of my yearning to belong to an artistic elite. Apart from the fact that I could visit its museums and see works of art I'd only known in reproduction, I imagined the city as that most romantic of paradoxes: a community of misfits. Here was a place where one's eccentricities, chronic alienation, and skewed perceptions were looked upon as badges of distinction rather than flaws to be overcome; they comprised, if one was lucky, the elements of sensibility. Never having stepped foot in the city allowed my fantasies about it to run wild. The recurring theme involved addressing famous artists by their first names: *You're looking a little pale, Andy! Nice turtleneck, Roy! Oh, Claes, you nut, sit down already!* The presumption of it quickened my pulse.

The notion that artistic and personal redemption was not only possible but probable in New York City had been planted long ago by Rublowsky's book. Picture, if you will, the pastels of every other state blanched from the map; I mistook Manhattan for America and vowed to get there however I could.

I'd recently sent away for applications to a couple of art schools in Manhattan—the School of Visual Arts and Cooper Union—and toward the end of summer, I filled out the various forms. Each school required a lengthy essay in which the applicant explained why he'd chosen to study fine art. In an effort to

drum up ideas, I dug my yellowing manifestos from the bottom of my closet. What a shock it was to read them again! By then I'd gained enough distance on my past to cringe at the capitalizations and exclamation points. No doubt I'd been convinced of my sophistication when I'd written them, but now lines like "Take the common egg which we eat every day but ignore even though it means BIRTH and CHICKENS and EVERYTHING!!!" made me weak with embarrassment. How easily my zeal had boiled over. Were my present convictions equally absurd? I couldn't help but suspect that several things I'd said or done that very day were lying in wait to shame me in the future.

Each of the application forms stated that the admissions committee placed special emphasis on one's portfolio rather than on grades. This suited me fine, since my grade-point average was modest at best. Nor was acceptance based on SAT scores, a big relief considering I'd received the lowest SAT score for math in my entire graduating class. A counselor had called me into his office to break the news and inform me that, according to the Scholastic Aptitude Handbook, my number (around three hundred) was the probable score one would get if they had simply guessed at every answer. He'd intended, I think, to humiliate me into studying harder, but I was awed that the statistics, in a kind of numerical clairvoyance, had revealed my method of taking the test: darkening all the circles in a pleasant but random pattern.

. . .

The night before I left Los Angeles to attend the School of Visual Arts (SVA) in New York City, my parents made an uncharacteristic attempt to offer guidance. Up until that point, they'd

never interfered with my decisions, remaining steadfast in the belief that my destiny would take its own course. Besides, they had their own problem to contend with: a mutual estrangement that had all but nullified their marriage. For years I'd been aware that an icy silence had descended on our house, but it wasn't until the months before I left home that my mother voiced her suspicions about my father's infidelities. She told me about the bills from local motels and florists that she'd intercepted from the mail. Perhaps my parents' visits to my room that night were an attempt to stake independent claims for my affection, or to compensate for the steady wayward drift of our family history.

My mother was the first to knock on my door. She perched beside me on the edge of my bed, warning me that drugs were easily available on college campuses and urging me not to get "hooked" on marijuana. She wanted to touch me, I could tell, but both of us had relegated displays of affection to the past, and our differences—sullen housewife and artistic hippie—made us shy with each other. I couldn't bring myself to tell her that pot had motivated my late-night forays to the kitchen, where I devoured enormous portions of canned fruit cocktail—chunks of wet confetti!—and laughed, for a change, at my father's corny jokes. She'd beam at these inexplicable moments of family bliss and chalk them up, I suppose, to the fleeting possibility that things hadn't gone so wrong after all.

"I won't get hooked," I promised.

My father took her place on the edge of the bed a little while later, asking whether I was sure, absolutely sure, I wouldn't be better off in a more lucrative profession. "Lucrative" was what my father would have called, without irony, "a two-dollar word," which he reserved for only the most serious occasions.

The author's soggy re-creation of James Rosenquist's 1964 painting *Fruit Salad*. The actual painting sold at Sotheby's in 2000 for $194,750.

I'd always suspected that my father's resistance to art stemmed from his belief that, since art didn't guarantee a monetary return, it was, occupation-wise, a decorative flourish dwarfed by more important matters, like one of those frilly paper ruffs stuck on a pork chop. Now and then I'd considered professions other than fine art, furniture designer and actor among them, but none promised a substantially better shot at financial security. Besides, every summer job, household chore, and hour spent in school seemed like a distraction; I was always aware of my restless hands and an inexplicable surfeit of feeling that only making art could ease. Heart-to-heart talks were as foreign to my relationship with my father as the geography of Mars; although he once instructed me on how to write a check, in every other respect he expected me to learn about the world through osmosis or trial and error. And so his proximity on the edge of the bed, his grave patience, and the fact that he actually searched

my eyes, were cause for alarm as well as warmth. Don't misunderstand; I long ago stopped blaming the loneliness of my youth on my parents; benign neglect was the very medium in which my artistic ambition thrived, and I appreciate, to this day, the advantages of solitude. Still, my father's sudden regard left me, if not speechless, then too startled to defend, with any real persuasiveness, the gamble of a creative life.

"Art is all I think about," I said.

5. Junk N' Stuff

A few weeks before the freshman semester, I found a bachelor apartment (I loved the suave and manly sound of it) on East Twelfth Street between Second and Third Avenues. The basement windows were level with the sidewalk, the legs of pedestrians blurring past. If I pulled down the shades, harried shadows raced across them till daylight faded. Late at night, the homeless migrated up Twelfth Street from the Bowery and rummaged through the building's trash cans; my dreams echoed with a tinny clatter and I often awoke from a shallow sleep with the desperate sense I'd been searching for something.

I purchased a single bed (a testament to my sexual pessimism), and a wobbly bookshelf from Junk N' Stuff, the used furniture store around the corner. On its shelves I kept, among a few other books, *Pop Art Redefined*, *Pop Art and After*, and *Pop!* Unfurnished and white and lit by the fluorescent tubes above the kitchenette, the room bore enough of a resemblance to a gallery or loft to make me feel that I inhabited my future, or at least some affordable corner thereof.

Junk N' Stuff was owned by the young married couple who lived directly across the hall. Beginning my first night in the apartment, the sounds of their fights wafted though the bathroom air vent, a series of muffled but escalating accusations followed by a volley of fleshy thumps. Each time I ran across them in the hall, they were trussed up by a new set of slings, crutches, plaster casts, Ace bandages, or eye patches, their wounds and bruises in ever-changing colors and locations. Back then, spousal abuse was not the public issue it is today, and I was stunned not only by the extent of their injuries but by their displays of what appeared to be genuine affection. Before donning their sunglasses, they exchanged loving glances through blackened eyes, one of them graciously holding open the lobby door while the other hobbled through it.

The city was stranger than I expected. Or rather, I felt like such a stranger there, it failed to meet my expectations. Within those first few weeks, no college-freshman mishap was too far-fetched or clichéd to befall me. Food in the refrigerator grew velvety with mold. I shrank half my clothes at the Laundromat. I once buzzed into the building a man who claimed to work for the phone company. He shat on the floor of the lobby and left.

If there were opportunities to meet or have sex with other men—I was on my own after all, could sculpt desire into any shape—my sense of geographical dislocation, my attention to matters of daily survival, and plain fear prevented me from noticing. However, men whom I'd quickly passed on the street during the day would reappear in my fantasies at night. Without even thinking, I'd hoard erotic provocations, physical details I could conjure at will: the landlord's imposing shoulders in a tank top, the arch of a window shopper's ass.

I suppose I half hoped to meet another gay student once school began. And yet I hadn't entirely given up on the idea that a female might come along whose compelling beauty or artistic daring could detain, or even derail me, from the inevitable. But on the day of my first class—it had the baffling title of Art Praxis—what struck me most about my fellow students was the collective bashfulness that prevented us from talking, joking around, or introducing ourselves to one another as we waited for the teacher, Vito Acconci. As a group we seemed not only green as artists, but too unformed and introverted as people to give off any clear signals regarding our sexuality. A wall clock ticked. Beyond the tall windows, clouds gathered over the city, buildings in the distance hazy from rain. A glum spell had fallen over the room, and just as I braced myself for disappointment, the instructor appeared in the doorway, crushing a cigarette beneath his heel and hyperventilating from his climb up three flights of stairs. Or so I supposed.

Rather than books or a briefcase, he carried a small tape recorder that he placed on the table at the head of the class. He looked at us for what seemed like a long time. Beneath a head of scraggly hair that was limp from the rain, his features were almost farcically large, yet his face possessed, as homely faces sometimes can, a crude appeal. Once he'd caught his breath, I fully expected him to call roll, hand out a syllabus, or engage in some academic formality that would let us know we were in the big league now—no dabblers or dilettantes, please. Instead, he said, "I ran all the way from SoHo while counting." He punched a button on the tape recorder, left the classroom, and paced in the hallway, occasionally peering through the open door to check our response to his "piece."

From the very start you could hear the impact of his feet on the pavement, faint blows pulsing in his breath. Soon he began to struggle for air, counting with a hollow rasp. By the time he reached two hundred, he'd succumbed to a rapid, doglike panting. His tongue sounded dry. Sometimes he'd cough, muffing the numbers. It was difficult to listen to him without feeling exhausted or thirsty or starved for oxygen yourself. By then we were glancing at one another to make sure we weren't alone in our puzzlement or, in some cases, disgust. One student asked if it was too late to go to the registrar's office and get a refund, and few kids snickered in solidarity. As he approached five hundred, you could barely make out which numbers he was heaving, the act of counting painfully abstract. Alternating waves of agitation and boredom beset the class. Nearly twenty minutes had passed. "What does this have to do with art?" someone barked from the back of the room. "That's good," Mr. Acconci shouted from the hallway. "An excellent question. Thank you." He lit a cigarette.

Finally the tape spooled to an end. Someone applauded, but it was unclear whether they did so out of appreciation or because the counting had finally stopped. Even in the silence, numbers continued to throb in my body, like the phantom sensation of rocking after you've been on a boat. Mr. Acconci returned to the room with a weary expression (he had, after all, jogged twenty blocks). He turned off the tape recorder and glanced at his watch. "That's all we have time for today." Someone groaned with facetious disappointment, but Acconci impressed me as a man so thoroughly focused on his own ideas that he hardly noticed when they were met with derision. I found myself captivated by, and envious of, his self-possession. He cleared

his throat. "Your assignment for the next class . . ." Notebooks opened. Pens were poised. ". . . is to bring in nothing."

"Hold it," said Delia, the black girl who sat in front of me. "Are you saying there's no assignment, or what?"

"I'm saying the assignment is to bring in nothing."

"Zero?" asked Carl Tornquist, a boy with lank blond hair and wire-rimmed glasses.

"Is that how you interpret the assignment?"

Carl shrugged and bit the end of his pencil.

"Is it possible to make a work of art that is not embodied in an object?" said Acconci.

A ponderous silence.

"Well?" said Delia.

"Is it the artist's job to answer questions, or to ask them?"

In a classroom in Manhattan on a rainy day, my perception of art was changed forever. I heard the sound of one hand clapping, of a tree falling in an unpeopled forest. Vito Acconci's pedagogy was a mixture of persistent inquiry, faith in the invisible, and nudges toward the unknown. It struck me for the first time that art might find forms beyond painting and sculpture. This was a mind-boggling revelation, like opening a door in your own house and discovering an entirely new room. My jaw went lax, my breathing deepened. The spirit of conceptualism had entered me, and I became a convert then and there.

"Will we be graded on nothing?" asked Delia.

"Not," said Acconci, "if you come empty-handed."

. . .

The next morning, while mulling over the nature of nothing, I sipped the instant coffee I'd made with hot tap water. I thought

of the residue absences left: wet rings on the surface of a table, the rubbery crumbs when a word was erased. Nothingness took so many forms, each of them elusive. I considered handing in a blank sheet of paper, but that was too obvious a solution to the assignment, and I was sure another student had already thought of it. I wracked my brain and pressed ahead. Wasn't it every artist's assignment to make something out of nothing for the rest of their lives? Wandering the paths of free-association is the only skill I can boast I was born with, and so, sitting cross-legged on the floor of my apartment, I incubated odd ideas.

Eventually, I decided to write one of my secrets on a piece of paper. I'd use lemon juice instead of ink, a trick I'd learned from a Hardy Boys book (the story involved amateur sleuthing and intercepted letters, a little like my mother's life) in which the boys held an invisible message above a candle flame until the letters were cooked to a legible brown. As the elements of my project came together, a strange chill spread over my skin. For a blissful instant, chaos was shapely.

When I heard the couple across the hall making their early-morning maneuvers into the outside world, I dashed out my door and asked if I could borrow a candle, a lemon, and a pack of matches. They responded to my request without asking a single question, the kind of incurious etiquette they expected in return. While we made small talk, the husband blocked the door to their apartment, as if he were trying to prevent me from seeing inside. Finally the wife limped out holding a votive candle and matches in one hand and a wrinkled, anemic lemon in the other. They nodded and donned dark glasses when I thanked them, walking arm in arm toward the door.

Back on the floor of my apartment, I squeezed lemon juice

into a bowl. I needed a toothpick to use as a pen, and I found one spearing a shriveled sandwich in the refrigerator. But when it came time to commit a secret to paper, I found myself balking. My deepest secret was far too incriminating to share with a group of strangers, and yet the temptation to do so gave me a thrill, like curling my toes over the edge of a precipice and daring myself to look down. Though I'm not particularly proud of the fact that, in the end, I opted to maintain my secret by being oblique, this would be a practice-run that made my eventual honesty possible. *Sometimes I'm Afraid*, I wrote. This statement managed to touch on the truth without actually jarring it loose.

Along with typewritten instructions—*Light candle. Hold paper six inches above flame. Burn secret after reading*—I neatly arranged everything in the clear plastic pouch my shaving kit had come in. Since Pop art had made me too ardent a lover of objects to entirely forsake them, packaging an idea as if it were a product seemed like a pleasing compromise.

At the following meeting of Art Praxis, only three out of twenty students brought nothing into class, which is to say that seventeen students took the assignment literally. Delia went first, standing in front of the room at Mr. Acconci's urging. During her valiant attempt to explain the large zero she'd made by bending a coat hanger into a crooked circle, she grew flustered and giggly, finally falling silent. The zero dangled from her outstretched arm. "Hell," she said finally, "I thought of it while I was getting dressed, looking in the closet for what to wear. It's just something I made at the last minute."

If Delia thought she'd gotten off the hook by trivializing her project, she was wrong. Acconci launched into a lecture about

artists who employed the materials they found all around them, no matter how ordinary or unpromising. He told us that Robert Rauschenberg had stretched his own bedding over a wooden frame and used it as a canvas, the sheets and pillow and patchwork quilt splattered with paint. According to Acconci, *Bed* had ingeniously bridged the gap between the abstract expressionism of the 1950s and the representation of common objects in the 1960s. "Rauschenberg's *Bed*," he said, "is interesting not only as an *object*, but as a *gesture* that turns making a painting and making a bed into similar activities." Acconci insisted that Delia's zero was "gestural," like the quick but knowing strokes of a sumi-e painter who captures the lines of a bird in flight or leaves sprouting from a sprig of bamboo. "Maybe you did throw

this together at the last minute," he told Delia while he paced back and forth, "but suppose the value of a work of art isn't determined by the amount of time it takes the artist to make it? And what if the artist doesn't make the work himself? Take Andy Warhol, for instance, whose work is made by assistants. If we eliminate time and labor as determining factors in the value of art, what are we left with as a marker of value? The artist's intention? The artist's idea? Or perhaps art no longer has a *value* as we once understood the term, but rather a *significance* that is always changing. Your response to the assignment addresses several important issues."

Delia's arm had fallen to her side. "Whatever," she said.

Next, Carl Tornquist lumbered to his feet. He cupped in his palms a handful of shredded paper and explained that it was a letter he'd been writing to his girlfriend, Cindy, but tore to pieces when words failed him. No matter how often he'd tried to write her, he couldn't think of what to say or how to say it. In fact, he hadn't written to her in so long that he wasn't sure Cindy was still his girlfriend or if she even lived at the same address. He stared into his hands and began to drone on and on about their relationship. Fortunately, Mr. Acconci stopped him and wrestled the subject back to art. "Take a pointillist's daubs of paint," he said, "or the splatters of abstract expressionism; what are these if not a record of energy and passion, not unlike a shredded letter?"

Carl continued to stare into his hands and floated, morose, back to his seat.

Finally it was my turn to stand in front of the class. I gripped the plastic pouch and gave what I'm sure was a rambling explanation of my project. All the while, Acconci nodded thoughtfully.

Then it came time to enact the idea. He asked for a volunteer from the audience, as if he were a magician and I his assistant. When it became clear that the class was too abashed to respond, Acconci suggested I demonstrate the assignment myself.

Like many gay men, I understood at an early age that a fey gesture or tone of voice could put me in harm's way, and so I'd developed, in the presence of strangers, an acute self-consciousness that both protected me and produced a clammy anguish. As I lit the candle, sweat dampened my forehead and blood throbbed in my ears. Before I knew what I was doing, I held the match to the paper instead of holding the paper above the flame, skipping the step where the secret was revealed. A couple of people muttered when they realized what I'd done wrong, but by then it was too late; the secret ignited with a quiet whoosh. When the fire grazed my fingers I quickly let go, a few black cinders drifting to the floor.

Only then did I realize what I'd been hoping for all along: Vito Acconci would take one look at my piece, proclaim me his peer, and insist that his dealer exhibit my work. A one-man show remained my greatest ambition, the event toward which I aimed my days; it carried far more symbolic weight than my bar mitzvah (I'd memorized the Hebrew phonetically and gave a flat, perfunctory performance, for which I was rewarded with—among other gifts—a bottle opener in the shape of Israel, the Dead Sea a hole for prying off the cap). No, a one-man show was the rite of passage that would change my life, rectify years of anomie, and assure my appearance in *Life* magazine. At a gallery I'd become a man, not a rabbi or Talmud in sight.

But there I was in front of the class, the prospect of a solo show receding yet again. Acconci said something about embrac-

ing mistakes. "Look at it this way: because it went unread by a stranger, the secret retains its mystery even after it's been destroyed." As his thoughts began to percolate, he paced the floor. "In fact, by basing a work of art on destruction, you've challenged one of our most basic assumptions: that art is *created*. And because of its impermanence, your piece opposes the principle that art must be *timeless* instead of *timely*." In one fell swoop my blunder was forgiven, my wrong made right. Acconci had found a way to aggrandize my project's vague, accidental virtues, and although I hadn't exactly set out to achieve the effects he praised me for, I had no problem basking in his praise. "We're living in a period of history where the meanings of art have been shaken to the core," he said. "There's very little an artist can take for granted anymore. Every rule is open to disagreement. Every aesthetic leads to doubt." He stopped pacing and turned to face me. "That should make you very happy."

. . .

The rest of my classes at SVA were studio courses that involved time-consuming assignments like rendering the same bowl of fruit from six different angles, or making a color chart by mixing fifty distinct gradations from the palest to the darkest blue. Unlike Art Praxis, these classes were conducted by rote and rarely deviated from the syllabus. Of course, in all fairness to those who taught them, their pedagogical point was to help improve a student's technique rather than to alter his concept of art. Still, I'd been given a new standard on which to judge instruction; if the class didn't wrench me in a new and unexpected direction, it didn't seem all that interesting.

Before becoming a conceptual artist, Vito Acconci had been

a poet who was perhaps best known for his ode to the world's fastest typist, Claire Washington. *Typist* is a manic scattering of verse that is both ironic and laudatory when it comes to Ms. Washington and her nimble digits. I wasn't surprised to discover that Acconci had been a poet; his classroom spiels were abrupt and bardic. The previous year I'd read *The Contemporary American Poets,* edited by Donald Hall, for a senior English elective; awed by Anthony Hecht and Elizabeth Bishop and Sylvia Plath, my reverence for poets now shone on Acconci. Because his verbal improvisations teased meaning from art, I began to understand that thoughts, and the words that embodied them, were a clean, incisive medium. Conceptual art didn't require the mess of paint, the expense of a large studio, or any number of the technical skills I hadn't yet mastered, and might never master. Since an idea could be plucked more or less directly from one's imagination, conceptualism was the perfect art form for someone as impatient (and lazy) as me.

None of us in Art Praxis was aware that our instructor was fast making his reputation as one of the most influential artists of the era. Having tried his hand at both fiction and poetry, Acconci discovered that he didn't want to represent the world on the page so much as he wanted to actively participate in it by way of language, or, in the case of *Running Tape*, to document his movement through it by counting out loud.

Piqued as I was on that first day of class, *Running Tape* is a fairly methodical work of art, one that holds few surprises once the listener understands its premise. Far more provocative and unpredictable were the pieces that came in its wake. In one, Acconci chose a random stranger from a group of passersby and then followed that person block by block, keeping his distance

and stopping only after he or she entered the private domain of an office or apartment, at which point the piece was over for the day. Acconci carried out this project for an entire month, sometimes boarding buses to outlying boroughs or patronizing restaurants he'd never been to, and in one instance buying a theater ticket and watching a matinee. He enlisted photographer Betty Johnson to take shots of him trailing after his subjects— though the artist himself was as much the subject as the people he pursued.

The stalkerish aspect of *Following Piece* is obvious, but undercut by the fact that the artist surrendered his will to the people he followed, or, more accurately, who led him on a chase. Their errands became his. Their schedules, his. He never intruded on their privacy. They had no idea they were participating in a work of art (assuming they would have considered it as such). It was they who set the artwork's pace, who

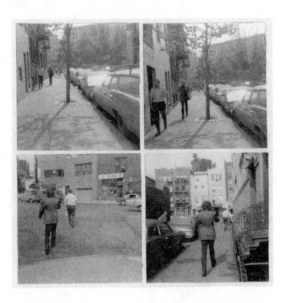

determined its direction and created its shape. The voyeuristic impulse behind *Following Piece* is, after all, the voyeurism common to countless films, novels, paintings, and plays—an unfamiliar life observed, its imperatives made visible.

A subsequent piece went even further in blurring the line between public and private. For *Seedbed*, Acconci had a false floor built inside the Sonnabend Gallery's main room. Every day for eight hours, he entered the crawlspace and lay there waiting, his pants pulled down around his ankles. When a visitor walked in, unawares, the artist began to masturbate while verbalizing sexual fantasies based on the footsteps he heard overhead—heavy or light, rapid or suddenly brought to a standstill—a microphone amplifying his voice through two speakers placed in the far corners of the otherwise empty room. "You're pushing your cunt down on my mouth," he'd murmur, or "You're ramming your cock down into my ass."

I never saw the piece firsthand; *Seedbed* ended its three-week run by the time I heard about it. Besides, I'm not sure I could have mustered the courage to go even if I'd had the chance. I liked the *idea* that he'd found a direct and confrontational way to transform his desires into art, but I was perfectly happy to let him do the grunt work, so to speak, when it came to making sexual desire public. Had it been *me* hidden beneath that floor, I would have gone mute.

It wouldn't be an oversimplification to say that, while I lived in New York, my infatuation with art and my paralysis regarding sex existed in inverse proportion. My response to art was quick, metabolic, and revelatory, while my response to sex was a muddle of delayed reactions and missed libidinal signals.

I've come to see myself in those days as a sort of idiot savant,

a boy who could fix a broken clock yet couldn't tell the time. Many of my high school friends had lost their virginity by then, and some, I learned from letters, had found lovers at college. Of course, my heterosexual classmates had a pervasive culture from which even the most prim and thickheaded among them could extrapolate a few helpful clues when it came to dating or getting laid.

I was so inhibited, in fact, that losing my virginity might have taken even longer had I not been visited during my freshman semester by Nicky Howard, my high school's self-proclaimed nymphomaniac. Tall and blond and perpetually tan, Nicky's goal was to taste mankind in all his shapes and flavors. She'd "had" almost every eligible boy in our twelfth-grade class, and I worried that my peers were beginning to wonder why I wasn't among her conquests. One side-effect of high school graduation was finally being free of the pressure to bed her. And then she simply showed up during one of her visits to New York, knocking on my apartment door and proposing we go out for an Indian dinner.

The restaurant reeked of sandalwood incense. Ragas whirled and eddied in the air. Instead of sitting across from me, Nicky swept into the same side of the booth, prodding me along the seat with her hip until I bumped the wall.

"Don't you like to face the other person?" I asked her.

"I'd rather feel them while I eat," she said. "Did I mention that I'm famished?"

When we talked, I had to twist my neck at an uncomfortable angle and stare into her eyes, intrusively blue. Sometimes her head veered so close I could feel my eyes begin to cross as they strained to focus. Kissing was as much accident as effort,

since our lips were practically touching anyway. As far as I was concerned, our proximity was distracting and unnatural, about as romantic as viewing someone's pores through a magnifying glass. If I leaned to one side in order to get a little air, she'd lean too, maintaining the intimate inch between us, her warm breath bathing my face. Soon, the mechanics of fornication began to seem like less of a physical challenge than our seating arrangement. This suited my date just fine; Nicky acted as though our having sex that night was a foregone conclusion. She not-so-tenderly nibbled my ear, radiant with the assurance that she could not only second-guess, but grant my every erotic wish. Nicky possessed enough desire for both of us, and if I wasn't actually excited by the prospect of having sex with her, her avidity threw my doubts into doubt. By the time the waiter arrived to take our order, the opportunity of a lifetime had literally thrown itself into my lap, and the easiest thing to do was give in.

When I confessed that I'd never had Indian food, Nicky grabbed the menu out of my hand and ordered for us. She asked if I preferred the meal spicy or mild, then ordered it spicy anyway. The waiter grinned at her culinary daring.

During incendiary courses of saag paneer and shrimp vindaloo, Nicky kneaded my thigh with one hand while she fed me forkfuls of food with the other. Spices ignited the fuse of my tongue. My eyes were wet as though from emotion. She poured glass after glass of beer from a pitcher, and I guzzled them with gratitude. Every now and then, a certain flavor made me moan. Nicky's strategy, it seemed, was to get foreplay over with during the main course, thereby making an after-dinner fuck as inevitable as a mint or a toothpick.

And so it was. Inevitable. Back at my apartment, our skin

still smelled of curry, our breath of beer. Her tongue was surprisingly agile and cool. She cupped her breasts and lifted them toward me as if to say, *Look what I'm giving you!* For whole moments I loved the girl for her sheer insistence, for guiding me inside her, for being too hell-bent on her own pleasure to notice I was a novice in bed. She's the one who did the fucking. I could feel the slippery muscles inside her, firm as a handshake, and perhaps for her as routine a greeting. If my kisses grew too eager, she'd roll on top and wrest control, shoving my limbs wherever she wanted.

In the aftermath of lovemaking, Nicky wiped herself and tossed me the washcloth. I felt manly when I caught it, and thought of all the catches I'd fumbled on a field. She reached high into the sleeves of her sweater, letting it shimmy down around her. The formalities of brushing her hair and reapplying her lipstick were executed with a haste that might have been insulting had she not been so graceful, a woman practiced at fleeing the scene. "This apartment's so bare," she told me, standing at the door and looking around. "Like no one lives here." She insisted on walking herself to the subway, and raised her hand to stop me when I made a move to rise.

After she shut the door behind her, I sprawled on the bed, spent from erotic accomplishment, a man who belonged in the world at last. The traffic on Twelfth was unusually quiet, the couple next door in a lull between sieges. It only took moments to fall asleep, and at some point during the night I found myself lying on a desolate stretch of highway instead of in my bed. An air horn blared in the distance as faintly and sweetly as a lone bird, and the next thing I knew I was crushed beneath a truck. I awoke bolt-upright, distraught not

only because I'd been mashed to a pulp but because of the fact that I'd lost my virginity and then dreamed I'd been run over by a truck. What ridiculously overt symbolism on the part of my subconscious! Did the truck represent Nicky? The highway my fate? Did I think of my virginity as road kill, for God's sake? Despite my rite of passage into manhood, the world still barreled relentlessly forward while I was left dazed in middle of the road.

The next morning as I walked to school, the men I saw were just as tempting as they had been the day before.

. . .

I blamed my disappointment on New York. Cold and slush had settled in. The novelty of the first winter living on my own was fading fast. I began to pine for the temperate, light-drenched flatness of L.A. People there knew me, or thought they knew me; I was fixed in the minds of my family and friends, and this, I believed, might stave off change.

After sleeping with Nicky Howard, my visits to museums and galleries took on a new urgency; I stared at works of art more intently than ever, as if committing them to memory, provisions for an imminent journey. The decision to leave New York was clinched one night in the student lounge when I came across an article in *Art in America* that told of a new art school under construction in Valencia, an arid expanse of rolling hills, stucco tract houses, and fast-food chains forty minutes north of downtown Los Angeles.

According to the article, CalArts was the lifelong dream of Walt Disney, who, as far back as 1960, had envisioned an interdisciplinary laboratory where artists, dancers, designers,

actors, musicians, and filmmakers would be fostered by prestigious instructors and have available to them the finest facilities: darkrooms, galleries, electronic synthesizers, film and video equipment, and a state-of-the-art theater whose modular stage could be rearranged by a system of hydraulics. Animators were of special interest to Disney, who saw the school as a potential gold mine of future employees, though the board of trustees was far too savvy to present the institute as a mere trade school. Disney had died in 1966, but a photograph accompanying the article showed a smiling Walt, dapper and mustachioed, towering like a proprietary giant behind an architectural model of the college.

Paul Brach, future dean of the Fine Arts Department, claimed that CalArts was destined to become the new Bauhaus, that glass-and-steel Pandora's box from which sprang some of the most daring art and design of the 1920s and '30s. It was difficult for me to reconcile Walter Gropius's sleek building in the Weimar Republic with the dancing broomsticks and hippopotami of Disney's *Fantasia*, yet the dean's hyperbole rang in my ears: a Bauhaus in my own backyard!

Most persuasive of all was the architect's drawing of the school—a 500,000-square-foot structure that would hug the rolling hills just off the Golden State Freeway. Thornton Ladd's plan for a multiwinged campus was typical of institutional architecture in the 1970s; the blank walls and slender, repetitive columns making it look like a cross between a mausoleum and a carousel. Despite the building's bland design, there are few seductions to which I'm more susceptible than architectural renderings; I love their exaggerated perspective, lush foliage, the stylized figures of busy people, the grand and

frothy backdrop of clouds; I'm a sucker for the utopian hope that humans can make a perfect place where none exists.

6. Ye of My Aye

The campus wasn't ready in time. The contractor had underestimated how long it would take to finish miles of cinder block and drywall. Unforeseen delays in construction forced the administration to lease, for the institute's first semester, a former Catholic high school in the foothills of Glendale.

Villa Cabrini's dilapidated Spanish architecture and overgrown gardens gave CalArts, for all its modernist aspirations, a melancholy Old World air. Dozens of us routinely gathered on the crumbling front steps, reading and sketching and arguing about the merits of various artists while we waited for buses that shuttled us back and forth from our temporary dormitory in Northridge. The doors to the villa were always unlocked, a faded impression of a large cross still visible on the entry hall's far wall—a phenomenon that prompted more than one of us to remark on the similarity between religious fervor and faith in art.

Students wandered across the sprawling campus at all hours of the day and night in search of the performances and seminars and workshops that seemed to arise spontaneously rather than from any schedule I can remember. Villa Cabrini might as well have existed in its own time zone; the schoolroom's electric bells were broken; nuns had evidently absconded with the wall clocks as well as the Catholic iconography; no one bothered to wear a watch. And so a kind of migratory attendance became the norm. One was let loose on the school like a cow in a pas-

ture, grazing from this aesthetic to that. As far as the instructors were concerned, taking attendance would have been as anachronistic as making students wear tartans or knee socks, and so we were free to come and go as we pleased. Even the teachers were known to sneak away without explanation in the middle of their own seminars—off to the restroom, one could only assume, or to the cafeteria, or perhaps to another instructor's class, the discussion forging ahead without them.

Several classrooms remained empty while others teemed with students who delved into the nuances of, say, a video in which cellist Charlotte Moorman improvised a squeaky solo, naked except for two small television sets affixed to her breasts and tuned to the evening news. Gerald Ferguson, the instructor of Video Art, explained that the "TV Bra" had been designed for Moorman by the Korean video artist Nam June Paik. Paik, he told us, was currently sequestered somewhere on campus, experimenting with the effects of a powerful magnet that, when placed against the screen of a television set, stretched cartoons and game shows and newscasts into a kind of bright electronic taffy. The class digressed into a long discussion about how Paik commandeered the mass media for his own artistic purposes, making broadcasters unwitting participants in his work. And now, with magnets, he'd literally draw his art from the airwaves, pulling millions of images into his goofy oeuvre. Most gratifying to me was the thought that TV watching could be not only a catalyst for Socratic discussion but the very stuff of art. Perhaps the hours I'd spent basking in the blue light of a cathode tube hadn't been wasted after all but were better preparation for college than taking the SAT. By the end of the Video Art seminar, while Charlotte Moorman plucked catgut in the background,

I felt for perhaps the first time in my life the welling up of an emotion that could legitimately be called "school spirit," an overwhelming gratitude that all my past exposures to art—*Life* magazine, Ron's portrait of Bob, Vito Acconci counting as he ran—had brought me back to California, to this institution, to this very room. Villa Cabrini felt like home. Today's home, to be exact, so different and appealing.

. . .

One of the first friends I made in Video Art was a woman named Lyn. She'd lean against the back wall during classes, frowning at someone's irrelevant tangent or nodding in agreement with the teacher's point, her opinions strong and omnipresent whether she bothered to voice them or not. When she did speak, she'd straighten up and square her shoulders, cresting to a full six feet. We often hung out after class, reviewing the seminar's high and low points while we drank coffee and gossiped about the other people who were milling around us, doing the same. I'll never forget walking away from Lyn after our encounters; she seemed, by some fluke of perspective, to actually grow taller as she receded into the distance, looming above the less impressive students.

In what was perhaps a subconscious effort to blend in, Lyn routinely dressed in beige and gray "outfits," complete with matching shoes and belts. If this fashion strategy was meant to make her less conspicuous, it backfired; compared to the patched denim, paint-splattered T-shirts, and Indian-print dresses worn by the other women at CalArts, Lyn looked substanially different than the rest of us, someone who'd be more at home in an accountant's office than at an art school. Yet Lyn, like me, was a zealot in the making when it came to conceptu-

alism. She used terms like "structuralism" and "language-based imagery" while seeming to actually understand what she was talking about rather than (as I so often did) taking the phrases out for a test drive. The incongruity between Lyn's attire and her sensibility reminded me of René Magritte, whose bowler-hatted politesse only emphasized, by contrast, his surreal imagination.

Lyn's studio was one of several tiny, fluorescent-lit rooms in a prefabricated trailer parked on the back lot of the campus. She spent hours there hunched over an electric typewriter, pounding out her recent piece. ("Piece" had become the catch-all for everything we did and saw at school; contemporary art so often defied pat categories that it couldn't be pinned to a single genre or a more specific word.) For weeks on end, Lyn had been typing individual words onto hundreds of index cards, her fingers quick and precise as pistons. Happy to be interrupted by my visits, she'd lean back in her folding chair and stretch her arms above her head, offering terse reports on her progress. "I'm finished with Sensation," she'd say, or "I'm halfway into words for Lightness. Darkness isn't far behind." Lyn had begun with the word "inconsequential" and was dutifully typing out every synonym from the thesaurus; this led to words that spawned more words, a lexicon of connections growing larger by the hour. She was hoping to pretty much reiterate the entire English language by the end of the semester, showing, in a rather labor-intensive way, that nothing is inconsequential when it comes to language and art.

"Isn't it boring?" I asked. "I mean, all that typing."

"I don't mind being bored. I can type and think at the same time. Can't you?" She cracked her knuckles. "There's something cleansing about hard work. According to Karl Marx, the artist is a worker just like a plumber or a person on an assembly line."

I didn't have the temerity to suggest that, as far as I could tell, spending weeks retyping the thesaurus served no political or practical purpose. Besides, I admired the strength of Lyn's conviction, and hoped that art mattered to people half as much as plumbing.

Lyn resumed typing and explained her plan to encase the index cards in an enormous block of clear resin once she was done.

"But all that *work*," I said. "No one will be able to thumb through the cards and see that you actually did it!"

"You know how it is here at Villa Cabrini," said Lyn, genuflecting with mock piety. "They'll have to take it on faith. In the end it's really the process that counts; the product is . . ."—and here she practically curled her lip—"the product is nothing but residue."

Lyn was garnering a great deal of attention from the faculty for this ambitious piece, particularly from Gerald Ferguson. Dark-haired and diminutive, Ferguson had become, over the course of that first term, the object of Lyn's ardor, an ardor every bit as monolithic as Lyn herself. More than once I noticed her rapturous gaze as he spoke in class or walked past us in the parking lot, her body listing in his direction. Whenever he came to pay her a studio visit, Lyn must have blared sexual tension like a foghorn. "The problem," she told me one day, "is that Gerry is married." Not only was Gerry married, but one of Ferguson's pieces involved him and his wife having identical dots tattooed on their shoulders. The hypothetical line connecting those dots (his wife resided at their home in Nova Scotia) constituted an ongoing work of art that Ferguson periodically documented on a map of North America. The line's length and angle shifted

continually, depending, at any given moment, on where the couple was located in relation to each other. Of course, it didn't necessarily follow that little blue tattoos, however indelible, meant that either Gerald Ferguson or his wife were monogamous, but both Lyn and I assumed—*wanted* to assume—he was; as long as it remained unrequited, her desire for him fed on itself and intensified, heating our every conversation, an antidote to the chilly rigors of conceptualism.

Lyn wasn't the least bit sexually attracted to me, which allowed me to enjoy the drama of her thwarted courtship from a safe distance. Neither was I attracted to her. Still, I assumed that she assumed I was heterosexual, and I was not beyond being a little insulted by her lack of interest. Perhaps I was too brotherly, what with my sycophantic willingness to learn, my parroting of her art-world terminology. Also, I wasn't her type. In those days I wore a thrift-store wardrobe of baggy pinstriped pants with patterned sport shirts. I'd begged a skeptical barber to shear my hair to a quarter of an inch but leave the bushy sideburns intact. I was the physical inverse of Gerald Ferguson, whose collegiate grooming and unvarying uniform of sweater and jeans were just the touch of boyish pragmatism that sent Lyn to heaven. At the mere mention of Gerald's woolly pullovers, she'd lick her lips in a parody of flirtation that made lust seem crazy and larger than life—sentiments I wholeheartedly shared, though for reasons Lyn would never know. It never occurred to her to ask me who, if anyone, I lusted after, yet she gave expression to enough pent-up eroticism for us both.

With her intellectual authority, not to mention her sheer endurance when it came to typing, Lyn was a model of the Dedicated Artist. Because of her, I began to think of my type-

writer with the romantic associations usually reserved for a paint-smeared palette; my portable Corona could not only make thought manifest, but the symbols that conveyed those thoughts instantly appeared on a field of white, every letter hurtling toward the platen and making a loud, definitive clack. For Lyn, the stationery store made the art-supply store obsolete. She bought clear plastic page protectors by the gross; they were to conceptualism what gilded frames were to neo-classicism. Page protectors instantly gave even a single sentence the weight of an aphorism. It's now almost impossible for me to imagine, let alone admit, the degree of sophistication I felt when I'd typed onto a sheet of pristine bond *A haiku consists/of seventeen syllables/so this must be one*, then slipped it into a plastic sheath and pinned it to my dorm-room wall.

Lyn deemed the haiku *self-referential* then showed me a photo of a piece by Joseph Kosuth. On one side of an actual wooden folding chair there hung a life-sized photograph of the chair, and on the other side, a blow-up of the dictionary definition of the word "chair." Object and image and referent—how crystalline a concept, didn't I agree?

How could I stand before Lyn Horton, so tall and persuasive and tidily dressed, and not agree?

Despite Lyn's influence, there remained an essential difference in our sensibilities. Still an avid reader (I'd taken my dog-eared copy of *The Contemporary American Poets* with me to CalArts), I found myself gravitating more and more toward the poetic as well as the conceptual. Lyn, on the other hand, saw anything overtly poetic as a concession to subjectivity; as far as she was concerned, the whims of the individual weren't nearly as noble as the selflessness of reason. Lyricism, furthermore, pandered to the viewer's need to be "moved"—that is, to be stimulated and entertained as effortlessly as possible—and she saw this as the same kind of pandering that, art-historically speaking, led the bourgeoisie to venerate the Impressionists, a group of artists whom Lyn, along with several other members of the post-studio program, detested for their leisure-class sentiments and purely sensual effects. She opted for an art that was difficult, detached, and edifying, an art whose rewards were cerebral, whereas I, despite any pretense to the contrary, liked to be clubbed over the head with aesthetic pleasure.

For the most part, big "B" Beauty was a private pursuit. In a nondescript room at the Northridge dorm, while my roommate, Kevin, a handsome bearded boy from Colorado, snored on the other side of a thin partition (not thin enough it seemed on the nights I was lonely), I reread poems by Hecht and Bishop and Plath. They offered, respectively, filigree, clarity, and tangible anguish, their words turning an almost hallucinatory blue-black in the glare of my bedside lamp. Though part of me wanted to believe that all experience was quantifiable (how reductive a notion that seems to me now, how naked a need for

the comforts of the known!), I was drawn to poems *because* they eluded my understanding, compelled me toward thoughts and sensations I could neither name nor ignore. Certainly my overwhelming response to poetry couldn't be quantified; it would be like asking a man treading water to guess the number of gallons in the sea.

. . .

One class at CalArts promised to satisfy what I sometimes saw as my shameful, old-fashioned craving for poetics: Concrete Poetry: An Introduction. Beyond an immediate mental image of stanzas laid out like paving, I had no idea what the phrase meant. I arrived late to class—timeliness, of course, being relative on our campus—and well over halfway into the first semester. The instructor, Emmett Williams, plump and immaculately bald, was having lunch with the boy and girl who constituted the class, a vending-machine feast spread before them on a sheet of butcher paper. They waved me in and explained that they annotated their lunch every time the class met. Each of them held a pen and wrote comments about a food's flavor next to its residue—spots of grease, a droplet of mustard—or recorded snippets of conversation that were taking place when a stain was made. A hearty, unabashed eater, Williams shoved a bunch of junk food in my direction. As I munched potato chips, grains of salt pattered onto the sheet of butcher paper. "So, what *is* concrete poetry?" I asked no one in particular.

The girl, whose pupils were dilated, I couldn't help but notice, made a fist and said, "It's trying to make words be more like this."

"More like a fist?" teased the boy.

"No. You know. Like . . ." She held her fist out for us to con-template, waiting with what threatened to be infinite patience, as if she hoped that, sooner or later, her point might sneak up and tap us from behind.

"I think what Kara means," said Emmett, "is that concrete poetry gives words the heft and weight of objects. It's about paying attention to what words are physically, their typography and size, the material they're made from, so that words become more. . . tangible."

Kara unclenched her fist. "Wow," she said, jotting on the butcher paper "words have heft."

"Recently," said Emmet, "I've been interested in making poems you can eat, poems whose meaning you literally have to digest. Annie, my wife, says that I've finally found a way to put words in people's mouths." Within moments it became clear that Emmett was a cherubic hedonist who lived by the principle that all things, poetry and food and Annie in particular, existed for his delectation. He told us that Annie was a great cook as well as a concrete poet herself, and that she was helping with the recipe for his latest piece, *Poetaster*, a ten-pound meatball that would include, in its savory interior, hardboiled eggs with terms like "couplet," "dactyl," and "rhyme" painted onto them with food-coloring.

A poem you could eat! The seemingly distinct worlds of con-ceptual art and poetry had merged! In a meatball!

I liked Emmett right away, felt instantly susceptible to the effects of his mentorship. I was fascinated by his round face, a lit-tle goggle-eyed, a little bulbous in the nose and forehead depart-ment, a face alive with the anticipation that, at any moment, the serious might turn absurd, or the absurd, serious.

After class, moved to make my new instructor a kind of edible mash note, I drove directly home and asked my mother if I could do a little baking. Given my history of odd projects, she wasn't particularly surprised by my request. "No laundry?" she'd asked when I walked in the door empty-handed. Her shoulders sagged. With one son dead, my brother Ron away at law school, and the youngest living on the outskirts of the city, she was no longer called upon to perform the chores that once consumed her, and now there were only so many spices to arrange, doorknobs to polish. Alone in the house, marooned without a driver's license, she stared for hours out the kitchen window. On the sill above the sink, she'd planted a potato in a ceramic baby carriage, its tendrils pressing against the glass.

Compounding my mother's isolation, my father was busy that year with a new investment: kosher burritos. These were flour tortillas stuffed with corned beef and slices of dill pickle, but not a shred of forbidden cheese to make the food *treif*. "What kind of rabbi is going to bless burritos?" asked my mother. I pictured a rabbi in a tallis and sombrero. Let me add here that my parents were anything but orthodox, and they certainly never kept a kosher house, yet they viewed the partaking of kosher food as a nod to the Creator, a healthful penance, an excuse to visit the delicatessen.

As I rummaged in the cupboards for a cupcake tin, my mother told me that, what with the burrito business in addition to his law practice, my father came home late most nights and fell into bed. "Some nights," she added, lighting another cigarette, "your father doesn't come home at all."

I mumbled something sympathetic, but it was growing more and more difficult for me to be around my mother's unhappiness, thick as humidity, without feeling that she was part of a league of weary adults I would one day join, accruing disappointments like everyone else, no matter how modern a boy I might be, or how desperately I wanted to believe that my life would never end up like my mother's. And so I changed the subject back to baking.

Mom had on hand, as I knew she would, a box of Betty Crocker cake mix, a can of frosting, and assorted tubes of goo for spelling out *Congratulations!* and *Happy Birthday!*, and a package of pastel cupcake papers. It struck me that she still kept the shelves stocked for a mob—cans and boxes to contradict loss. While Mother watched, I went to work mixing batter and cracking eggs. Once the cupcakes were in the oven, I considered what to write on them, the kitchen filling with the smell of vanilla cake and cigarettes.

"One of my teachers," I said to make conversation, "is making a ten-pound meatball." For the first time that night she let out a laugh, though I hadn't meant to be funny.

She turned from the window. "What's the class?"

"Concrete Poetry: An Introduction."

"Oh," she said, exhaling smoke. She opened her mouth as if to ask a question, then turned to stare out the window.

. . .

My cupcakes won him over. The syllables of an-ti-dis-es-tab-lish were written on the cupcakes' frosted tops. We devoured them at the next class meeting. Kara, her eyes dilated as usual,

took a bite and said, "Wow! Eating words is, like, you know, eating your own brain!"

The boy looked at her and said, "You must still be hungry."

Emmett threw back his head and laughed, his shoulders bouncing up and down. The girl recovered her composure, or perhaps forgot the insult the second it was leveled. "Marvelous!" said Emmett. He transcribed their exchange on that day's sheet of butcher paper. "There's nothing like a good bon mot."

For the rest of the semester, Emmett and I made a date for dinner at least once a month. I had managed to avoid dating since Nicky's force-fed Indian dinner, so meals with my teacher took on, to my mind at least, a vaguely romantic cast. We met at Pronto, a tiny Italian restaurant in Laurel Canyon. One of the last hippie strongholds in Los Angeles, the canyon was home to musicians like Joni Mitchell and all four of the Mamas and the Papas. From Pronto's picture windows we could see houses half-hidden among stands of trees or cantilevered over the steep hillsides. A mangy federation of stray dogs routinely stopped to scratch their fleas and lick their crotches in the middle of the street, oblivious to the honking horns and screeching brakes.

During one of those dinners, Emmett told me about his most recent trip to Germany. He'd gone there to mount an exhibit and to visit some of his old friends from Fluxus, a loosely knit group of international artists to which he'd belonged in the early 1960s. I had seen a few examples of work by artists associated with the Fluxus movement, their "events" and objects so offhand as to be nearly indistinguishable from the events and objects of daily life. The German artist George Brecht, one of

the central figures in Fluxus, composed what he called "Event Scores," such as:

TWO VEHICLE EVENTS
Start
Stop

and the oddly incomplete:

THREE WINDOW EVENTS
opening a closed window
closing an open window

(If the third part had involved "staring out a window," my mother had it mastered.)

Brecht also placed a coat rack in a gallery, then hung a coat on it. Perhaps the coat rack was a reference to the bottle rack that served as one of Marcel Duchamp's early ready-mades, though Brecht may have trumped Duchamp by not only placing a found object in a gallery ("recontextualizing," as Lyn would have said), but by restoring its utility, further eroding the line dividing art from life. I wondered why any of us even continued to consider it a line, the poor thing was so thin by now, so battered by aesthetic and philosophical assaults; it was as if we were mistaking a spiderweb for a brick wall.

What impressed me most about Emmett's association with Fluxus, however, was the fact that Yoko Ono had also been a member of the group. I loved the story about how she met John Lennon (still married to his first wife, Cynthia) during one of her performance pieces at a London art gallery. At one point, she handed Lennon an imaginary nail and, without any

prompting, he drove it into the wall with several strokes of an imaginary hammer, a gesture they both claimed had changed their lives. Today, this encounter seems no more remarkable to me than a hundred Hollywood movies in which a couple "meets cute," as the industry folk say, but in my long-ago opinion, it not only affirmed the romantic idea that two people could be drawn together by mysterious and irresistible forces, it also represented a pivotal moment in the arts.

Ono's *Cut Piece*, performed at Carnegie Hall in 1965, was by now something of a legend among the avant-garde. Sitting cross-legged on the stage, she'd invited members of the audience to come up one by one and snip off pieces of her dress with a scissors. At first, she had to entice the shy audience members to step forward, conveying with her soulful expression that she was willing to trust them, to be vulnerable, to be nude in public, and that she wanted the world to be a place where everyone could be trusting and vulnerable and nude in public. Eventually a line formed, and within twenty minutes Yoko Ono was stark naked, sitting in a virtual scrap heap of her former dress. Even after the dress had been shredded, however, people were still lining up to get a crack at the scissors, which looked awfully long and sharp in the photos I'd seen, nothing like those snub-nosed safety scissors they make for kids and which I, personally, would have chosen were I planning to have my clothes cut off in public. Ono later admitted in an interview that, given the disposition of certain audience members, this piece involved a bit more vulnerability than she'd bargained for, but of course the impending violence, and the fact that it never happened, was part of the performance.

For Emmett's German exhibit, he'd stenciled letters onto live carp with nontoxic fluorescent paint, then put them into a huge aquarium and lit the whole shebang with a blacklight, the alphabet darting to and fro. "Sometimes," he told me over a basket of greasy garlic bread, "little words came together by chance."

"Like?"

"Lob," he said. "Hum. Toe. Of course, there were several almost-words I don't exactly remember but would be glad to approximate, with your permission."

"Sure," I said, leaning closer.

Emmett took a gulp of red wine and cleared his throat. His pate gleamed in the candlelight. "Fuh, ge, urt, noli, baw." It was a cryptic recitation, but one delivered with reverence and passion, as if he were reciting Sappho from the Greek.

"That piece worked like a dream," he said. "The only problem was that the dealer's assistant resented having to feed the fish."

"I worked as an assistant once, in a gallery on La Cienega."

"Did you have to feed the art?"

"No. Just keep it clean."

"Sponge baths?"

"Practically."

We studied the menu.

"Speaking of things that come together by chance," I said, "are you into John Cage?"

Emmett peered at me over his bifocals. "You have to admire a man who's made so much out of randomness. Of course, admiration is quite different from enjoyment. I *enjoy* Dixieland.

I *enjoy* Chuck Berry. I even *enjoy* the organ music they play at ice-skating rinks. Why do you suppose organ music reminds me of bubbles?"

"All the air that's needed to make the notes?"

"Yes! That must be it! The slide whistle is my favorite wind instrument. What's yours?"

And so it went. Emmett clearly amused himself (and me) with his verbal eccentricities—shtick in a rareified, writerly vaude-ville—but his wordplay was also genuine, reflexive. Squinting through his bifocals, he often misread words, then improvised on the misreading. "Oh my," he said that night, pointing to Char-broiled Chicken on the menu. "Chagrined Chicken. How very sad. What can we do to cheer up the chicken?"

Though Emmett Williams's sensibility was utterly his own, I learned that his work had an important precedent in the Merz poems of Dadaist Kurt Schwitters. As early as 1918, Schwitters composed fragmented texts in which he manipulated tradi-tional typography, playing with the size and placement of the letters. And yet, for all their visual acrobatics, these texts were meant to be read aloud, to have a life beyond the confines of the page. Ultimately, Schwitters chose words for their sonic quali-ties just as he chose the objects he used in his collages—ticket stubs, gum wrappers, parts of broken toys—for their shape and color. Only rarely did he give in to the demands of syntax, and then, it seemed, only for the thrill of letting it devolve into nonsense.

One night after Emmett and I returned from dinner, we sat in his living room with Annie, who had spent the night taking photographs of herself behind a large cardboard "I," her head, with its nimbus of frizzy hair, serving as the dot. The three of us

chiseled away at bowls of rock-hard ice cream while listening to a rare recording of Schwitters reciting his poem "He She It," his overwrought enunciation perhaps a parody of bombast:

 ok
 dog
 tak
 pack
 Karakte
 youroundyou
 youinyou
 God mercy you
 to live
 to run
 to strive
 to pardon
 giving
 youinyou
 tak
 pack
 youroundyou
 you

Emmett explained that he had first been introduced to Schwitters's poems on a trip to Europe. Though born and raised in Newport News, Virginia, Emmett had lived in Europe off and on since his midtwenties. Never having set foot in Europe myself, his stories of allegiances and feuds and collaborations with other concrete poets had me believing, by the end of the evening, that Europe was for him what I hoped CalArts would

be for me—a society of artistic kin. In Europe, he met men and women whose mission was to germinate the seeds of concretism, imbuing words with a new vitality so that we might hear, see, and feel them forming in our mouths as though for the first time.

Neither Lyn Horton nor Emmett Williams were given to ponderous airings of their past. If I talked with either of them about their parents, their personal worries, or their childhood traumas, if I probed for their secrets or hinted at my own, these were brief digressions in a conversation that sooner or later led back to art. Emmett, in fact, referred to artists he admired as "forward-thinking," and I took the phrase literally, assuming that many of us at CalArts were allied by a wish to shed the past (as if one could!), history a condition too stifling to live in. We wanted to remake the world, and therefore ourselves, from scratch.

What remains of those days I spent in the company of Lyn Horton and Emmett Williams is wordplay rather than candor. Lyn once gave me a piece (in a page protector) in which she'd typed the permutated letters of my first name:

> Bernard,
> ernardB,
> rnardBe,

and so on, but each variation was typed over the one before, the effect a small, indecipherable black rectangle in the middle of the page. This opacity has become, over the years, more emblematic of Lyn than what little she told me of her diplomat father and home in Washington, DC. And the same is true for Emmett; during one of our dinners, flush with wine, he must have let slip some revealing detail about his past, some quip about his pretty wife. What I remember best, however, is the

poem dedicated to her in his chapbook, *The Last French-Fried Potato*. It began with the lines:

> *art of my dart*
> *arrow of my marrow*
> *butter of my abutter*
> *bode of my abode*

In the middle of the poem, as soon as the schema becomes predictable, Williams throws a wrench into the works:

> *curry of my eden*
> *den of my scurry*

And ends with a rousing:

> *ye of my aye*
> *y of my my*
> *zip zap zoff of my o zip o zap of zoff*
> *zim zam zoom of my o zim o zam o zoom*

. . .

Our temporary dormitory had been leased from Cal State Northridge in the San Fernando Valley, a school whose utilitarian architecture bore a somewhat greater resemblance to the Bauhaus than Mother Cabrini's villa. Three stories tall, its stucco exterior the color and texture of oatmeal, the dorm was a network of small rooms, each divided by a five-foot-high partition into two oblong stalls just large enough for a regulation bed and desk. But not large enough to ward off the claus-

trophobia that kept many of us awake and restless through the night. "All-nighters" were common—a coffee machine on the main floor dispensed a bitter, gut-churning brew for this very purpose—and given the perpetual tai-chi sessions and marathons of folksy jamming that went on in the student lounge, our dormitory, like the campus itself, stayed active at all hours. The U-shaped hallways had no windows or skylights, and this made life, even on the second and third floors, feel subterranean on the sunniest of days. It was as if we were a part of a scientific experiment to see how long it took art students to crack without natural light. If there was a "dorm mother" or "dorm father" or dorm authority of any kind, they stayed out of sight. Not that supervision would have done much to discourage our rowdy exchanges in the hallway, the loud impromptu parties, or to lessen the graffiti scrawled in the elevators and stairwells (*Dial 911! I can't stop making art!*). Any attempt to impose rules would have been looked upon as despotic, a repressive blow to our autonomy, and we would have resisted with all our youthful strength. Apart from an unspoken prohibition against destroying the furniture or setting the place on fire, anything went.

This was especially true when it came to sex. At all hours you could hear doors opening and closing up and down the halls as students not-so-furtively slipped into one another's rooms. More than once I returned to my room late at night and heard, on my roommate Kevin's side of the partition, the voice of Tanya Bixler, one of two harpists from the music school. Despite her long pale hands and the dreamy concentration with which she played the harp, Tanya was the most foulmouthed person I'd ever met. Something as minor as an untuned harp string could send her into a frenzy of invective. "There's no

fucking moisture in the air! This city needs a motherfucking humidifier! How the hell am I supposed to play under these conditions? My instrument is turning to shit!" But such outbursts were mere overtures compared to the coarse glory Tanya achieved in Kevin's bed; she could actually make *You fucking donkey!* and *Ram it, prick man!* sound like the endearments they were meant to be. Kevin was, for the most part, a silent recipient of Tanya's effusiveness, though he did occasionally grunt and bray, confirming her colorful choices of phrase.

I'd try to alert them to my presence as soon as I walked in, but no matter how much noise I made clearing my throat and taking off my clothes and plumping my pillow, Tanya was unstoppable, either oblivious to anything but sex or excited by having an audience of one. Lying in my bed, pretending to sleep, I entertained the vague hope that they might call over the partition and ask me to join them. And I would have in a second, though it was Kevin I wanted, and who knows what purple curses Tanya would have dreamed up had she sensed my interest in him instead of her.

Did I mention that Tanya was exceptionally generous with her drugs? She always had a Baggie of pot stashed in the red-velvet recesses of her harp case, the kind of marijuana that made my feet feel detached from my body, as insensate as a pair of shoes. Whenever we got stoned together, Tanya sucked greedily on the joint, seeds popping like the Fourth of July. Not a wisp of smoke escaped when she finally exhaled. As soon as we decided we were high enough ("decided" isn't quite the right word; it would be like saying a sponge "decided" it'd had enough water), she'd stub out the joint and rise from the floor, floating wordlessly toward her harp. With what strength and reverence she

tilted the massive instrument toward her, supporting its sound-board against her shoulder, caressing the polished wood with her cheek. She always began by holding a pose with arms out-stretched and fingers poised, her entire body relaxed yet ready. Then Tanya closed her eyes and lunged toward the strings, plucking so many and with such precision, they nearly disap-peared in a blur. The vibrato seemed to shudder through my blood and echo in my chest.

Where did she go when she closed her eyes? Where did either of us go? An impossible number of notes rained from the ceiling, drenching her room in Schubert or Brahms. Sometimes Kevin walked in—he could hear the harp from down the hall, but it seemed as if he'd been summoned by our wanting—and he'd sit on the floor and relight the joint, stroking his auburn beard as he listened, shoulders molding his denim shirt, his bloodshot eyes beatific.

7. Box with the Sound of Its Own Making

Much to my relief, I wasn't the only student in the dormitory who abstained from sex. There was also Lyn, whose room remained as clean and organized as a laboratory. The stack of white paper piled on her desk was grist for the mill of her end-less ideas. Whenever I visited, I found her intently working in the pool of light cast by her goose-necked lamp. Since she had no trouble typing and talking at the same time, she was always willing to discuss my latest projects—a continuation of the brief phase of work that began with the aforementioned haiku and ended with a small drawing of a piece of lined notebook

paper on which I'd written in pencil: *I've always wanted to draw a piece of paper on a piece of paper as a drawing.*

This was a particularly tautological moment not only for me but for art in general, and its examples included Roy Lichtenstein's paintings of stretcher bars seen from the back of the canvas, Robert Morris's *Box with the Sound of Its Own Making,* a wooden box containing a tape loop that continuously played the sawing and hammering noises of the box's construction. Then there was a five-by-six-foot oil painting by John Baldessari that read:

QUALITY MATERIAL - - -

CAREFUL INSPECTION - -

GOOD WORKMANSHIP.

ALL COMBINED IN AN EFFORT TO
GIVE YOU A PERFECT PAINTING.

So numerous were examples of art-about-art, so common have they become, it's difficult to convey the startling gestalt those works once offered. Here was art without a loose thread or a rough edge. Airtight. Self-enclosed. Insistently hermetic. You could practically feel the suck of an aesthetic vacuum when you grasped it. Such art excluded the world with all its requisite complexity—loneliness, confusion, hypocrisy, loss. Tidy and unambiguous, all denotation and closure, these works were the inverse of the poetry I read in secret. No matter how gimmicky or facile such art may seem in retrospect, it appealed to the part of me that wanted to seal myself away from conflict, to live within a bell jar of art.

During this phase, Lyn gave her unstinting approval to everything I made. Plus, self-referential stuff was a breeze to produce, almost instantaneous in its translation from idea to object. This was the closest I'd ever come to conjuring a coin from thin air, or simply wishing a thing into being. Never had I felt more accomplished, more inarguably *finished* after I finished something, never more free from the nagging doubt that reverberates now after every sentence, every page: *Is this what I mean? Is there some better way to say it?*

Fellow celibates, Lyn and I probably believed that, like the art of the period, we were as self-sufficient as fountains that recirculate their own water, or small countries whose economies don't depend on tourism. Oh, we snarled and groused and generally martyred ourselves to the hapless state of singlehood, but for all our complaining, we would have balked if the opportunity to have sex with a man were to actually present itself. Our libidinal impulses were rerouted into art-making,

and if we weren't "getting any," at least we had the dubious satisfaction of knowing we were among the school's most prolific students.

. . .

On the wall next to my bed I'd taped a few postcard reproductions of Roy Lichtenstein paintings, comic-strip women who greeted me every morning with woeful exclamations like "I'd rather sink than call Brad for help!" or "I tried not to think of Eddie, so my mind could be clear and common sense could take over! But Eddie kept coming back..." The contents of their speech balloons were so emphatic as to be almost audible, exclamations that teetered between sincerity and melodrama. The paradox of Lichtenstein's women made them ideal pin-ups for a latent homosexual; they were and weren't what they seemed to be. That men were the source of their trouble was a fact I took for granted, a "universal" aspect of the work. One moment the women's tears appeared to be nothing more than pendulous

ovals outlined in black, graphic simulations of grief. The next they were warm and salty and wet, springing as they did from an anguished face seen at close range, a woman in pain for all her stylization.

My favorite was the close-up of a wordless nurse, her blue eyes wide with alarm and focused outside the frame of the painting. *What has happened?* one wonders. All of Lichtenstein's paintings invite this question by removing a single, incomplete frame from the entire narrative. In my personal scenario, the nurse had been summoned to help a patient in trouble, and I remembered the day at the UCLA hospital when blood began to seep from my brother's nose, spontaneous, unstoppable. Before my parents hustled me out of the room, the three of us were dumbstruck, unable to move. Bob lifted a hand, searched his face for the source of spreading warmth. Gaunt and bald at twenty-five, beyond shame or shock or apology, he stared at the blood on his fingertips, waking to his death as if from a dream.

The nurse's white cap and uniform give her a heroine's authority, yet her fretful expression suggests her powerlessness over the forces of life and death. She hears a cry, stops in her tracks. And the tragedy, fixed in paint, impends forever.

. . .

Movies were shown nightly in the school auditorium, the usual collegiate smorgasbord of Jean-Luc Godard, Roman Polanski, and Ingmar Bergman. This being an art school, however, the film series also included documentaries on designers Ray and Charles Eames, and experimental animation from the Canadian Film Board's Norman McLaren, who scratched his movies directly onto the film's emulsion with a straight pin,

scribbles of light writhing to jazz. Here is where I first saw Jackson Pollock filmed from beneath a pane of glass, squinting against a lit cigarette and flinging paint by the bucketful, his face as troubled as it was intent, lined by the booze that slowly consumed him. Then there were the repeat screenings of Alain Resnais's inexplicably popular *Last Year at Marienbad*, five minutes of whose mannered acting and rigid art direction— you could practically impale yourself on the conical topiary— made me feel as if I'd been dipped in starch. Cinema served as the common currency among musicians, dancers, actors, and visual artists, all that filmic symbolism kept alive long after the last reel by our avid debates and interpretations. I not only enjoyed the sport of deconstructing the films we'd seen, but found solace in the idea that no narrative could be taken for granted; if I imagined myself isolated by my secret desire for men, at least I wasn't alone in the notion that life, as manifested in movies, contained hidden meanings that one might endlessly dissemble.

Kara, the stoner from Concrete Poetry, often sat beside me during screenings. She'd lean close, reeking of weed, and offer cryptic bits of cinema theory. During Andy Warhol's *Empire* she whispered, "The building is standing still, but time is moving. 'Empire State' . . . get it?" Almost no one actually made it through the entire twenty-four-hour shot of the skyscraper, but even during movies with plots and dialogue (which compared to *Empire* would have been any film in which something happened or someone spoke), the audience came and went at will; the auditorium's folding chairs and warped floorboards creaked while every distracting arrival and departure was thrown into silhouette against the screen. With its red velvet curtains, shal-

low stage, and the gently arched proscenium inscribed with a Latin homily about the virtue of learning, ours was the archetype of the 1950s school auditorium, a place where upstanding young citizens assembled to pledge allegiance to the flag of the United States of America or hear a lecture on fire safety. But the curtains were musty, the flagpole flagless, and you couldn't touch the rickety balustrade that led up to the stage without it wobbling like a loose tooth. The place was proof that the education most of us had grown up with—flash cards, field trips, open houses, pop quizzes—was gone for good, replaced by another type of institution: New and Improved.

Toward the end of that first semester, the composer Morton Subotnick (his electronic music sounded remarkably like his name) arranged for Ravi Shankar to perform at school. Shankar was becoming well known in America, the steely oscillations of his sitar a kind of unofficial soundtrack for the counterculture. So many students showed up for the free concert, however, that the auditorium couldn't accommodate us, and so the concert had to be held on the courtyard's expanse of brittle lawn. The winter sun was oblique but warm, white clouds hovering overhead like empty thought balloons. Flanked by a tabla player and a guitarist, Shankar sat cross-legged on the grass. He began by saying he was glad the concert had been moved outside because, "A stage, very wrongly, makes the players higher than the audience." He meant to strike a blow for spiritual equality, but a few chuckles peppered the otherwise reverential silence, none louder than Kara's; she sat beside me absently rubbing her bare feet back and forth across the grass, which must have felt, given her state, as soft as flannel. Shankar chose an evening raga, a wave of notes we'd ride till nightfall. Unlike the restless atmo-

sphere during screenings, no one moved from their place on the lawn except to sway and sprawl and surrender themselves to the music. I spotted Emmett and Annie on the outskirts of the crowd, eating what appeared to be the leftovers from *Poetaster*, slices of which—eggs intact—must have kept them fed for weeks. Deeper in thought than I'd ever seen her, Lyn leaned against a tree and stared into the distance, wearing, uncharacteristically, a T-shirt and pair of shorts, her long pale limbs mottled by shade. A few yards away, my roommate, Kevin, lay with his head in Tanya's lap. She raked her fingers through his hair and bent low to whisper what was surely a bawdy comment, nipping his ear to punctuate her point.

The raga drew me back to my Indian dinner in New York, and it occurred to me that, at this rate, Nicky Howard might be the last human being I ever slept with. If I was destined to be lonely, art would be my saving grace, a degree from CalArts my ticket to success. As the tabla throbbed, however, I realized that I had no idea whether we were to receive grades at the fast-approaching end of the semester. If we *were* to receive grades, some important procedure must have escaped my attention. Had I become too complacent in my artistic idyll, too blasé about education's formalities? I doubted CalArts was the kind of place that would give grades (*give* grades, as if they were a gift!), yet I wouldn't have been surprised to learn that, being a daydreamer capable of the most astonishing oversights, I had finally done something to jeopardize my academic standing, and therefore my future in the arts.

I turned to Kara, startled to discover her staring at me through her small green sunglasses. "Your sideburns are cool," she said. "They're like peninsulas." I thanked her and asked if

she knew whether or not we were supposed to get grades. She continued to stare. "I think...yeah. Experience Reports."

"What are Experience Reports?"

Kara cocked her head. "Anything you want."

"Anything?"

"Yeah. Sure. Aren't they?"

My negligence was made all the more striking by the fact that an incorrigible pothead like Kara had picked up on a requirement I had somehow missed. I turned my attention back to Shankar. Bits of mirror sewn into his shirt glittered in the fading light.

. . .

After some investigation, I discovered that Kara had been right: as John Baldessari, instrumental in planning the institute's curriculum, would later put it, "... we just eliminated grades. We had pass/fail. You can't use grades as punishment, to force students to attend class or do this or that. They are there of their own free will. We also had no curriculum. In other words, you chose from a menu and made up your own dishes."

This approach may seem like a cliché of progressive education in the 1970s, and while it's true that, in the midst of seemingly limitless freedom, I craved a taste of the mandatory—I longed for a class with requirements and tests—I also shrank at academic pressure. I'd received my share of poor grades throughout junior high and high school, and I had to believe, for the sake of my self-respect, that grades were by their very nature misjudgments, unable to convey the excellence that a student may not have achieved that semester, but might achieve at some point down the road. The institute's pass/fail policy, its loose

rules, suited me fine. The only rule I remember was the unspoken rule about swimming naked in the dormitory pool, where it was considered lewd and inconsiderate to wear a bathing suit. We were "privileging the nude," as a theorist might say, and to not be nude could be seen as an act of open hostility toward the greater, uninhibited good. Being somewhat bashful myself, I swam naked only once, late at night, darkness clinging to my skin like clothes.

Experience Reports, in contrast to hierarchy of grades, could include anything the student wanted in order to document his or her progress. The registrar, a CalArts employee who tolerated our artsiness and disorganization with waning patience, held the forms in front of my face and explained that, at the end of the semester, we'd be asked to turn in one form for each class we'd attended. "I mean *really* attended," she said. "We're working on the honor system here. And last but not least"—she switched to the drone of officialdom—"the exit vita will be validated by the registrar only inasmuch as it is supported by the student's experience reports." Finally she handed over the forms, which contained spaces for the titles of the classes and the instructor's signature. The rest was blank: the emptiness artists love and dread in equal measure.

Soon I discovered that other students were also hustling at the last minute to provide the registrar with the necessary documentation for their files. We were obliged to prove a truth we knew to be unprovable: that our exposure to the arts had changed us in all sorts of quantifiable ways. Lyn, not surprisingly, was busy organizing a semester's worth of index cards and at least a dozen black ring binders filled with permutated words, most of them layered into illegibility. I could imagine the look

on the registrar's face when Lyn lugged box after box into the office, as if she were delivering an exhaustive government study on some topic of national importance.

For Susan Starbird, a fellow student I'd met through Tanya and Kevin, fulfilling this particular requirement would be a cinch. One day, while we were talking in the courtyard, she pulled from a canvas handbag the latest volume in a series of journals she'd been keeping since high school. In it, she not only chronicled every aspect of her classes at CalArts but had taped onto its pages the flotsam and jetsam of her daily life: matchbooks from a number of local bars, a lock of her own hair. On the upper half of one particular page, she'd recorded a dream in which her handsome high school guidance counselor sprayed her with milk from a garden hose. "Homogenized," she'd noted. "Freud would have a field day." Below this entry was a drawing, as detailed as any illustration in a medical text, of a "Siamese Cheerio" whose conjoined O's she'd discovered one morning at breakfast.

One glance at Starbird's journal (she preferred to be called by her last name) was all it took to for me to fall in love with her, or at least to believe I'd fallen in love with her; she'd juxtaposed disparate bits of the world and made a tenuous, lyrical sense. Plus the girl was adorable in a frazzled sort of way. She clomped around in a pair of precipitous cork platforms, teetering when she came to a stop. The brown hair pinned to the top of her head stuck out at odd angles, giving her the look of someone who had just fought her way through a strong wind. Her glasses tended to slide down her nose whenever she spoke, and after poking them back into place, she never failed to smile at the fact that her sight had been restored.

I asked her out for dinner the night she'd shown me her journal. The semester was almost over, and in the rush to tie up loose ends, I thought I might persuade Starbird, as well as myself, that we were meant for each other. The more I feared eccentricity within myself, the more I revered it in others, blind to the irony of my having chosen someone so willfully odd in a bid for normalcy. Even in 1971, at the most aggressively experimental art school in the country, there were only three or four openly gay students, and because I didn't know them personally, I believed the penalty for their frankness was greater than it probably was, certainly greater than I believed I could bear.

I mooned over Starbird in a big red booth at a local coffee shop while she sawed away at her sirloin. She speared a piece with her fork and, impersonating a cavewoman, grunted, "Meat good." An awkward moment of silence. My gulps of coffee were audible. Starbird looked skyward while she chewed, as if a clue for the next conversational gambit were written on the ceiling. "Did you make any art today?" she finally asked. "An artwork a day keeps the doctor away." The girl was undergoing a seizure of levity in an attempt, I know now, to avoid what must have been the lovesick expression on my face. I explained how I'd drawn a piece of paper on a piece of paper, and also—I couldn't help myself—why I'd done it, launching into a floor show of artspeak: meta-this and structuralist-that.

"I don't understand what you're talking about," she said. "Do you read *Artforum* or something?" She rummaged through her handbag and, after several futile swipes of a match, lit her cigarette.

"Sure I read it. Don't you?"

Starbird pointed at herself. "I just wanna make stuff. If I read

Artforum, they'd have to put me in a straitjacket. I mean, OK, so I'm a bumpkin from Nowhere USA, but do I have to have fancy excuses for what I'm doing?"

"But there must be reasons for the things you make."

She lurched forward, bony elbows clunking on the Formica tabletop. "The reason is: if I don't make things, I'll go crazy."

Bracing as a bucket of cold water! All other philosophies dimmed in comparison, seemed fussy, high-minded, false. I didn't understand half the articles I read in *Artforum*. Unlike Susan Starbird, however, I felt obliged to not only struggle with but adopt the verbiage, seeing it as a kind of art-world credential. Look what it had done for Lyn, the darling of the Art Department! Of course, it's only fitting that an art student grapple with theory, but I was also cowed by it, too worried about my intellectual standing to confess to anyone that most writing about art left me baffled, not to mention bored. Many years later I would find Starbird's skepticism echoed by many writers I admired, such as poet Marvin Bell, who said, "Theory is fine, but it won't help you write the next word," or Joan Didion, who wrote that she remembered nothing of the theory she advanced in her graduate thesis on Dante but could recall "the exact rancidity of butter" on the train she took from her home in Sacramento to her classes at Berkeley. Some people, in Didion's words, "veer inexorably toward the particular." Susan Starbird was such a person, a lover of stray details, tangible fragments, and braver than I was when it came to stating her position (if you could even call it that) in regard to art theory.

"Starbird," I said. "I think I'm falling in love with you."

"Really?" She thrust the cigarette into her mouth so abruptly, I thought she might swallow it whole. Her glance was

skewed to one side of me, just far enough to give the impression that she was making eye contact without her having to actually make it. "That's . . . Are you?" Her cheeks flushed and, to my surprise, her eyes grew red-rimmed, verging on tears. I immediately abandoned my original mission and replaced it with a new one: to rescue the poor girl from an embarrassment so extreme it threatened to send her into a fetal position then and there.

"But if you want to be friends," I said, "I'm good at being friends with girls. No problem. Honest." The moment I said this I knew it to be true. So true, in fact, I wondered which of us was more relieved. I'd been smitten by her sliding glasses, her catapulting hands, her sketch of an aberrant Cheerio, but I hadn't been wise enough to understand that this constituted the romance of friendship, with all its promise and fellow feeling, but none of love's carnality.

When I recall our drive back to the dorm, I picture the two of us pushing the big blue rattletrap of her pickup truck from behind rather than riding inside it. This image is a trick of memory, of course, but it captures the strain of our trip down Sepulveda Boulevard, each of us at a loss for what to say. Starbird punched the buttons on the radio, every station playing a song about love's wonderfulness, or love's awfulness, or love's wonderful awfulness, the lyrics deepening our already considerable discomfort. "You can't dance to this one!" she announced, landing on static.

Humiliation can be physically taxing—was hopeless naïveté the flip side of artistic radicalism?—and that night, overwhelmed by fatigue, I decided to go home and take to my bed. I knocked on Starbird's door on my way out. "I think I'm coming down with a cold," I told her, "and I'm going home to die."

"I hope you don't," she said, peering from her door and biting her lip. "Die, I mean."

"I'll be fine," I replied, but I coughed one of the throaty faux coughs I'd perfected as a child when I wanted to stay home from school, a whole day stretching before me in which to paint and draw. Starbird and I said a shy good night.

As I waited for the elevator, a Brahms sonata wafted from Tanya's room while the toots and bloops of a composition by Morton Subotnick echoed from the opposite end of the hall. A can of spraypaint hissed in the distance, and then there came the ping of a hammer repeatedly striking a nail. The dorm was a box with the sounds of its own making, and I had no idea that this would be the last night I'd spend inside it.

8. Old World

My bid for sympathy seems utterly transparent to me now, but all I knew then was the need to retreat to the quiet house of my childhood, an ideal place to recuperate from courtship. I sped away from the San Fernando Valley on the freeway's current of red taillights. Half an hour later I was home. Ordinarily, I would have told my mother I was feeling under the weather the second I walked in the door; this would send her into worried nurse mode (picture Lichtenstein), and she'd ply me with aspirin and a bowl of warm borscht. Recently, though, my mother's heart had been giving her trouble. She'd been overcome by a dizzy spell at the Safeway. A box boy, finding her clutching a shelf to keep her balance, had called for a cab. As a result of this incident, her doctor forbade her to smoke. He also prescribed tran-

quilizers and blood thinners, advising her not to climb the stairs until her arrhythmia was under control. For weeks she'd been sleeping in a room off the kitchen.

While I scarfed down a plate of cold leftovers, Mother perched on the kitchen stool and tried to explain the fine points of craving, her hands restless without a cigarette. "My pores are begging for what I can't have. It's really bad. Know what I mean?"

"Yes," I said, "I think I do." I rinsed my dish then kissed her forehead. "I'll see you in the morning, Mom." She followed me to the bottom landing and watched with envy as I climbed the stairs.

Because my father was working late again, I had the entire upstairs to myself. Burrowing into bed, I lay on my stomach and listened to the house tic and settle around me.

I awoke at dawn. The whole house shuddered with a deafening rumble, books flying off the shelves and raining onto the floor. My old painting of a towel rack shimmied from its hanger and slid down the wall, a corner of the canvas barely missing my head. Windowpanes rattled and threatened to shatter. Through them I saw detonations of stark-white light in the sky above Hollywood. Beneath the din there churned a watery subchord: the ocean surrounding the house? I froze, certain the world was coming to an end, my body alert yet unwilling to wake. Not until the shaking stopped was I able to throw off the covers and bolt across the room. I sprang over fallen objects and ran down the stairs barefoot despite my fear that the floor might be littered with broken glass. I headed toward my mother's makeshift bedroom, afraid the shock had stopped her heart. I noticed through the living room's bay window that other houses in the

neighborhood were still standing, though the bulb of the cul-de-sac's single streetlamp sputtered like a candle flame. Where there had been only noise before, a vacuum now swallowed the sound of my footfalls. The neighborhood dogs, usually provoked by so much as a car horn, were strangely silent, as were the birds that screamed from the trees at the first sign of dawn.

My mother lay in the gloom, covers drawn up to her chin. "Are you OK?" she asked hoarsely, her fear tamped by a chemical calm.

"Yes. You?"

"I don't know. I don't know anymore."

My father ran into the room, panting. "Is anything broken?"

My mother shook her head no, peering up as if she couldn't quite, or didn't want to, place him.

"We'd better check the house," said my father. He signaled me to follow with a wave of his hand. Only then did I realize that, fully dressed, he must have just come home.

Our inspection began in the dining room. We tested light switches, none of which worked, and examined hairline cracks in the plaster. The pendulum of the grandfather clock in the foyer (an "antique" my parents bought on Main Street at Disneyland, nostalgic for a past they never had) had fallen off its pivot, the hands frozen at 6:01. Hazy morning light flooded the entry hall when we swung open the front door, and there, in the center of the brick landing, propped on a florist's easel, stood a spectacular floral wreath made of pink and white carnations. A satin ribbon stretched across it: REST IN PEACE.

"What the hell?" barked my father.

I'll never know how I had the presence of mind to breathe, let alone figure out how the wreath had arrived at our door, but

I saw each step as if I'd been a witness: Starbird felt badly about our dinner; she told Tanya, who told Kevin; inspired by the story of my melodramatic exit from the dorm, the three of them pooled their money and thumbed through the Yellow Pages until they found an all-night florist who delivered on this end of town. I had, after all, claimed I was going home to die, a remark whose repercussions brought this wreath to our doorstep.

"It's from my friends," I told my father. "It's a joke."

"Some joke," he said, glaring at the wreath. In the pause that followed I thought of Bob, gone for years, sure that my father was thinking of him too. And just as I began to imagine, against my will, my brother's bones at the bottom of a coffin, a strong aftershock rolled through the city. My father and I grabbed the doorjamb and braced ourselves against the trembling house.

The paintings on our walls now hung at funhouse angles. I moved through the rooms, adjusting the Parisian street scene, balancing Rivera's basket of flowers. How comforting, after a quake, to straighten those crooked images, to concentrate on the horizontal. I could have been righting the Earth itself.

With each aftershock, powdery traces of plaster sifted down from the ceiling and walls. Working slowly so as not to strain her heart, my mother swept the floor again and again, Sisyphean in her flannel bathrobe. She flatly refused my offer of help. "Better I should keep busy," she said, "than sit around and chew my nails, desperate for a cigarette."

Upstairs, Father sat on the edge of his bed, fiddling with the dial of an old transistor radio he'd retrieved from his workshop in the garage. For a while I kept him company, the two of us listening to news reports and trying to piece together what had happened. The quake had measured 6.6 on the Richter scale,

the epicenter near Sylmar, a bedroom community ten miles east of Valencia, where the new campus was in the final stages of construction. A crack in the Van Norman Dam threatened to flood the houses below it. My father mentioned that water had sloshed over the edges of our neighbor's pool and poured down a retaining wall into our yard. This must have been the watery onslaught I mistook for the sound of the ocean. The bursts of light I'd seen from my bedroom had come from transformers shorting out across the city, vast swaths of which, according to the frantic newscaster, were still without power.

By ten a.m., the electricity in our neighborhood had sputtered back on, and I spent the remainder of the day in front of the television, watching replays of CalTech's wagging seismograph. By noon, every channel broadcast footage of the six collapsed floors of the Sylmar Veterans' Hospital, only a few miles south of the new campus. An unknown number of patients were trapped beneath the rubble, some presumed dead. The stunned survivors, still in their metal beds, had been wheeled into the hospital parking lot, where they glanced at intrusive news cameras or stared in disbelief at the wide-open sky where, only moments ago, a ceiling had been. Disney's dream school, I realized, may not have withstood the quake. Meanwhile, live on several channels, microphones were thrust toward the impassive face of Dr. Kate, a seismologist at CalTech, who repeatedly explained the mechanics of the quake—thrust fault, magnitude, liquefaction—with oracular calm.

Her monologue was interrupted by a special bulletin reporting that a woman driving a pickup truck had been crushed beneath a fallen overpass on the I-5 Freeway, the victim's name withheld until relatives were notified. I thought of Starbird and

sprang off the couch. Earlier that day, Ron had somehow gotten through the jammed phone lines to let us know he was OK, but outgoing calls had been impossible; every time I'd lifted the phone to call the Northridge dorm, I was greeted with an urgent pulsing instead of the regular dial tone. I tried unsuccessfully to convince myself that Starbird would have no reason to be driving on the freeway at six a.m. True, she was unpredictable, but much more likely to die from falling asleep with a lit cigarette than from being crushed by a chunk of Interstate 5. Still, I had no way of knowing for sure, and I suddenly wished I had a carrier pigeon or a Ham radio.

Late that afternoon I heard honking and opened the front door to see a blue pickup idling in front of our house. The engine's ominous vibrato drew my mother and father to the front door. I raced past them and, once outside, almost tripped over the wreath (no matter how grim a gift it was, my parents were too frugal to throw away dozens of perfectly good flowers), which exuded its funerary perfume in the full heat of day.

"You must think I'm a ghoul," said Starbird as I hopped into the passenger seat.

"Flowers are always thoughtful," I said. "But do me a favor and never send them again. How did you get here, anyway."

She revved the engine, shifted into drive. "Side streets. You couldn't pay me to get on the freeway. Someone was crushed!"

I turned and waved good-bye to my parents, shouting that I'd be home later. They waved back, framed by the doorway, a palpable unease between them. For Starbird and me, however, it became immediately apparent that we were friends again, resilient as only kids can be, any lingering awkwardness between us a wall the quake had toppled.

"Were you scared?" I asked her.

"Shitless," she said.

. . .

We met Kevin and Tanya at Old World, a popular restaurant on the Sunset Strip. Old World was pretty much vacant that night, its rustic, dimly lit decor featuring parchment maps whose unfamiliar continents and now-extinct cities reminded me that the earth could shift as quickly as art.

"We were taking a shower together when it hit," said Tanya, forgoing hello. Ordinarily, she would have made such a statement in order to titillate her listeners, but tonight innuendo took a backseat to the facts. "We practically broke our asses trying to get out of the tub. My hero," she said, referring to Kevin, "pulled the shower curtain off the rod and left me standing there." Kevin shrugged, thrusting his hands into the pockets of his jeans. The vision of him naked and wet was bound to come back to me later that night, but for now I had to pack it in storage and attend to the crises.

"We were stoned on *the* finest dope," he said. "What a freaky ride."

"And our room?" I asked.

Kevin held his hands a couple of inches apart. "There's a space about this big between the baseboards and the floor. Everything's all over the place, but basically OK."

"And the dam," said Tanya. "The National Guard is evacuating the whole area in case of flooding. Thank God my harp is on the second floor! Those jarheads better guard the dorm with fucking machine guns because, I swear, if anything happens to that harp . . ."

Starbird had invited two other art students to meet us. Carson Pardo's lankiness began with the straight black hair cascading to his shoulders. His eyes bugged out just enough to give him a look of constant wonderment, and this, combined with the fact that he wore a turtleneck sweater and gestured more often than he spoke, lent him the gently enigmatic presence of a mime. The moment he'd walked into the restaurant, a tremor rattled the dishes and swayed the brass chandeliers. The group of us froze, and when the rumbling stopped, Carson summarized our close call by wiping imaginary sweat from his brow. "No kidding!" said Starbird, as if Carson had not only spoken aloud, but to her alone. Right then and there I knew they were destined to become a couple, if they weren't already. I saw their future as though it were unfolding in the glassy depths of a crystal ball: he would forever communicate to Starbird in a semaphore of skinny limbs; she would commit every detail of their love to her journal, pressing locks of his lanky hair between the pages, writing odes to his giant eyes.

This prediction left me crestfallen, but only for a second; I wasn't attracted to Carson myself, and so was given an opportunity to *not* be tempted by a man, momentarily free from the pull of male beauty. Carson did nothing for me. Nothing! And I adored him for it.

Next, Jean Stockton arrived, a woman Starbird had known from her years at Darby West, a progressive high school in Northern California. She wore khaki pants and a Hawaiian shirt printed with sprigs of bamboo. Freckles were scattered across her cheeks and over the bridge of her nose. Like many nascent feminists at CalArts, she wore no makeup. "This shaking is too much," she said after the introductions. She held out

her hand, palm up. "Bird, I need a cigarette." A thoughtful, almost worried pause preceded each remark, a reticence hard to square with the pale, translucent skin that made her appear to be an imminently forthcoming and knowable woman.

The six of us were led to the smoking section by a hostess who hugged a stack of menus to her chest, her obligatory smile a rictus of pure fright. "I've been stuck here since my shift ended," she told us once we'd been seated. "My replacement hasn't shown. I don't even want to think about what my place is going to look like when I finally go home." She dealt the leatherette menus around the table like a deck of hefty playing cards and suggested we order plenty of wine.

We poured several rounds while waiting for our food to arrive, too tired and tipsy to carry on a sustained conversation. Instead we listened, alert to the slightest sound or vibration—prelude to an aftershock. Old World's ordinarily sociable din had become a Cageian performance of accidental sound: tinkling forks, scraping chairs, the creak of the kitchen door as it swung open to reveal cooks and busboys attempting to carry on business as usual. Hardly a diner's voice was raised, and then only to blurt, "Did you feel that?" The lengthy silences at our table would have been excruciating under any other circumstances—after all, some of us had just met, and the time was right for get-acquainted gab— but the atmosphere of emergency made it permissible for us to simply sit there, becalmed by glasses of dry white wine, occasionally letting loose a sigh or shaking our heads in disbelief.

I don't remember whose idea it was to pile into Jean's ancient Mercedes and see how far we could drive into the Valley without being stopped by the National Guard. One minute we were in the restaurant, tossing money toward the

center of the table and trying without much success to divide the check six ways, and the next we were crammed into a car and debating which route to take. The Mercedes, a dented and oxidized brown hand-me-down from Jean's mother, rumbled percussively, barely able to accelerate under the burden of our combined weight. I sat in the front with Jean. Behind me, Carson and Starbird and Kevin and Tanya were wedged together shoulder to shoulder—a good thing, since, if given an extra inch, they'd probably have tumbled around like drunken rag dolls. My limbs were a little loose from wine and a warm coal of courage glowed in my chest.

We drove for what seemed like hours, creeping through lightless intersections. We passed a family who were huddled together on their front lawn, cocooned in blankets and afraid to return to the dangerous indoors. The few drivers we passed were also navigating the streets with a caution that someone new to L.A. might have mistaken for politeness. Dust congested the sky, turning the sun a pale gray. Sometimes it loomed ahead of us, sometimes behind.

Eventually, Tanya and Kevin's heads lolled together, their eyes closed. She'd flung an arm across his chest, holding him as intently as she did her harp. Kevin's mouth fell open and he started to snore. Carson draped his arm around a subdued Starbird—she was spent from excitement and cigarettes—and he stared fixedly through the windshield. When I turned and saw his large dark eyes, I was overcome with the feeling that we were headed somewhere only he could see, the very place that inspired his silence. I turned back to face the road, the same half mile of which seemed to slide forever toward us, an optical illusion carrying us nowhere, the same bland suburb always up

ahead. I rolled down my window. The frying sound of tires on asphalt assured me that the road was real, the wind in my hair proof that we were moving.

Jean drove slowly, the most sober one among us, which wasn't saying much. She tucked a lock of hair behind her ear. "Don't wake the children," she whispered to me, referring to the limp passengers in the backseat.

I said, "The little ones are all tuckered out."

We would have gone on with the Mom-and-Dad banter, but by extension it meant we were husband and wife. The game ended abruptly, but not before we recognized in each other a certain skill at finessing heterosexuality, roles we'd just given a quizzical twist. Though it would be months before Jean and I slept together, our becoming a couple began that night, a bond made plausible by the briefest parody of marriage.

Jean came to an unexpected stop and peered into the distance. It took me a moment to see the cluster of shadows approaching from the far end of the road, just beyond the range of our headlights. I couldn't be sure if what I saw was a single thing or something composed of many restless parts. It—they—moved low to the ground, nearing us with such unmistakable purpose that Jean flicked on the high beams, daring the shape to make itself known.

"Jesus," I muttered, gripping Jean's arm.

"What's wrong?" asked Starbird.

First to enter the light was a dirty white terrier. I might have mistaken his slow, delicate steps for timidity if his lip hadn't been raised, exposing a row of pointed yellow teeth. A German shepherd trailed behind, ears pricked forward. At least a dozen other dogs followed, all of them slinking closer to the car. Judg-

ing from their tags and collars, they'd been house pets the quake had instantly turned feral, mongrels and purebreds who'd leapt over fences and dashed through gates without ever looking back at their masters. No more tricks or begging for scraps; they belonged to one another now, a marauding pack to whom we were intruders.

The small scruffy terrier made an unlikely alpha, but his dirty coat suggested that he may have triumphed over a larger dog in a recent fight. He let out a yip and bit the air. As if on command, the other dogs fanned out on either side of him and faced the car. They'd reached a tense, unthinking agreement: we were not to pass. The rumble of our idling engine could have come from the animals' throats.

Kevin awoke, oblivious. "Hey," he asked me, stifling a yawn, "did you ever get those flowers we sent?"

Tanya stirred herself from sleep. "Seems like we sent them years ago." Her voice was hoarse. "Why are we stopped?"

"Look," I whispered, and we all leaned forward.

The dogs remained in strict formation, standing their ground. A flank of eyes refracted our high beams, ablaze with ancient canine light.

9. Somewhere There Must Be Something That's Different from Anything

At last my mother could gloat over her foresight; how wise of her to stockpile canned goods in the pantry. For days following the quake, she checked and rechecked the shelves with a medicated, faintly self-satisfied smile; for her the disaster was,

above all, a vindication of her lifelong tendency to prepare for the worst. I'd moved back home from the shambles of the Northridge dorm, waiting for classes to resume the following month at the new Valencia campus, which sustained only minor damage. While gorging on our surplus of canned fruit, I listened to news bulletins about road closures and contaminated drinking water. My father mixed batches of Spackle and filled the cracks that branched through our walls.

City life hadn't exactly reverted to primitive conditions, but there was hardship and superstition enough to make modernity seem like a thing of the past. A number of students had dropped out of CalArts and fled California altogether, seeking education on more stable ground, and perhaps in more acceptable professions. Left behind were those students and faculty willing to risk geophysical upheaval in order to take part in that most wondrous of redundancies: a new avant-garde.

I pushed open the school's doors on registration day, 1971, and wondered if I'd shown up on a Sunday or a national holiday. Since the buildings had been designed for a projected student population far larger than the number then in attendance, the lobby was virtually deserted, its plaster walls blank except for a sheet of paper whose hastily painted arrow urged me onward. With the friction of every step, the varnished wood floor of the two-story main gallery caused the rubber soles of my shoes to chirp and echo like birdcall in an aviary. Finally, I stumbled upon a small group of people—Lyn, Kara, and Starbird among them—filling out registration forms in the Art Department office, where a row of metal filing cabinets promised more Institute than Arts.

Within a few days it became clear that the dwarfing enormity of the place necessitated its own etiquette. When

approaching a stranger from the opposite end of a seemingly endless hallway, the suspense about what I'd say to them when they were finally within earshot had just enough time to fester into dread. *Hello* was too predictable, *How ya doin'?* too folksy, *Hi* too adolescent. Such avoidance of convention does an innovator make. Although the administration would eventually color-code the buildings' four stories to make it easier to tell each floor apart, for now the elevator doors invariably slid open onto a disorienting white anywhere. Once, after being inside the building for most of the afternoon, I paused in a corridor whose cinder-block walls flickered stroboscopically beneath yards of recessed fluorescent tubes, and I could have sworn that just yesterday I'd stood in exactly the same spot having today's déjà vu. If there was no one nearby from whom to ask directions, you had to decide whether to stay put and wait for somebody to come along or else to go looking for somebody and risk wandering the halls forever. There soon circulated a schoolwide joke about a missing population of students who had walked into the building on the first day and still couldn't find their way out. It had been one thing to stroll through the congenial, overgrown gardens of Villa Cabrini, stumbling upon classes and staying as long as you liked, but the same free-form curiosity didn't fit within the floor plan of Thornton Ladd's campus, which managed to be austere and overcomplicated at the same time. In fact, the school's layout fostered a desire to stay in a class as long as possible—who knew when you'd find the room again. It was not uncommon, once students had gathered and a seminar began, for a lost soul to periodically poke his or her head though the door and ask, with an existential quaver in their voice, *Am I in the right place?*

Movie studios routinely began to use the campus as a setting for impersonal futuristic bureaucracies. I still occasionally see on late-night television a sci-fi film in which, say, affectless androids cultivate human organs in a sterile biofarm that looks suspiciously like my alma mater. The school that once held for me the promise of an artistic utopia was a place I now revisited in B-movies—schlocky visions of the world gone awry, of society becoming too advanced for its own good.

Built in the same nondescript style as the main buildings but on a smaller scale, the CalArts dormitory was easier to navigate. Jean and Starbird lived in the adjoining rooms directly above Carson and me. Had my suite mate been a boy other than Carson, a boy to whom I'd been attracted, the shared bathroom would have been a source of sexual tension, the tub and sink and toilet like suggestive soft sculptures by Claes Oldenburg. Fortunately, given Carson's cryptic gesticulations and his puppylike devotion to Susan Starbird, he remained the object of my *non*-desire, a buddy and a puzzlement. The most vivid evidence of his private life took the form of plastic livestock in our bathtub, toys Starbird purchased for him by the dozens at a Valencia five-and-dime. Carson bathed with cows and sheep and pigs bobbing on the surface of the bathwater. He batted at them languidly, a guy steeped in barnyard soup and reveling in his girlfriend's generosity. He never bothered to remove the animals after he drained the water, and one day, according to Carson, when Starbird saw those little carcasses strewn across the bottom of the tub, she sniffled and bit her lower lip, touched as if by a valentine.

Many of us at CalArts were fond of toys. Their primary colors and basic shapes had stirred our earliest understanding that there

existed objects whose sole purpose was to engage us, to make us the glad inhabitants of a world in which we could improvise laws of cause and effect. Long ago, we'd been able to simultaneously inhabit and lose track of ourselves while we played, a state we now regained, or hoped to regain, when making art.

The first time I went to visit Jean in her dorm room, we sat cross-legged on the floor while she showed me a model of the Visible Woman, an educational toy she'd modified so that loose plastic organs rattled around inside the transparent body along with several polished rocks. When Jean held the woman by her calves and shook her like a maraca, her miniature anatomy made a pleasing racket—stone against stone, lung against stomach. "This is the piece that decided it for them," she said of the admissions committee, who'd considered it a hybrid between a sculpture and a musical instrument. The Visible Woman/rock-filled maraca had served as Jean's ticket into the not-so-hallowed halls of academe.

Jean handed me the woman and I gave her a shake. It occurred to me that a person might draw like Leonardo da Vinci and still be rejected from CalArts on the grounds that they weren't the kind of student the institute was seeking. Jean and I had been chosen not because we possessed an outstanding technical skill but because of our penchant for making things that were weirder than the things other people made, or would ever think of making. Of course, weirdness can be cultivated as studiously as technical skill, and in the coming years, those of us in the post-studio program would do exactly that: Jill Ciment sat in her backyard for a period of one week and, in a strange application of Marxist ideology, tried to convince the industrious ants crawling through the grass to stop working. Suffice it to say, the swarm paid no attention. Steve Galloway created a fake arm that jutted from

a wall and patted you on the shoulder when a cord was pulled; droves of students flocked to the small, windowless gallery where they could be touched by what someone dubbed *The Reassurance Machine*. Based on the coy Fluxus instructions in Yoko Ono's book *Grapefruit* ("Cut a hole in a cloud and watch the sky drip through"), Jean would compose parodies such as "Wake up and write the National Anthem" and "Play dead until you are no longer playing." Suzanne Kuffler called the identi-kit division of the Los Angeles Police Department, described the *Mona Lisa* over the phone, and then displayed the composite portrait beside a reproduction of Leonardo's painting; of the two portraits, the police composite appears to depict a woman somewhat more capable of committing a crime than the artist's enigmatic model. Students already understood that, if we wanted to establish a name for ourselves and stand out from the crowd, we had to treat art-making as a competitive sport, hurling ourselves with ever more athleticism toward whatever was new, whatever was next.

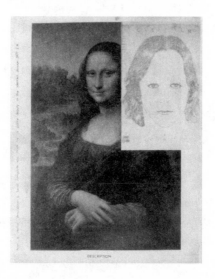

DESCRIPTION

During those first weeks in the dorm, I read "A Sick Child" by Randall Jarrell, a poem in which a bedridden boy, desperate for fresh daydreams, says into the darkness, "If I can think of it, it isn't what I want. / . . . somewhere there must be / Something that's different from everything. / All that I've never thought of—think of me!" How well I recognized the impatient desire in those lines, lines that could just as easily have been spoken by an artist beseeching himself to imagine the as-yet unimaginable.

Jean, it turned out, shared my fondness for poetry. I found this out during one of the late night talk-a-thons that had become common between us, our tireless conversations fueled by cans of Coke. Come midnight we'd be antsy and caffeinated, practically effervescing with snap judgments. Jean played Thelonious Monk over and over on her tape deck. While jazz arpeggios chased their tails, we spoke of artworks we either "loved" or "hated," sidestepping noncommittal assessments like "interesting" because the hour was late and we were eager to know each other and there seemed no reason to temper our enthusiasm—a youthful enthusiasm it seems to me now, full of feeling without being particularly discerning, as impulsive as a drunkard's hug. Still, talk about poems and paintings and movies was not only thrilling in itself, but served as the catalyst for disclosures of a more risky kind.

One night, for example, Jean said she particularly admired an Adrienne Rich poem about a man anesthetizing himself with booze. She quoted the phrase "stunned by Scotch." Beyond her window, other windows glowed in the adjacent wing of the dorm, and in every one a student read or drew or played a musical instrument, each seemingly earthbound body in a free-fall

of contemplation. Jean cleared her throat, her green eyes downcast, and I noticed her translucent skin, just as I had on the first night we met; she was a living version of the Visible Woman, unable to hide her thoughts for long; although she may have maintained a poker-faced stoicism, Jean involuntarily blushed or paled, her face a page on which appeared the legible message of her inner life.

"My father was an alcoholic," she told me. "He inherited his father's mining company and had nothing to do all day. Nothing. The board of trustees didn't want him; they paid him to stay out of their way. He spent every day sitting in his chair, reading the paper." At first this struck me as a fairly benign predicament, the tipsy, ubiquitous father hiding behind the news, his feet propped on an ottoman. I couldn't quite understand the gravity in Jean's voice, couldn't square it with her sudden pallor.

According to Jean, her father brooded about his uselessness night after night, year after year. There was a gardener, a cook. No household chore required him. No routine suffered in his absence. An inheritance had made his life lax in its demands, and so his duty to that life was like a vow he had to renew each morning, dreaming up reasons to rise and shower and submit to the formality of polished shoes and starched shirts even though his occupation asked nothing more of him than to sit in his living room and thumb through the daily newspaper till his hands were smudged with ink. He read stock reports, political commentary, letters to the editor, weather forecasts, baseball scores, obituaries, ads. Come dinnertime, however, Mr. Stockton slumped at the head of the table, gripping a crystal tumbler of whiskey, too bleary to recall a single thing he'd read. Before

him sat the sullen wife and child who knew better than to ask how his day had gone, knew better than to unleash the self-pity or lacerating sarcasm such a question was sure to cause. As he glowered over the rim of his glass, he may have been struck by a dim realization: silence was his job—a job he'd done so well he couldn't undo it.

And then one afternoon Mr. Stockton folded the paper into a smaller than usual oblong, climbed the stairs, and rummaged through a closet pungent with cedar. His clothes sagged from hangers as if from the weight of indolence itself. Limp sleeves dangled, empty of arms. Silk ties he'd never worn were pointlessly embroidered. Sitting on the edge of the bed, he clamped the butt of the rifle between his dress shoes and lowered his head. The metallic taste of the muzzle might have reminded him of well water, of minerals fermenting for centuries in the dank earth. He might have interlaced his fingers as if to drink from his cupped hands. In the rifle there glistened a silver drop, cold and quenching and necessary.

. . .

Jean and I talked and talked as if every secret would sooner or later become sayable. Our lives had crystallized around a family tragedy—her father's suicide, my brother's death— and we believed in the purgative power of words. When talk wasn't possible, there ensued other, more inventive, forms of communication.

One night, I opened the door to my dorm room and saw a naked, headless baby doll dangling in the darkness just beyond my window. It swayed in the wind and knocked with a hollow thud against the pane. Jean had lowered it from her window

on a string tied to its chubby arm. She'd stuck a note inside its neck hole, which I read and replaced with a note of my own. By the time I awoke the next morning, the doll was gone, hauled back to her room. For months thereafter, that doll ascended and descended like a heavenly messenger delivering mundane news—what we ate for dinner, who we'd passed in the hall—we nevertheless felt a great need to share with each other. But not even a decapitated doll could disguise the thoroughly conventional aspect of our courtship: full of epistolary pleasantries, almost Victorian in its formality.

By the time I'd met Jean, I'd pretty much given up on having sex with anyone other than myself, the most discreet and responsive partner I could find. I didn't trust my romantic instincts after what could mockingly be called my date with Starbird. Thanks to Nicky, I knew that I could make love to a woman, but I also knew that this was merely a technical boast, an action sometimes independent from the complexities and rewards of desire. Still, Jean was kind and fine-boned and lively, her company at once the cause of, and respite from, my sexual uncertainty. During our talks, if she leaned forward to emphasize her point, a strand of hair would fall across her face, and she'd sweep it back behind her ear with a stroke of her pale, freckled hand, a gesture that impressed me as the epitome of the feminine, though Jean was otherwise still the tomboy she professed to have been all her life.

We each admitted that we had been sexually attracted to members of our own sex, and then, worried that the other might react poorly, we exchanged a few handy platitudes about homosexuality—*Live and let live,* and so forth. I asked Jean if she'd ever seen *Tea and Sympathy,* a movie in which Deb-

orah Kerr, a faculty wife, does a favor for an unpopular college student named Tom by sleeping with him in the woods, a mission of mercy meant to quell the boy's doubts about his sexuality. Tom is suspect because he's sensitive and intellectual and his wrists are thin. Kerr's charity is not entirely selfless, however; her football-coach husband hasn't performed his conjugal duty in quite a while and prefers to spend his time with a squad of fawning, athletic boys. Tom apparently performs quite well despite his doubts, judging from Kerr's voice, which is less quavery and British after their tryst. From then on, she seems relieved of a certain frenetic intensity that had caused her to flutter through the movie like a trapped sparrow, leading one to believe that her fling with Tom is enough to carry her through another long and loveless school year while Tom goes off to live his normal, unquestioning life, and the coach, cuckold or not, carouses as usual. The film's message—too blunt to be considered subtext—is that the right woman will make an unmanly man manlier than the manliest of men. Homosexuality, in other words, was a problem treatable by sex with Deborah Kerr.

Not surprisingly, perhaps, Jean and I had seen the movie more than once, and after a capacious toke on the roach, we quoted Kerr's famous line from the film, spoken the moment before she and Tom do the deed: "Years from now, when you speak of this—and you will—be kind." After we fell silent, recalling Kerr's saintliness, we began to laugh. Quietly at first. Then we doubled over and pounded the floor, weeping hot, involuntary tears. Jean and I would become a couple that night and stay together for nearly three years. But first we had to catch our breath. Once the laughing fit subsided, we

looked at each other through dilated eyes, aware of what was coming next.

10. Art as Idea

In her 1968 essay, "The Dematerialization of Art," Lucy Lippard predicted that the art object might become wholly obsolete. She believed the visual arts of the early 1970s were distinguished by two trends toward immateriality: art as idea and art as action. "In the first case, matter is denied, as sensation has been diverted into concept; in the second case, matter has been transformed into energy and time-motion."

Lippard's observation is a kind of alchemy in reverse: a process whereby a precious object is transformed into base, impermanent stuff—or non-stuff, as the case may be. The earliest theories regarding conceptual art were for the most part dry, negating, stoic, and impersonal, yet they held for me a richly theatrical, romantic charge; a wave of the magician's wand and—poof!—an object could vanish like a rabbit into a top hat. I understood *diverted sensation* and *denied matter* all too well, though the sensations diverted were sexual and the matters denied were matters of the heart. Although Jean and I were lovers, I had good reason to suspect that, even if my desire for men had been delayed by our relationship, it wasn't gone forever. Longing not only persisted despite my attempts to suppress it, but grew more compelling the more it was confined—a flourishing mutant, as compact and minutely pruned as a bonsai. And yet I'd fallen in love with Jean, had more fun with her than anyone else. Because I'd never known intimacy

like this, I believed that leaving Jean would condemn me to the life I'd seen portrayed on the local news when I was a child: two trench-coated strangers met beneath a lamppost on a desolate street—men converging in silhouette—while a voice murmured statistics about the increasing cases of venereal disease in Los Angeles County. I asked my mother what "venereal" meant.

"It's what two homosexuals get."

"Those two?" I asked, meaning the men on the screen.

My mother lit a cigarette. I saw in her expression a dawning melancholy; she could not then, nor would she ever, be able to explain the world to herself, let alone to her youngest son.

Eventually, the cliché of the clandestine homosexual encounter—beneath a streetlamp no less—would strike me as grimly ridiculous, but back then I lacked the understanding to mount a persuasive case against it. I'd seen it on television, after all, right there in black and white, objectively reported in low, disdainful tones. By the time the weather report began, shame had made a place within me.

The stronger and more tangible my longing for men, the more adamantly I crusaded for art's dematerialization.

. . .

One class in particular showed me ways to disentangle art from the confines of an object. It was taught by Allan Kaprow, the artist who had coined the term *happening* to describe his Fluxus-influenced events of the early 1960s. The skeletal instructions for a happening (like George Brecht, he called them "scores") guided participants through a set of activities that were meant to be experienced for their own sake; nothing practical is

accomplished during a happening, nothing of value left when it's done. Some happenings left a mess—pools of melted ice or a pile of discarded rubber tires—but nothing like an object that can be possessed by an art collector or sold at a gallery or shown in a museum. The "art"—and I use quotes here not to be ironic, not to cast aspersions on Kaprow's work, but to suggest the mind-boggling relativity of the term at this point in my story and in the history of modernism—the "art" of a happening exists in the present and then settles among each participant's remembered experience, leaving a significance that lasts only as long as the memories of the participants themselves. Even the blurry black-and-white snapshots that documented Kaprow's events looked like they'd been retrieved from some lightless archive, proof of time gone by. If there was a poignant strain that ran through Kaprow's work, it was the dogged acknowledgment that nothing lasts forever, not even art. Strivings for artistic immortality struck him as a little overblown and foolish—he once chuckled when a student used the word "posterity"— though Kaprow himself enjoyed a fame he hadn't necessarily sought, and exerted an influence he never could have predicted: just a few years earlier, "happening" had become a household word thanks, in part, to the Elvis Presley movie *Easy Come, Easy Go*, in which a benignly eccentric artist in the mold of Jon Gnagy climbs a ladder and dumps a giant bucket of cold spaghetti onto the heads of a young couple who are making out atop of a Volkswagen Beetle, so deep in a the oblivion of a kiss that they appear unfazed by the deluge of noodles. When Elvis, standing on the sidelines, is informed by a pretty, raven-haired yoga student that he's just witnessed a new art form called a happening, he lets loose with his asymmetrical trademark sneer

and says, "Looks more like a smash-up in an Italian restaurant." His glib reaction, however, doesn't stop the bongos from beating tattoos of approval or the audience from shouting tidbits of bohemian praise such as "Groovy!" and "That really turned me on!" The scene captures a particularly ambivalent moment in American culture of the post-Eisenhower era, giving voice to a deeply ingrained populist skepticism about the merits and integrity of modern art while at the same time allowing audiences to be entertained by its foolishness. Even crusaders for the avant-garde would have to admit that Elvis's summation of the faux happening wasn't *that* far off the mark. Let's face it, sarcastic reactions to art are often legitimate because plenty of good artists are good precisely because they risk appearing ridiculous. And a lucky few succeed in appearing more ridiculous than they ever dreamed possible.

The pasta avalanche was based on an actual happening by Kaprow called *Household* (1964), in which a group of people converged in what the score described as "a lonesome dump out in the country" and licked strawberry jam off a Volkswagen Beetle. Kaprow himself often said in class that the intention to make art constituted the difference between art and non-art, by which I understood him to mean that art requires all the awareness one has at one's disposal, though the spirit of Kaprow's statement—*anything an artist does is art*—could just as easily be seen as the triumph of wishful thinking over talent. Interpretations aside, I have to admit that, when I heard about *Household*, my first bourgeois thought was that I personally wouldn't lick jam off a car in a dump, lonesome or otherwise, unless I'd made certain that the jam was fresh from the jar and hadn't been sitting under the sun for too long, and more important, that the car

had first been professionally washed and waxed until it gleamed like a clean china plate.

Still, I was tantalized by the vaguely sexual idea of a bunch of people joining forces to become an oral car wash. The happening also touched upon the intimate relationship between humans and machinery, and it did so in a relatively gentle and tasty way, as opposed to, say, the mechano-fascist bombast of artists like F. T. Marinetti, whose 1909 *Futurist Manifesto* urges his followers to ". . . exalt movements of aggression, feverish sleeplessness, the double march, the perilous leap, the slap and the blow with the fist. A racing automobile with its bonnet adorned with great tubes like serpents with explosive breath . . . a roaring motor car which seems to run on machine-gun fire is more beautiful than the Victory of Samothrace." The long-haired men and women in Kaprow's documentary photographs could have been the devoted congregants of a jam-worshiping

church. Their licking left painterly, abstract marks that echoed across a decade.

The term "happening" was quickly absorbed into the vocabulary of American pop culture, a convenient catch-all used to describe love-ins, acid tests, group sex, and any spontaneous behavior the general public viewed as the first signs of rampant anarchy. Allen Ginsberg's funeral was repeatedly described in the media as *a happening* because people danced and wailed and read poetry with a nearly ecstatic disregard for order. Diana Ross's song "The Happening" made the pop charts in 1975, though the lyrics about the pain of lost love were nothing new.

Understandably, Kaprow had settled on the term because it

LEFT
The Winged Nike of Samothrace
Artist: Pythokritos of Lindos
Year: c. 200–190 BC
Type: Parian marble
Dimensions: 244 cm (96 in)
Location: Louvre, Paris

RIGHT
Illustration of "La Jamais Contente," first automobile to reach 100 km/h, in 1899

Untitled painting, 1957 *Household* (detail), 1964 *Brushstroke*, 1968
Franz Kline Allan Kaprow Roy Lichtenstein

embraced the informal, open-ended activity that characterized his work, but some embraces are so wide that a flock of birds can flap right through them.

Ten of us were enrolled in Introduction to Happenings. We met once a week in one of the institute's windowless interior rooms. (Were all my classes in the same room, I've sometimes wondered, or did all the school's interior classrooms look exactly the same?) The recessed fluorescent lights made everything beneath them flicker like an 8 mm home movie, which might have given Kaprow's teaching assistant, a wiry Jamaican named Isaac, the idea to show up for one of our sessions with a film projector on a rolling cart. He pushed the cart through the doorway and we all watched it glide toward the center of the room. Since any of the white cinder-block walls could have served as a screen, we waited to see where it rolled to a stop and then turned our chairs accordingly. "Get comfortable," Isaac advised, his vague smile suggesting that he intended to make us *uncomfortable.*

Isaac was one among a handful of charismatic figures at CalArts who'd cultivated a mystique around their purportedly radical body of work, work that no one had seen but that was, at least according to the artists themselves, coming to fruition in whatever off-limits space they used as a studio. The less these

students revealed about their art, the more mythically brilliant it became. I don't mean to disparage those students who relied on talk more than they did on the labor of actually making stuff—this was the heyday of conceptualism, after all. Besides, I had no doubt that it *did* require hard work not only to promote, but to sustain, a reputation for possessing an exceptional artistic vision without offering any tangible evidence to back it up. In many ways I envied those students—they projected a winning mixture of bravado and illusiveness—and I saw my inability to generate the same kind of excitement and anticipation about my own works-in-progress (which, even at their best, could have been better) as a failure of imagination. Still, I couldn't understand why an artist would risk promising more than he or she could deliver. It would be like claiming that you'd built a great stone pyramid in your backyard but weren't quite ready to let the public see it. Why put all that pressure on yourself when just trying to make something halfway decent is pressure enough? Anyway, Isaac's coiling dreadlocks brought to mind not only reggae star Bob Marley, but the young Albert Einstein, associations that went a long way in persuading me that he possessed a streak of wild genius, his hair like strands of complex thought.

"What you're about to witness," said Isaac, "will put all the performance art you've ever seen, including happenings, to shame." The potential insult to Kaprow was mitigated by the fact that our instructor, unperturbed, rolled up the sleeves of his denim work shirt and slipped into a chair along with the rest of us. He stroked his beard, a gesture that had become so widespread a signal of philosophical contemplation among young males of the decade that I'd decided to stop shaving in order to have a life of the mind. Although he may not have known in advance what his

TA was up to, Kaprow practiced the Socratic method and, unlike other instructors who talked about democracy in the arts but never let anyone get a word in edgewise, he was willing to yield the floor and let us draw our own conclusions.

The room went dark. White clouds boiled to strains of Wagner. A cruciform shape glided over miles of pastoral landscape and then over a city, and it took me a moment to realize that I was looking at the shadow of an aircraft. People on the screen were shown going about their everyday tasks—hanging sheets on a clothesline, shopping among the stalls of an open-air market—and then, startled by the oncoming buzz of propellers, they shielded their eyes against the sun and gazed expectantly heavenward. A subtitle identified the city as Berlin and the plane's passenger as Adolf Hitler. Next—at least in the stunned chronology of recollection—half-naked young men were soaping each other's muscled backs. They'd gathered like thirsty animals on either side of a wooden trough. In fact, the trough was so long and accommodated so many young men that it seemed to diminish into infinity like the impossibly elongated perspective of a painting by de Chirico. Water shivered in black and white, as bright as liquid mercury. Buckets were passed from hand to hand. A few men erupted in antic splashing. The communal bath could have been comprised of a single bather immersing his hundred glistening limbs. Then a close-up of one shirtless boy shaving another's upturned face, the barbering so slow, so attentive to the pressure of touch, it verged on sexual tenderness.

"You're looking at art-as-propaganda, people. Every frame is dedicated to an agenda. Maybe you think Leni Riefenstahl was some Aryan chick hired by Hitler to film what was going

on right in front of everybody's eyes. But tell me, people, does a neutral position exist?" Isaac posed his question at such a sharp, interrogative pitch, I felt as though I was taking a test, one I hadn't known about and whose grading criteria was mysterious to everyone but the test's administrator. Those wet men made it hard for me to think. "Tell me, people," Isaac continued, "is there any edit, any camera angle, anything (any-*ting*, was how he pronounced it) an artist does that doesn't send a message?"

One student shook her head no, which meant: *Yes, everything sends a message.* Another student nodded, which meant the same thing.

As a child, I'd found a book on my parents' shelf called *Eichmann and the Holocaust.* Its cover showed a mound of naked bodies whose limbs were thin as kindling, countless mouths wrenched wide in silence. As I held the book in my hands, unable to look away, I couldn't reconcile my comprehension that this was a photograph, a record of verifiable fact, and my utter inability to fit this fact into the depictions of human brutality I'd been exposed to thus far in my life: Technicolor crucifixions and panoramic battle scenes accompanied by welling orchestral soundtracks so lushly tragic as to be almost self-congratulatory, the blood of violence staining clothes and faces with relative delicacy compared to the forensic gore fests we've come to expect. The "sweeping" historical epics of those decades were filmed behind the iron-gated lots on Gower and Selma, two otherwise quiet streets I traveled along on my way to the Hollywood Magic Shop, the "emporium" where I'd spend my allowance on a puddle of rubber vomit or a clear plastic ice cube containing a fake fly, gags that seemed like hilarious and shocking transgressions in concept, but that

ceased to thrill me the second I'd plunked down my money, the purchase all but forgotten in my pocket on the way back home. Those were the days when my parents first let me venture out on my own and, traveling beyond the familiar parameters of our neighborhood, I became that most privileged kind of child: unchaperoned. I walked past courtyard apartments built in the 1920s for a booming population of studio employees, each central garden distinguished by a tiered plaster birdbath or faux Roman statue, the hedges trimmed, the flower beds tended. The pavement beneath my feet was dappled with the shadows of overhanging trees. What could I have known of danger, having seen it only in matinees, intervals of distraction and darkness that existed, it seemed, solely to ease the heat of summer, each ninety-minute cataclysm coming to an end before the credits ascended.

My brother Bob was healthy then, his wayward cells still held in check. The kosher burritos were "selling like hotcakes," as my father put it. The war my parents had lived through was over and the most they would say about it was that decent people would never, must never, let it happen again. The only obstacle blocking my path were the fallen carob pods that lay scattered across the sidewalk, reeking of sweet rot and spilling hard brown seeds into a world where the worst turn of luck I could imagine took the form of a singsong curse: "*Step on a crack and break your mother's back.*" And so I believed that my careful steps spared her.

When I brought the book on Eichmann to my mother and asked if we were Jewish (I knew the answer, but needed confirmation at the sight of piled corpses), she gripped my hands in hers and said, "If anyone ever asks you what you are, tell them

you're an American." The firmness of her grip, her imploring voice, had the effect of convincing me that one of those bodies could have been hers, could have been my father's, my brothers', mine, if not for a hairsbreadth of history.

Isaac knew how to milk a pause for all it was worth. Film stuttered through the sprockets while legions of uniformed troops goose-stepped and saluted in choreographed patterns that made individual men and women appear as insubstantial plankton, though their collective presence was as vast and solid as a continent. "How's that," asked Isaac, "for minimal art? The average fascist's rage for order."

The propulsive consonants of Isaac's accent made him sound emphatic, decisive. When he spoke, he gave the impression that art meant a great deal to him and that he was determined to prove to us, and perhaps to himself, how unorthodox and revolutionary a thinker he could be. On the other hand, the hint of a smile never left his face. It wouldn't have surprised me if he'd stopped mid-sentence to tell us that, as the painter Jasper Johns once said, "Art is just a little bit of nothing," and shouldn't we just abandon the pretense, here and now, that all this crap mattered?

The second Isaac mentioned minimalism, the visual connection between thousands of men marching in precise rectangular formations and minimalist sculpture became hard to ignore. I thought of Carl Andre's unprepossessing arrangements of mass-produced bricks and pre-cut metal plates. Laid flat on the floor, these "sculptures" challenged the very idea that sculpture took up three-dimensional space rather than simply defining the parameters of a certain area in the same way that a wheat field or a parking lot defines the parcel of land it sits on. Andre's "floor pieces" were composed of nearly identical,

standardized parts, like a mass of individuals who conform to a single belief. Seen from above—from the height of a viewer's downward gaze—they echo the omniscient vantage point from which Riefenstahl shot the Nazi rally.

Art journals frequently used the phrase "mathematical purity" to describe the minimalist's reductive approach to art-making, but now, as Isaac had intended, it became impossible to conceive of any object being even remotely "pure"—a word that, in the context of this film, connoted the racial purge of eugenics and carried the taint of annihilation.

"Whoa!" said Kara from somewhere in the dark. "My mind is, like..."

"...like nothing else in nature," someone said.

"Prick," hissed Kara.

I'd have shot her a consoling glance had I been able to see her in the dark.

Isaac ignored the little outburst, avid to make his point. He was the kind of talker who seems to have predicted his powerful impact well in advance while also being genuinely startled by his own oratory force. He reminded me of the aspiring poets who moved themselves to tears during their own readings, or

the dance students who concluded a strenuous step with a look of plain amazement on their faces. Isaac's connection between the Third Reich and minimal art may have come to him by way of marijuana—he, like Kara, was the reverent type of stoner who smoked *cannabis sativa* rather than mere pedestrian *pot*—though this isn't to suggest that the link he arrived at was in any way farfetched. Isaac's remarks were, for me, a revelation, and I'm pretty sure *I* wasn't high that day. Silence may have been the collective reaction of a typical class but the longer you were enrolled, the easier it became to distinguish the silence of students afraid to say something ignorant and the silence that filled a room when what we thought we knew was held in suspension, an assumption subject to change. Is there any sweeter prerogative than changing one's mind? Postmodern before his time, Isaac "problematized" what the minimalists wished to simplify. He muddied the theoretical waters.

. . .

After the earthquake, the bottom dropped out of the real-estate market in and around the Sylmar epicenter, radiating economic shockwaves like a seismic map of the quake itself. Four-bedroom, two-bath houses were "going for a song," as Susan Starbird put it one day in the cafeteria, waving the five-page *Sylmar Sun* at me and Jean and Carson. Places that hadn't been outright flattened or turned into an uninhabitable shambles were advertised for rent *as-is*. Desperate landlords dependent on income property, as well as homeowners too traumatized to return to the area, were in no position to hold out for top dollar. Insisting on long leases was unthinkable, given that people would be paying to live in places with

crooked foundations or ruptured pipes. For renters and land-lords alike, it was month-to-month or nothing.

Starbird slapped the "For Rent" section onto the table and the four of us huddled around the listings. Starting that very second, we set about looking for a house to share, arriving at an impromptu agreement we felt no need to discuss or define. The possibility of cheap square footage trumped any qualms we may have had about living together as a group, or as two newish couples, or a quartet of the soon-to-maybe-be-famous. However we parsed ourselves, we were ready to become citizens of the non-student world, pro-fessionals who were responsible for what the market-driven artists of today have little trouble calling "product"—a word that would have sounded treasonous to the armchair Marxists we were back then, though our almost ruthless need to succeed as artistic trail-blazers remained acceptable insofar as it was allied with the value of *ideas* rather than the value of hard, cold cash.

Most of us who would have told you that currency carried the curse of church and state wanted lots of money anyway. Andy Warhol touched upon this personal and political ambiv-alence with a painting he made after one of his friends (one of many whose ideas he routinely strip-mined for subject matter) suggested that he paint what he truly loved. *One Hundred Dollar Bills* (1965) is the result, the work of either a venal genius or a lousy amateur forger.

Gathered around the "For Rent" section, our heads nearly touching, it must have dawned on us that, although we inhab-ited one of the most progressive college dormitories in the country, we were always reminded that we lived there because, if we weren't exactly embryonic, we weren't yet fully formed. Who else lived there with us but more of our striving kind?

The only way to stand out, it seemed, was to break off on our own. If we'd thought about this for more than a second, we would have realized that living with three other people who proudly cultivated their eccentricity would be just like living in the dormitory, except on a smaller scale.

The four of us ended up renting the first house we looked at. It was cheap and not too awful. And if we took it and didn't have to look any further, we could all get back to making art.

Our street was desolate in the way of many wide streets in the San Fernando Valley; neighbors faced each other across the four-lane asphalt divide of Winnetka Avenue, peering toward houses on the other side as if from across a canyon. A handful of home-owners in the area were able to afford a high water bill during the dry season, allowing moist emerald lawns to flourish here and there, but most other properties, ours included, were parchment illustrations of drought. Santa Ana winds carried grit from the eroding slopes of the Tehachapi Mountains, and the steady scouring left every surface pale, abraded, except for the 7-Eleven sign on the corner, its newly minted red and green plastic as conspicuous as Christmas. On our first day at the house, Carson and I chased a couple of tumbleweeds that bounced through our yard on their brittle, articulated branches. Whenever the wind shifted, their sudden turns seemed willfully evasive.

The four of us couldn't have picked a more traditional house to rebel in. Yes, the clapboard siding had warped in the heat. Yes, several windows had cracked in the quake, but it was "Homey enough for most folks," as the rental agent claimed, "flaws and all." She said the windows weren't so badly cracked that rain could seep through or heat escape. She said she might even call it "crazing." The damage, she said, was cosmetic. Thin Colonial

Andy Warhol's "Front and Back of Dollar Bills" (1962).

columns rose on either side of a small front porch whose paint was peeling. The straw doormat had been nearly pulverized to dust by the scuff of footsteps coming and going, its *welcome*

long ago worn away. All this set the stage for the particular odor one smelled immediately upon entering the house, a complex cloud of old cooking grease, unbathed dog, rusty exhalations from the drains in the house's bathroom and kitchen, and a pall of soot from a fireplace whose chimney, like hundreds of others in Southern California, had been damaged by the quake. It smelled, in short, like family life abandoned.

Carson chose to live in the long-ago remodeled garage, its four walls paneled in knotty pine. Not only was it next to Starbird's room, but he thought the knots and ripples in the wood might inspire him to draw. He'd just read about pareidolia, a phenomenon defined by Starbird as, "That thing were people see the Virgin Mary on a flour tortilla, or a cloud with the face of a dead president." The rumpus room also had a separate entrance, so Carson could return from his night shift at a local furniture warehouse without disturbing the rest of us—assuming we'd be asleep before dawn.

When I look back on that house, I see it from the vantage point of an aging man who recalls his days in college and, instead of feeling the warmth of nostalgia, feels something colder and more remote; It's as if I've lifted the roof away and can see the house's interior. It is night. The house is dimly lit except for desk lamps blazing in all four bedrooms. Each of the students is sitting alone, braced in concentration. If you asked them what they were doing, they'd glance up from their task and look at you blankly. They were wondering what they were doing themselves. They were either inspired or going nuts. Does what they do take any talent, or is it an automatic response like blinking and breathing? They are chronic self-doubters. And also blindly confident. They sketch and paste and take copious notes. Although each of

them expects to live forever, or almost expects it, they know they will die, or they nearly know it, and there's so much yet to make and do. Carson's head is bent over his sketch pad, the lines of his Rapidograph spiraling outward like knots in wood. Starbird pulls open the drawer of a metal filing cabinet and adds a lost-pet flyer to her already sizable collection. Hundreds of pets who fled in the quake have yet to be found. Local telephone poles and supermarket bulletin boards are thick with pictures of the missing animals at their most photogenic, a menagerie that includes parakeets, hamsters, turtles, rabbits, and pot-bellied pigs. Starbird flips through her alphabetized files, scraps she keeps for a purpose that, like my father's trove of screws and bolts, might become clear to her later. From somewhere in the vicinity of her portable stereo comes marching music with the volume turned down so low that its tubas and trumpets are a faintly brassy ambience, the music's forward momentum no more than an idle wish. Jean is reading while tossing a pair of balled socks into the air and catching them in her free hand. Bernard is thinking of the harp player's bearded boyfriend, but he also is thinking of Jean sprawled on the bed in the next room and wearing nothing but an oversized T-shirt and panties. Jean is thinking of Jean-Paul Sartre. She turns her paperback over to look at his photograph on the back cover. In it, Sartre's lazy eye gazes far away while his other is fixed intently on the camera. Jean laughs at the idea that a divided nature could show so overtly on someone's face; Sartre makes the existentialists seem like a darkly funny bunch.

Porch lights are going out across the Valley. June bugs have ceased beating themselves against window screens. The students are getting tired despite what they jokingly call their "daily craters of coffee." They shift position, but only so it's more

comfortable to keep going, to stay awake. They barely stop to take a sip of water or smoke a cigarette. No one has noticed that the roof is gone, the moonlight intruding. No one has sensed the night bearing down. No one has felt the air begin to stir, to move through the rooms. The four of them are present but elsewhere. *Listen*, says the wind, but they can not hear it.

11. Message Units

More than once I heard a student repeat a story that may strike some listeners as art-school apocrypha, though it sounded perfectly plausible to me then and still does to this day. At the 1969 Venice Biennale, a young man reportedly spent all morning strolling through the exhibits along the Giardini, pondering works of art with perhaps too much concentration troubling his young face. He left each pavilion with one more pamphlet or catalogue stuffed into his shoulder bag. By late afternoon, several visitors saw the boy dashing frantically from building to building, talking to himself, his hair disheveled, his shoulder bag bulging. The bulging shoulder bag may have been a detail added to the story by one of the students who first told it to me, and which I've now conflated with the actual event. In any case, the boy wasn't seen again until early evening, when he was spotted on a small stone bridge screaming, "There's too much art! There's too much art!" while projectile vomiting into the canal below. As the story had it, one bystander turned to his friend and said, "My God! The poor boy must be high on LSD. Should we call the paramedics?" The friend shook his head and said, "He may be as high as a kite, but his condition isn't simply chemical; it's cultural

too. He's purging himself of cultural glut. It's a healthy response to the Biennale. I know how he feels. I've seen so much art today my eyes hurt. My brain is bloated. I'm at the point where I want to say, *More art? I'll pass, thank you. I've seen enough.* I mean, what exactly are we doing here?" The friends were middle-aged artists. "We're gorging on art until we're fat as ticks. We're filling ourselves with food we need to stay alive but can barely taste anymore. Year after year we fly all this way to see the latest trends and hope that having seen them sharpens the work we make in our studios so we can sell enough of the stuff to afford a trip back here to see the trends again. The ad infinitum in wearing me down." A ribbon of vomit arced through the air and landed in the water with a splash. After a moment the boy straightened up. He took a breath and wiped his mouth. At last he seemed calmer. He crossed the bridge and went on his way. "See," said the friend.

The boy on the bridge was the canary in the coal mine, so to speak, a harbinger of some momentous artistic shift. The story was meant to show, in a visceral way, how the historical moment was right for conceptualism. It implied that conceptual art was inevitable in an overcrowded world, and that those of us campaigning for art's dematerialization were inevitable too. The story was always told by a member of the post-studio program. Telling it congratulated the conceptualists among the listeners and shamed the painters and sculptors, most of whom had developed a pretty thick skin when it came to criticism by conceptualists. Smugness was rampant in both camps. That the painters and sculptors couldn't hear the clarion call of the story only confirmed our suspicion that they were stuck in a dead aesthetic, still mired in systems of patronage and guild. For their part, the painters and sculptors believed that, since many of us in the post-studio program couldn't paint or draw

or even touch-type to save our lives, our view of art's future was laughable, alarmist. It's true that most of us who hoped to free art from the prison of matter failed to realize that the story could not only be interpreted as the death knell of the art object, but of the avant-garde itself, which is to say that the boy wasn't sickened by the sum quantity of objects cluttering up art history, but by art's ceaseless, up-to-the-minute incarnations, conceptual art included.

. . .

In one of his seminars, Kaprow matter-of-factly predicted that many conceptual artists among the student body would probably migrate into fields that were extensions of their current medium; video artists would gravitate toward television and film, performance artists would move into acting or dancing or stand-up comedy. Because so much of the work I was doing for his class involved words, Kaprow suspected I might become a writer. His hunch would prove to be right, but at the time, it resonated about as loudly as a paper bell. I took no offense at Kaprow's remark, had no sense that his prediction deemed me, or anyone else in our class, unfit for the arts. His detachment was a gift; he offered us his guidance, and also our autonomy.

Chief among clichés of inspiration is the one in which the instructor tells a discouraged student—dancer, actor, painter, what-have-you—to persevere past stumbling blocks and, as the trope goes, "Never give up your dream." Kaprow expressed faith in us by placing no importance whatsoever on whether we succeeded in the art world. Weren't we in school to make interesting mistakes? If we ended up leaving art behind, Kaprow figured we'd find something else to do with

ourselves. Maybe something better. Defectors were fine. Go ahead and defect.

Of course, I wasn't inside Kaprow's head and can't vouch for all the nuanced thought that went into his prediction, but I tended to scrutinize my teachers closely enough to see food in their teeth and hairs in their noses (a memory that makes me wince whenever I stand in front of a class), and I would have been quick to spot so much as a glimmer of disappointment on his face. I watched for signs and portents then, for any message coming into focus like the words my brother Ron had painted on Bob's tie. In class and out, I looked intently and listened hard. Every student did. Our lives in those days were all anticipation. We were always asking without seeming to ask: *What will become of us?*

In any case, Kaprow generally approved of my pieces such as *Word Zones*, in which I'd used masking tape to divide the classroom floor into a grid of nine squares, three by three. I then chose nine words at random from the dictionary, one word for each "zone." Only that word could be spoken within its zone, and I asked the participants to converse with each other by leaping through the grid in order to construct brief sentences. "We're going to activate the space," is how I put it in the little preamble Kaprow required of us before we presented our work. "The piece will show how limitations can lead to freedom," and so forth and so on.

On the count of three, we all began to leap about the room like jackrabbits, directing a single word at whomever we happened to land beside before launching ourselves toward another word. Kaprow possessed the springy stamina of a professional trampolinist. Sweat stains darkened the armpits of his shirt. Two students, in their zeal to make meaning, collided midair, though no

one was hurt. Only Kara broke rank; she loitered in a single zone the whole time, mumbling the word "furniture" over and over.

Eventually, all that leaping and speaking left people out of breath. The piece required a tremendous effort, considering that we communicated next to nothing. I'd placed a large chart on the wall showing which word belonged to which zone, and people had to pause with some frequency and consult the chart in order to figure out what word they were currently standing in, or what word they wanted to jump to next. This made syntactical delays even longer. My piece created a kind of collective aphasia.

In the privacy of the Sylmar house I read and reread Elizabeth Bishop, whose words were so apt as to seem inevitable, every line modulated and allusive to her exact specifications. While reading *Geography III*, I convinced myself that if even one word in a poem was changed or reordered, it wouldn't be another draft of the same poem but a different poem altogether. I found myself riveted by the confessional poetry of Robert Lowell and Sylvia Plath, poems that made a blunt, unembarrassed music from personal disclosure—*Tamed by Miltown, we lie on Mother's bed; / The rising sun in war paint dyes us red* and *What a thrill— / My thumb instead of an onion. / The top quite gone / Except for a sort of a hinge / Of skin.*

Why, then, did I also rejoice in stripping words of sense, of compromising their already debatable meanings, of hastening their decay? In art, I communicated by obscuring words. I "deployed" language, as we said in those days, but the words I deployed were at cross-purposes, masking the very thoughts and sensations that language attempted to name. This wasn't simply the influence of concrete poets like Emmett Williams

or Tristan Tzara, as much as I'd been affected by their work. I wasn't an anti-artist at heart; I felt I didn't know art well enough to formally oppose it.

My double-edged relationship to language had found its initial expression in Vito Acconci's class the day I'd burned invisible secrets—*burned, invisible, secret*: all synonyms for silence—an impulse that arose from a lifetime of both calculated and unconscious obfuscation. I'd become adept at raising a smokescreen that would distract everyone—or so I thought—from the fact that I was queer. Ever since I could talk, my life had been shaped by the necessity of concealment, a vigilance that dogged me to college.

From the perspective of a culture that sanctions gay marriage, it may be difficult to understand how self-hatred and shame could haunt a man for so long. It's difficult even for me to understand. All my courage and daring were reserved for my love of the avant-garde, and in most other respects I remained cautious, compliant—is there an antonym for *avant-garde*? At least that's how I perceived myself in the presence of oth-

Univac Computer, 1970

ers, since it was in the presence of others that I became most acutely aware of how I'd learned to rein myself in, a gay boy constraining his hips and wrists, damping the higher registers of his laughter, flattening his enthusiasms until he's sure its safe to enthuse without risking the epithet *faggot*. I learned to monitor every thought before speaking it aloud, to assess shades of meaning as fast as the *Univac* computer. I intercepted incriminating truths before they saw the light of day.

During the class critique that followed *Word Zones*, Kaprow observed that my piece hadn't come to a conclusion so much as it petered out. I argued that its anticlimax was a legitimate aspect of the piece's *indeterminacy*—a term used by Kaprow's early mentor, the composer John Cage.

My quick rebuttal was common among the student body; it represented a skill central to the pedagogy of the era: Second guess every question that might be asked, no matter how challenging or out of left field. Once a question is decisively addressed, it becomes part of that dense intellectual nimbus we conceptualists called "the thinking around a work of art." *Explain yourselves!* the decade seemed to say. And so we cultivated a set of rationales to bolster every aspect of our practice, the articulation of which didn't necessarily make the work different or better, but might grant us an advantage in that blood sport known as discourse.

After a long (but not uncharacteristically long) pause in the crit, a student told me that she thought my piece could have been better executed. The words could have been taped onto the floor instead of being posted on the wall so people could see them right away.

"Not bad," I conceded.

"Why *random* words?" asked someone else. I had no answer.

Here is where beard-stroking came in handy as a delay tactic. Luckily, someone came to my rescue by suggesting I pick the nine words out of a phone book instead of a dictionary.

"They'd still be random," said Kaprow.

Another student raised his hand, a quaint gesture in context of the class. He said, "I'd kind of like to lead off from the comment that was just made about the phone book?"

"Yes?" said Kaprow.

The student turned to face me. "Well," he continued, "if you chose words from the phone book, they'd be proper nouns instead of words, and that would kind of tweak the piece in a more people-oriented direction."

"Proper nouns *are* words," I said defensively.

"I'm losing the thread," said Kaprow.

People unanimously agreed that the piece should "require less exertion from the participants," which was a tactful way of saying that I might want to more gently engage a stranger instead of forcing him to hop around till he drops from exhaustion. I could see their point. Many of us spoke of participants in the same way a writer might speak of his or her readership. Using the term was an act of faith; we'd gotten it in our heads that our enthusiasm for the avant-garde was infectious, and so it followed that the world was teeming with people who wanted nothing more than to take part in performance pieces. They were like Broadway understudies waiting for their big break, or baseball players sitting on the sidelines until the next inning. These mythical participants lived for direct, hands-on involvement in art, and they were willing to make great personal sacrifices in order to attain it. They wanted our pieces to succeed (we wanted to believe) every bit as much as we did.

We weren't entirely misguided in our optimistic outlook; New York's Living Theatre, for example, was lauded for their signature production of *Paradise Now*, in which naked performers implored the audience to abduct them from the stage and help them form anarchist cells that would work to overthrow the government. And of course there was Yoko, the giver-of-scissors. Audience participation had become a badge of theatrical radicalism. That formerly passive, ragtag group known as *the audience* were now a mob ready to storm the fourth wall, and we were there to lend them a hand.

Not until I actually took part in one of Kaprow's happenings did I begin to see the role of participant from a different perspective. Toward the end of the term, he asked us if, that night after class, we'd be willing to try out his piece-in-progress. He said he'd been working on it for so long he'd lost perspective. He needed feedback. If students had to subject their work to *his* critiques, he thought it only fair that he should have to do the same.

We'd been enlisted by a charismatic artist and we jumped at the chance to help him out. We'd also been given an opportunity to see ourselves as Kaprow's peers; no matter how egalitarian his teaching, he still commanded a shy deference from most students. Kaprow, we knew, would carefully weigh our comments and consider any suggestion that might make his piece better. One of his inadvertent lessons: art wins out over ego.

Kaprow handed out Xeroxed copies of his score and asked us to grab a partner as if we were at a square dance. One pair of buddies were quick to buddy up, but the rest of us deliberated like people who'd been asked to choose a spouse from a group of improbable candidates. "Try not to think about it too hard,"

said Kaprow. "No decision is right or wrong. The work should be permeable to a wide array of outcomes."

"People," said Isaac, "don't be proto-fascists." I happened at that moment to be passing close to Isaac and, in what John Cage would call "a chance operation," he reached out his arm, slapped me on the back, and proclaimed me his teammate.

We'd both driven our cars to school and, on the way to the parking lot, Issac suggested we unwind by sharing a spliff in my car before we left campus. I was too intimidated by Issac to unwind in his company, but he probably scored fantastic dope. "Cool," I said.

With the windows rolled down, a cross breeze shot through the car and repeatedly cleared it of rich, mossy-smelling smoke. We stopped talking for a while, as if to conserve our energy for the happening ahead. The parking lot overlooked a sloping embankment that led to the dormitories in the distance. The campus pool buoyed tiny nude students, their voices barely rising above the drone of the freeway.

After a couple of tokes, Issac proposed that we synchronize our watches, and when I chuckled at his military precision, his faint smile vanished and he looked at me puzzled, maybe even irked. The problem with some strains of pot is that they amplify experience to such an extent that every detail, large and small, cries out for attention with equal force, making it difficult, perceptually speaking, to separate the wheat from the chaff.

Synchronizing our watches gave a gravitas to the happening that made it seem more intimidating than I had first believed. I began to feel like the Cowardly Participant, and nothing had even happened yet. In contrast, Isaac seemed to possess some secret knowledge just beyond my grasp, some comprehensive understanding that, like unified field theory, offered an all-

purpose answer to the riddle of art. Sitting beside him in the close quarters of the car, I couldn't help but notice that his perpetually arched eyebrows gave him the wily air of the Trickster who fools you into a new awareness. Plus, once I was buzzed, his dreadlocks appeared hydra-like in their profusion, and his eyes, shining like polished gemstones, began to look independent from his head.

"Shit," I said. "I'm really baked."

"You're not baked," he said.

"I know when I'm baked," I said, "and this is one."

"One what?"

"Of the times I am."

I must have taken the freeway to Sylmar because the rapidity with which I found myself pulling into our driveway reminded me of how crew members were tele-transported in episodes of *Star Trek*. No one else was home, a relief since I wouldn't have to explain what I was doing to three inquisitive housemates.

As per Kaprow's instructions, I set about unscrewing lightbulbs. Before we'd left class, he'd given each of us a small bag of five disk-shaped flasher circuits. About the size of a quarter, a flasher circuit interrupts the electrical current when a light is switched on, causing the lightbulb to blink at one-second intervals. The flashers were to be screwed into five light sockets of our choice. A cursory glance at the instructions told me that, once the piece began after dusk, Isaac and I were to take turns telephoning each other and speaking brief lines while flicking the lights on in a predetermined sequence.

Once I'd prepared the light sockets—Kaprow mentioned the parallel to Cage's "prepared piano," a method of skewing the notes by placing small objects such as bolts and pencils on the stringboard—all I had to do was wait until dark.

Waiting wasn't as easy as one might think. It wasn't even "waiting" in the sense of sitting idly by while the future replaces the present and the present slips into the past. Time turned boundless, difficult to gauge. No sooner would I glance at my watch to see how much time had passed than I'd forget what time it had been when I'd last checked. Essentially, it was always the same time. Forever o'clock. My high seemed to be growing more intense instead of tapering off. Could the dope we'd smoked have some kind of time-release effect? How could it, though, if there *was* no time? This ontological knot grew tighter the more I tried to figure it out. After a while, I stopped trying. I gave myself over to the strange vacancy pervading the house.

Wind carried away the sound of traffic on Winnetka Avenue. Late-afternoon sun elongated the shadows of rocks and scrub brush in our yard, making the view from my bedroom more lunar than usual. I'd recently read about a phenomenon W. H. Auden called "a Vision of Dame Kind," in which the world appears exactly as it is, but without people or animals, as in a dream absent of all creatures except the dreamer. As I sat alone in a suburban house abandoned by its former owners, the notion of a world emptied of objects suddenly brought me up short, chilled me with its finality. Everything, all of us, over and done. The stars blinking off in their sockets.

I recalled a line of a poem by Richard Wilbur: "A world without objects is a sensible emptiness." I'd liked that line when I first read it, a nod to absolute austerity that brought to mind the all-white paintings by Kazimir Malevich and Robert Rauschenberg. But at that moment, as I waited for night to fall and the happening to happen, emptiness seemed senseless, a condition I might never grasp, might never be at peace with.

Push-button phone on the cover of the *Information* art catalogue,
MoMA's first major show of conceptual art in 1970

My memory of Auden's and Wilbur's words surprised me
because I hadn't set out to memorize those or any other poems.
I'd never been good at memorization. I wasn't a student who
learned by rote. And now whole poems had etched themselves
inside me because I'd turned to poetry so often in my need to
find the fleeting world stilled upon the page, fixed into a form
that remained alive yet restless. Art, I thought, doesn't get much
more dematerialized than poetry. If Vito Acconci had made a
transition from poetry to conceptual art, couldn't this transi-
tion occur in reverse?

The ringing phone might have been startling in and of itself,
but I had been so deeply submerged in my hypothetical isola-
tion, so busy inhabiting Auden's desolate vision, that the sound
jolted me down to my bones. The phones of the early 1970s may
have been molded from sheets of colorful, lightweight plastic,

but they were as different from today's mobile phones as a red-wood is from a twig. Attached to the wall by a tightly coiled cord, they might as well have drawn electricity from across the entire L.A. grid, concentrating a city's worth of wattage into a single, explosive ring. Those phones could rouse the dead.

It couldn't have been Isaac calling; it was still light outside, and the instructions explicitly stated that the happening was supposed to start after dark. I searched for the score to double check. I could have sworn I'd been holding it only a second ago. The phone kept ringing, as hard to ignore as a wailing baby.

I snatched up the receiver. Before I could speak, Isaac said, "I've turned on the first blinking lightbulb."

"What are you doing?"

"A happening," said Isaac. I stretched the phone cord as far as it would go, holding the receiver to my ear while I rummaged through the piles of paper and stacks of poetry books on my desk.

"You answered wrong," said Isaac. I could hear him smiling over the phone.

Was *You answered wrong* a line from the score, or was Isaac pissed off? Before I could gather my thoughts, he hung up, the dial tone a buzzing rebuke. Damn happening, I blasphemed. I looked for the score beneath my pillows, got down on my hands and knees and groped beneath the bed. A frayed shoelace. The cap of a ballpoint missing its pen. The phone began to ring again and—ridiculously, humiliatingly—this startled me just as much as it had the first time. I answered by pleading, "Give me a minute ..."

"I gave you a minute."

"That wasn't a minute."

He laughed. "What was it then?"

"I'll have to call you back," I said.

"Read the instructions. I call *you* first. I'm called *the first caller*."

"We're supposed to start after dark. Besides, I can't find the instructions."

"Fuck the instructions. We have leeway, man. We're artists."

"Are you being sarcastic?"

A pause for who could tell how long. The walls of the room reddened in the sunset. "I don't *think* I am," said Isaac. He sounded genuinely taken aback. "I'm ... I'm really ... "

"Blitzed?"

"Blitzkrieged," he embellished.

Without any coaxing, Isaac agreed to call again after nightfall when we'd start again from scratch.

. . .

After finding the score folded in the back pocket of my jeans, I lay on my bed and studied it intently, determined to say something worthwhile about the happening to Kaprow. He'd advised us not to memorize the lines as one would a script; he objected to the idea his scores bore a correspondence to conventional plays and screenplays. They existed in their own right, a set of plans that were both carefully organized and impishly provisional. Nor was the list of actions we were to perform meant to be equated with *stage directions*, a term that sounded almost aggressive when compared to the relative zephyr of *score*. One glance at the Xerox suggested that, with all its flicked light switches, *Message Units* was an homage to the On/Off of George Brecht's *Two Vehicle Events*, only with lightbulbs instead of a vehicle. I don't mean to sound glib. I honestly think there's enough of a differ-

ence between an electrical current and a mechanical engine to make the two pieces as distinct from each other as they are alike. Kaprow's score was a nearly Baroque elaboration on Brecht's microperformance. It was two pages long and, trust me, two pages seemed like a lot in those days, a tome when compared to two little words and a backslash. The score was peppered with boldface Ons and Offs. It was built upon the repeated statement, "I've turned on the first (or second, or third) blinking lightbulb," which in turn was always greeted with, "OK, then I'll turn mine on." I suppose you could say this was related to the structure of call and response in Gospel music, except it was a robocall.

During a recent visit to Kaprow's office, he told me that he was interested in the idea of narrating actions that are self-evident. He'd demonstrated by standing up while saying, "A man is standing up," and then he sat down while saying, "A man is sitting down."

"Right," I said, having absolutely no idea what he was getting at. Still, Kaprow could sit and stand with endearing enthusiasm, and I thought one of those romantic thoughts common to the acolyte: I want to stand and sit like him.

"The idea doesn't interest you, does it?" said Kaprow.

Had my bafflement been that easy to read? I hoped not, because I depended on the muscles of my face to outwardly contradict all my unacceptable thoughts. I hemmed and hawed and attempted to backtrack. Kaprow's art had been shaped to a large extent by his interest in Buddhism, and he'd told us in class that if we were bored by something, we should look at it for twice as long, and if we were still bored, three times as long.

I said, "It's not that it doesn't interest me . . ."

"What, then?" Kaprow enjoyed dissent, its energy and

focus, probably because he knew he could hold his own in any aesthetic argument, though he rarely argued.

"It bores me," I said.

"That's about as uninterested as it gets!"

"Do you read poetry, Allan? I do. More and more of it. And the thing I like about poetry, the thing I *love* about it, is that it talks about what *isn't* self-evident. Things I didn't know before reading the poem. Didn't even know I needed to know."

"Sounds like you're ready to write," he said.

. . .

My bedroom grew dark while I waited for Isaac to phone. In the last of the light, I went back to reading the score, my sense of duty compounded by Kaprow's good-natured reaction to my remark about being bored, which just about any other teacher would have considered an insult, with the possible exception of Emmett Williams, the most jovial concrete poet on Earth.

My commitment to the happening hit a roadblock when I realized that the number of times the telephone was supposed to ring increased with each call, until one finally waits for a total of seventy rings before answering. Seventy? Had I misread the number? When I turned on my desk lamp to get a better look, its bulb began to blink on and off. In order to unscrew the flasher, I needed a steady overhead light, but when I hit the switch, that bulb started blinking too. The hall light, the bathroom and kitchen fixtures—all booby-trapped by yours truly. Imagine sluggish stroboscopes—not flashing fast enough to cause any entertaining psychedelic effects, but also not flashing slowly enough for one's eyes to adjust to either the glare or the gloom. The dark was darker than usual, the brightness brighter. It may

not have been the kind of flashing light that causes petit-mal sei-zures, but my pupils, already dilated by THC, were getting quite a workout. The flashing wore me down.

I unscrewed the flashers, took the phone off the hook. I remembered a line by Sylvia Plath: *The black telephone's off at the root / The voices just can't worm through.* I'd figure out how to explain myself to Issac and Kaprow later. I slid a volume of Plath's from the shelf and read her in the steady light.

12. The Great Before

In 1964, six years before CalArts opened the doors of its Valen-cia campus, Walt Disney Productions went public with a film promoting Walt's vision of a "world-class" art school. I was thir-teen years old at the time, a devotee of Pop. *The CalArts Story* was first screened as a fund-raiser at the Hollywood premiere of *Mary Poppins*. Disney's decision to screen it at this particu-lar premiere couldn't have been an accident; Poppins is a magic nanny who forever improves the lives of her charges and saves their family (the Banks family, symbolically enough) from financial ruin—an appealing plot for potential donors whose sons and daughters could be future students. *The CalArts Story* depicts what might be described as abnormally normal behav-ior among the student body. The filmmakers carefully avoid any footage that might perpetuate the cliché of the artist as a tem-peramental egotist or dissolute garret dweller. Male teachers wear suits and ties to their painting workshops. Students gather in orderly groups to talk about one another's work, their ges-tures barely emphatic enough to wrinkle their ironed clothes. If

erotic tension exists between these youngsters, they have, to all appearances, successfully repressed it; their caresses are saved for lumps of wet clay, their loving strokes for primed white canvas. Life-drawing classes, a staple of art education, seem to be conspicuously missing from the institute's syllabus, though in hindsight, a strategically draped nude would have been tame compared to the soup of naked students in the dormitory pool.

In perhaps the film's most raucous scene, one class is shown constructing kinetic sculptures out of bicycle gears, brightly colored feathers, and dangling tin cans, while the film's narrator, in a trilling, upper-class British accent, assures nervous donors that things are not as eccentric as they seem. "The new may have unexpected beginnings," he explains. "Thus, in the atmosphere of a creative workshop ... inventiveness may lead to the unorthodox, even to the humorous"—cue the zany music—"but that's rather the point!"

In another scene depicting student life, an elephant uses its trunk to snatch a sketchbook from the hands of a student who, on a class trip to the zoo, had been drawing its portrait. When the elephant tries to eat it like a peanut, our narrator sighs. "One of the hard facts that every student must learn, generally in the school of experience, is how to get along with an art critic." Overall, though, the film takes its mission to heart. "In fact, the well-trained artist is a decidedly useful member of society. Standards of the highest excellence, and performance of only the most professional sort—this is the highest goal of CalArts."

Apart from training the artists of tomorrow, the prospectus was lofty in a literal sense: the original plan called for the campus to be situated on a hill across the ravine from the Hollywood Bowl. In the architect's rendering, the nearby Hollywood

Freeway bisects the landscape, low-rise office- and apartment buildings spreading out on either side. CalArts would be "An acropolis crowning the hills above Hollywood." Considering the narrator's polished diction, he sounded well-acquainted with, as he put it, all things "of enduring worth." Graduates of the institute would become the nation's cultural gatekeepers and, in turn, the school would admit the most promising applicants from across the country. "Only the finest talents will serve our temples and fulfill their purpose." By *temples,* he's not only referring to the Greco-modern buildings in the architect's rendering of the campus, but to the Dorothy Chandler Pavilion and Los Angeles County Museum of Art, then under construction.

The year after I graduated, I lived at the base of that still undeveloped hill, unaware that it had been the school's original site. My single apartment was one among a dozen in a 1920s Spanish-style building on Highland Avenue. The place was rumored to have been the guesthouse of silent-screen swashbuckler Douglas Fairbanks Jr., but the rumor, as everyone in the building knew, had been spread by the landlord to make the place more appealing to tenants who were drawn to Hollywood from far-flung parts of the country, and who tended not to rent for long.

In order to repay my father for college, I sold shoes on weeknights at the Paradise Packing Co., earning just enough money to satisfy my debt in roughly two hundred years. Paradise was a kind of boutique marketplace that also sold poppers, Lucite paperweights, and T-shirts printed with slogans like WE'RE NOT IN KANSAS ANYMORE. The store was located in the heart of West Hollywood, a neighborhood one of my coworkers, using gay slang from the 1950s, referred to as the Swish Alps. Paradise attracted a more or less intoxicated clientele who wan-

dered in from nearby bars such as the Blue Parrot, one of several tropical-themed hangouts through whose plate-glass windows drivers on Santa Monica Boulevard could see men drinking and dancing and making out with the subtlety of Huns. The fishbowl exposure of such clubs served as an antidote to the days when such goings-on were concealed from public view; this new openness to the street was something like modernist architects repudiating brick walls in favor of glass, a material more "honest" by virtue of its transparency.

I liked working in West Hollywood, though I wouldn't have chosen to live there. In those days the area was more of a village, really, than the incorporated city it's since become. The social pressure to conform was more pronounced among men who called the place home, and this pressure made me, once again, the odd man out—a position I'd cultivated all along, of course, and wasn't about to abandon now. Still, West Hollywood's nightlife was the opposite of the lonely coffee shop in Edward Hopper's painting *Nighthawks*; in this part of town, I seemed able to shed, for an evening at least, the surplus of loneliness I'd accumulated during my closeted years. Whether I was gay or not was a question I'd asked myself so long ago that I couldn't recall the reason I'd asked it, or why it had gone unanswered until now. The answer to my question was found in the bodies of other men.

My job at Paradise was to kneel before a customer, unlace his shoe, slip it off, and measure his foot. It was remarkable how many of those customers said to me, "Now that you're down there . . ." thinking no one had made that crack before. I'd note the man's tone, from lascivious to coy, and wonder if this was any indication of what the guy would be like in bed, or if it was a persona that, like a pair of shoes, he was trying on for size. Joke

or not, I took my flattery wherever I could get it. The reward for smiling at this tired one-liner was to see a flash of satisfaction lighting up a stranger's face.

My boss, only a few years older than his employees, insisted that his "boys" remain friendly but professional while in the workplace—a tough rule to follow at a shop that carried candles shaped like cocks. Mustachioed, punctual, "groomed within an inch of his life" as one coworker put it, Marc warned us that if he caught any of us fooling around with a customer, we'd get "canned," or "sacked," or "given the boot"—threats so suggestive they might as well have been propositions. None of us could have known that his coughing fits were an early sign of AIDS.

Let's call the time I'm talking about "The Great Before." Before we knew a virus lay in wait. Before half the men I knew were dead, whittled to bone, covered with sarcomas, their tongues white with thrush. This was before sex and death became, if not interchangeable, then mentioned in the same uneasy breath. Before Hospice and Tenofovir. AIDS Rides and Nevirapine. Contaminated blood banks and Diflucan. ACT UP and Bactrim. Had I understood the comparative innocence of those days, had I suspected the pummeling grief to come, the sky I saw while driving home from work would have terrified me with its dark, ubiquitous indifference.

I'd usually return home by midnight. Traffic had thinned along Highland. The Hollywood Freeway, elevated on concrete trestles, wound its way south. From the single window at the far end of my apartment, I could see across the hill to the house in which Jean rented a basement apartment. In the intervening years she'd become a lesbian feminist involved in the Woman's Building in downtown Los Angeles, an offshoot of the Femi-

nist Studio Art Program at CalArts. Jean and I remained fast friends, siblings of a sort. That some of her friends and colleagues were lesbian separatists didn't diminish her loyalty and her patience with either them or me. Once, I visited her apartment and her guest, a separatist I'd never met, turned her chair and sat with her back to me when I walked through the door.

"What's up?" I asked Jean.

"Carla refuses to interact with men. She wrote an essay about it called 'The Curdled Worm.'"

Jean and I grinned, but Carla couldn't see us.

I thought: If only I was hung enough to warrant such contempt!

Jean designed posters and books and curated feminist art exhibits, and she wrote poems as well. We'd give each other our drafts to read when we felt brave enough. Both of us wrote constantly but tentatively, fearful that no poem would ever exceed our expectations or see publication. When it came to words, the two of us prepared for a long apprenticeship.

My mother had died of heart failure shortly after I'd graduated, and her death spurred my father to see even more women than he had when she was alive. In our pursuit of sex, in our wonder at its availability, my father and I were driven by the compensatory energy of a second adolescence, believing we could make up for lost time. Each encounter made us incredulous with pleasure, as if we were inventing sex rather than having it, and despite the fact that we'd had sex before. Sometimes only the day before.

How easily and often I announced to people in those days that I was gay. I needed to substantiate the change aloud. Like Kara repeating "furniture" over and over, I needed to speak

aloud until I became familiar to myself and others, at one with this definition, turning the secret inside-out.

The last work of art I made in art school was called *Speech Regulator*. It led to the only public recognition I'd receive as an avant-garde artist. Allan Kaprow mentioned the piece in an article he'd written for *Art in America*, and the magazine reproduced a photograph of it, along with photos of dozens of works by other artists, both well- and lesser-known. The article was titled "The Education of the Un-Artist," and told how "large numbers of experimenters are bypassing the defined linguistic modes of poetry, painting, music etc., and are going directly to sources outside their profession." In my case, the profession was dentistry. Kaprow accurately likened my piece to a dentist's lip retractor; *Speech Regulator* was a metal device that hung from the user's lower jaw. Small one-ounce weights could be stacked on a post that hung below one's chin, making speech progressively more difficult with each added weight, until the only language possible was the garbled effort to shape a word, to complete a sentence, to say what couldn't be said.

c.f. Bernard Cooper's speech regulator

Blank Canvas

used to love the joke where you point to a blank sheet of paper and say it's a picture of a polar bear in a snowstorm. I repeated that gag again and again, sometimes trying variations that had the bear stacking cubes of sugar or drinking a glass of milk. The uniform whiteness of an empty page could conceal any number of things—eggs, toothpaste, kitchen sinks—and it became a challenge to see how much I could cram into absence.

A cloud served on a white china plate.

A lamb dancing the tango with a snowman.

I'd heard stories of tormented artists, their smocks splattered, eyes wild, who had to face the dreaded "blank canvas." I understood how emptiness upset them every time I told my joke. How dare anything just lay there and be nothing. Nothingness was an affront to stuff. Wasn't it the artist's duty to tease from the void something of substance, a vase or a clown or a snowcapped mountain?

In junior high, the margins of my notebook were dark with

doodles. I'd felt the urge to cover every inch of white paper with shaded boxes and cones and spheres, checkerboards, labyrinths, and tightly wound spirals. When I ran out of things to draw, I painted the paper with solid blue ink, the strokes of my ballpoint pen frictionless and hypnotic. Instead of solving algebraic equations or completing a vocabulary quiz, several of my classmates were also busy drawing in their binders: sports cars, fashion models, staring eyes. We were like a collective embellishment machine that cranked out hundreds of images per hour, warding off boredom, leaving our marks, imprinting our wishes on bits of blank space.

On the other hand, embellishment could be oppressive, as I learned every time my mother sent me on an errand to our next-door neighbor's. In the home of Maurice and Shirley Minsky, Persian rugs covered the dark wood floors and wallpapered rooms bloomed with flowers. The Minskys dressed in clashing stripes and checks. When they leaned close and offered me candy from a crystal dish, it was hard to look at the two of them without squinting. The odors of musty curtains, lilac airfreshener, and cabbagey foreign cooking would mingle with the candy's sweetness, the ornament of their clothes and rooms invading every corner of my senses, and I tasted and smelled the patterns and the colors, and the glut of sensation made me claustrophobic.

One night, after visiting the Minskys, I lay in bed and tried to become completely blank. I closed my eyes, let out a breath, and made my arms and legs go limp. The experiment scared me half to death; what if I stayed that way forever? I needn't have worried; within seconds I was sitting bolt-upright and gulping air. Sight dazzled my opened eyes. My thoughts beat the air like a flock of startled birds.

Given the persistence of sensation, I began to wonder if nothingness was possible. Lowered into the watery depths of a sensory-deprivation tank, scientists began to hallucinate, flail their arms, and babble to themselves after a few hours without stimulus. Blind and deaf and weightless in their wet suits, they imagined feasting on delicious meals while conversing with witty visitors or performing endless, backbreaking tasks. Deprivation was a busy place, or so they reported afterward.

Even at our local movie theater, when the music faded and the story was over and *The End*—so big and definitive!—rose on the screen, the darkness and hush were temporary. The aisles soon flooded with talking people, and ushers flung open the lobby doors to the rush and glare of a summer afternoon.

Plenty of people believe that not even death is absolute or empty, but chock-full of fleshy cherubim who dwell in a gauzy metropolis of clouds. White robes, golden harps, a halo encircling every head. As a boy, I'd seen enough oil paintings and religious pamphlets to suspect that the hereafter was as loud and crowded as Union Station, a place where one is reunited with deceased friends and relatives, former classmates and loyal pets; they gather around, unlost after all, winged and eager to greet you.

I don't want to make too much of it, but as far as I'm concerned, the universe should flash a neon sign that says SORRY, NO VACANCY. Because there is none whatsoever. Or so I'd like to believe these days, especially given all that's vanishing, all that's gone—lovely places, dear friends, a slew of hopes and assurances, one's susceptible vessel of flesh. And yet there's no room for a speck of regret.

Uses of the Ghoulish

Although it was on the third floor of a high-rise, the gallery, with its windowless rooms and raw concrete floors, had a chilly subterranean feel. It was as if I'd ventured into the crypt of a gallerist who meant to protect his artists from sunlight. It was 1999, and this was the first stop for my new job as the art critic for a monthly magazine, a reentry into the world of contemporary art after a long apprenticeship in the craft of writing. I'd last come here two decades earlier, in the gallery-hopping days when I was making conceptual art. Back then, the gallery hadn't yielded this art-after-death aura, which had everything to do with the two installations on display, work so lugubrious it cast a pall over . . . well, over everything, it seemed; dark clouds gathered above the city, and the gloomy weather might as well have emanated from the art.

In the first room, China Adams showed a piece about realizing her desire to become a vampire. On the butcher/baker/

candlestick-maker scale of ambition, I suppose this might strike some people as a fairly interesting thing to want to be. Her goal was made clear in a statement that accompanied huge, glossy color photographs of eight people whose blood the artist drank, one glassful per week, for a period of three months. The statement went on to assure the viewer that the blood had been extracted under hygienic, medically supervised circumstances. I couldn't help wanting to be a fly on the wall of the office when she first explained this project to the doctor who agreed to the procedure. There likely *would* be flies on such a doctor's wall. Ms. Adams's victims were uniformly photogenic, the color photographs cropped like actors' headshots. Beside each photograph, on a little white shelf, stood a small, blood-encrusted drinking glass.

This piece gave me the creeps, but not for the reasons you might think. It was creepy because it was so utterly ineffectual. If it was supposed to conjure thoughts about mortality, or the body's precious fluids, it did so only because dried blood will do that all by itself. If it was meant to stir thoughts about life as an endless search for vitality, or about blood drives at the Red Cross, it didn't; I came up with those associations just now. It doesn't take much to make me squeamish, but when I walked through this installation the art barely registered because (1) I've seen countless headshots of actors hanging on the walls of restaurants and dry cleaners all over Hollywood, and (2) the photos were reminiscent of the ubiquitous Facebook profile picture, where all of us are putting our best face forward, so to speak, as if perpetually at the ready should the paparazzi come bursting through our doors.

In an attempt to circumvent the viewer's incredulity, Adams

also displayed alongside each photo a certificate, signed and stamped by a notary public, explaining that she had "begun proceedings to obtain official vampire status." One wonders, from what city department might such status be obtained? Another mystery is how the notary granted the document on the basis that Adams had offered "satisfactory evidence," somehow proving she'd guzzled all that blood. Call me a skeptic, but the brown film around the inside of the drinking glasses did little to persuade me. It was like being asked to believe, based on a gravy stain, that someone had swallowed a whole roast turkey.

In the notarization, Adams reports "without hesitation" that after subsisting on nothing but so-and-so's blood for a given period of time, she "confirms experiencing a heightened level of élan coupled with a dynamic sense of vivacity." Maybe it's the writer in me, but "élan" and "vivacity" are gilded words, words that suggest what a high-society hostess might feel at her own party after downing too many flutes of Champagne. Not to mention that "a dynamic sense of vivacity" invites questions about its opposite, which I guess would be "a static sense of vivacity," and that doesn't sound like any fun at all. Let's face it, anyone can confirm anything about herself "without hesitation," yet all the insistence in the world is no guarantee that she really is, say, the Duchess of Windsor.

Furthermore, knowing that the *artist* drank blood doesn't automatically stir a vampiric thirst in the viewer. A crucial step in the process of evocation is missing. It's like pinching your own ass to get your lover's attention.

I have little doubt that Adams factored the existence of AIDS into her piece—after all, its premise hinges on breaking taboo, in particular the exchange of body fluids. Still, there was

no mention in her artist's statement of HIV infection, nor any other blood-borne disease. Too bad, because the piece would have been a lot scarier if those risks were acknowledged. By avoiding or downplaying or being unaware of these implications, they fall to the wayside, and what remains is the artist's whim: to drink blood with no understanding of the act's ramifications either for herself or for her donors—in short, a childish whim. Did the people in those glossy photographs wince at the sting of the phlebotomist's needle? Did they feel faint afterward? I suppose that vampires, as the undead go, aren't known for their empathy.

The shortfall of intriguing information leaves nothing much for the viewer but a passing gag reflex—*What a gross idea!* I might even argue that, in her emphasis on the work's physical effect, Adams is not unlike those impressionist painters who might at first appear anathema to her transgressive enterprise, but who, in their renderings of besotted picnics and strolls along placid jetty or pond, also sought a physical reaction from the viewer, though in the impressionists' case it was a retinal pleasure brought about by atmospheric color and light.

If I sound cranky, I'd argue that my crankiness makes me *more* likely to be engaged by new and challenging art because, like most of us, I go about my life in a muddle of half thoughts and contradictory emotions, and so I'm almost pathetically grateful for anything that sharpens my senses and snaps me to attention. I spent the bulk of my college years at the California Institute of the Arts, back then the most avant-garde art school in the country, where I watched countless videos of, for example, artist/instructor Wolf Vostel squeezing tiny plastic figures of Donald Duck and Mickey Mouse out of his foreskin—a ref-

erence to the school's founding father, Walt Disney. None of the other students or faculty watching this video reacted with either alarm or disdain, and I followed suit because all of us were willing at the time to give consideration to anything—*anything*— and see if it stood up to aesthetic scrutiny. In other words, I've paid my avant-garde dues in full, for which this school awarded me with something far greater than a master's degree; it gave me the right, as I see it, to be as dyspeptic about art as I damn well please, and to look at it with suspicion until I'm happily proven wrong. Not worth the enormous tuition, perhaps, but an education nevertheless.

The magazine editor who'd hired me (and who sweetened the deal by offering to print a bunch of existence-justifying business cards) made it clear that he'd chosen me because I was a writer of fiction and nonfiction rather than an art historian or a theoretician. But here I was on my first day out in the field, already torn between the memoirist's impulse to sift through the meanings of subjective experience and the critic's impulse to at least give the impression of objectivity and to arrive at an opinion supposedly untainted by personal matters.

One of those matters happened to be the number of people I knew who had died of, or were living with, the HIV virus. For the sake of full disclosure, I should also mention that Brian, my partner of fifteen years, was one of those people. Protocols on how to handle body fluids were built into our routine, which involved perpetual vigilance about protecting his immune system, and in turn, protecting me from exposure to the virus should he cut himself shaving, say. We engaged in safe sex. We kept a couple of boxes of disposable latex gloves around the

house just in case. The threat to his health was a grim reality, but taking daily precautions was not. We did what we had to. I once heard the writer Stanley Elkin say, "You can get used to anything, even your life," and that pretty much describes our adaptation.

The blood donors who participated in Adams's vampire fantasy (to receive official status, she'll probably have to graduate to unwilling victims) appeared to be in the flush of health, and this, combined with the jaunty tone of the artist's statement, made me resentful, a resentment I admittedly couldn't shake. Her fun was a luxury. Still, I wanted to be seduced; vampire stories move me because they're about the price that's exacted—eerie, inescapable—for satisfying one's longing. Anyone affected by AIDS understands this all too well.

I hadn't entertained any of these reservations when I'd learned about Marc Quinn's *Self* from 1991, a bust of himself the artist created from 4.5 liters of his own blood frozen into a crimson ice sculpture kept in a temperature-controlled vitrine. Although the sculpture has more to do with the natural world than it does to the supernatural, Quinn's piece touches upon the desire for immortality, which is, after all, a primary characteristic of the vampire myth, not to mention one of the driving forces behind art-making: the desire to create an enduring view of the world, a version of one's mortal being exempt from the degradations of time and the unbearable fact of oblivion. Quinn updates the sculpture, in the collection of the National Portrait Gallery, every five years, donating the necessary quantity of blood and recasting his head to reflect his aging face. There will be a final version of *Self*—the last cast-

ing done before the artist's death—although the ultimate version will exist in the manifold forms his enterprise has taken. Quinn recognizes the inevitability of physical change while simultaneously acknowledging the futile, all-too-human wish for immortality, and the aesthetic friction between these two contradictory ideas is held in perfect equipoise . . . as long as there isn't a power outage that affects the refrigeration unit and causes the likeness to melt, though this possibility only adds resonance to the self-portrait by highlighting the impossibility of permanence.

. . .

After viewing Adams's installation, I was faced with another. This by artist Teresa Margolles, and it was a bona-fide shocker. A sign informed me that she uses parts of cadavers in her work, and that the small, dry, charcoal-gray protrusion on the opposite wall of the room I was about to enter was a human tongue. If my reaction had a soundtrack, it would have been the sound of screeching brakes. I couldn't bring myself to step inside the room. The

idea of being all alone with a desiccated human tongue made me so queasy, I almost left an installation of my own.

The power of art, however, is not measured solely by the strength of the shock it sends through your nervous system, or by the number of somersaults your stomach does in its presence. For example, after seeing a performance poet devour a box of Oreo cookies while screaming his poem about being teased as a fat child, a student of mine said that she thought the piece was powerful. When pressed to explain why, she said it was because she sat in the front row and was fearful of getting splattered with masticated cookie. Wasn't she, I asked, equating her fear of flying food with art that had the capacity to move her? Given her dubious line of reasoning, wouldn't the performance have been even more powerful if the poet had spewed ground beef? More sophisticated if he'd binged on foie gras? Such distinctions preoccupy us in graduate programs.

But back to that tongue. Here's what troubled me. I wondered what permission, if any, the person once attached to the tongue gave as to the way his or her body would be used after death. Even if the soon-to-be-cadaver did have some say in what happened to its remains, perhaps willing itself to the artist, does that constitute "informed consent"? Other contemporary artists have ventured into this morally and legally shaky territory: after sneaking into a morgue, a grinning Damien Hirst had himself photographed while holding up a man's decapitated head. Using cadavers as raw material is unquestionably disturbing, and Hirst and Margolles aren't the only artists to have done so, but it's an easy way to shock the viewer because, pardon the tautology, it can't not shock. I think Hirst could have made a

far more transgressive work of art had he videotaped himself trying to recruit a live subject off a London street. "Excuse me, sir. Would you mind if held you up by your hair while someone takes our photograph?" To pit oneself against the living; now, *that's* interesting.

As I stood at the threshold of Teresa Margolles's installation, I was getting pretty worked up, though not nearly as worked up as when I continued to read the wall text. The artist, it turned out, had bought the tongue from a woman in Mexico whose son had died and who couldn't afford to bury him. Originally, the artist had offered to pay for the son's burial in exchange for both the boy's penis and his tongue, but in the end, maternal instinct won out, and they agreed upon the tongue alone. The transaction that took place between these two women is nearly unimaginable. Did Margolles feel she'd compromised her artistic integrity with the purchase of one body part instead of two? Had she considered driving a harder bargain and holding out for the dead boy's genitalia? At least the mother could rationalize the barter of her son's tongue—to herself and to the God whose name was evoked during the funeral; she sold her child's tongue for his soul's greater good.

Hours after seeing this installation, it occurred to me that this Mexican mother might have been a Catholic, and that Margolles had perhaps hoped to make a connection between the human body and church reliquaries. Here's the problem: nothing in the wall text or the artist's statement alluded to any of this. Nothing in the presentation of the tongue—it was fastened to the wall by some invisible means—suggested the elaborate gold philatory or crystal monstrance that traditionally houses the slivers of this or that saint. Nothing in the lighting of the

tongue or the scale of the room suggested spiritual reverence or drama. There wasn't so much as a hint of piety. By failing to even subtly emphasize this potential connection, one wonders if it *occurred* to the artist.

. . .

As much as I love it and have spent my most absorbed hours thinking about it and talking about it and trying to make it in one form or another, I'd rather be turned into fertilizer than donate my carcass to art. I know how astonishing and fine a thing it can be, and I also know what ugly junk can be made in its name.

I'm not rejecting ghoulishness out of a sense of propriety, either, but I believe there's a moral use of the ghoulish, and I'm using the word "moral" in the way Joan Didion uses it in her essay "On Morality." The essay opens with a nurse and her husband finding an overturned car on the side of the road while driving to Las Vegas. The driver, a boy, is dead and his passenger, a girl, in severe shock. The nurse drives the girl many miles to the nearest hospital while the husband stays with the boy's body. "If a body is left alone for even a few minutes on the desert," writes Didion, "the coyotes will close in and eat the flesh. Whether or not a corpse is torn apart by coyotes may seem only a sentimental consideration, but of course it is more: one of the promises we make to one another is that we will retrieve our casualties, try not to abandon our dead to the coyotes."

Given these terms, the tongue installation was a dud. The mother acted out of an arguably misguided desire to find resolution for the boy's remains, whereas the artist was concerned,

first and foremost, with the parts of the boy she could acquire and use in an artwork to be exhibited at this prestigious gallery and perhaps be sold to a museum or private collector, leaving her to profit a hundredfold on her initial expenditure. Margolles, in other words, played the role of coyote. There's something miserable in the idea that a boy's tongue is forever condemned to stick itself out in an a gesture of not his, but the *artist's*, defiance—a gesture that will titillate art patrons who might discuss its price at dinner parties and say to each other, "Yes, it's quite radical, but could you actually live with it?" And if one of those collectors purchases the tongue and hangs it in their foyer, say, a maid is going to have to dust it, and I can't help but imagine her holding a feather duster at arm's length and wondering what *she* would have done with the money her employers spent on a human tongue. Perhaps she would have sent the money home to her son in Mexico.

Taking their cues from all manner of precedents— Grünewald's diseased and broken bodies, the corpses of Goya's war dead hanging from tree limbs—there are dozens of contemporary artists whose ghoulish sensibility reminds us that we are, on some fundamental level, a bag of blood and organs and bones, subject to physical adversity so sickening the mind balks. An otherwise peaceful man in a painting by Tom Knechtel pours forth entrails in an intricate river, the ultimate offering; conceptual artist Agnes Denes photographed the literally gritty result of cremation and next to it listed the statistics that once animated those bits of bone: miles of cotton worn in one lifetime, cubic feet of air inhaled.

I do not need to see a dried-up human tongue to know that I will have one in a hundred years. Isn't it a form of condescension

to think your audience is so literal, so inured to death that they have to be confronted with actual body parts in order to grasp the fact of mortality?

Ghoulishness is a quality that can force us to face the limits of our physical existence, or it can hammer us senseless. When used well, ghoulishness has the power to sting like alcohol on an open wound, jarring us back to life and then reminding us that we dwell in the body, with its pleasures and horrors, for only so long.

Labyrinthine

When I discovered my first maze among the pages of a coloring book, I dutifully guided the mouse in the margins toward his wedge of cheese at the center. I dragged my crayon through narrow alleys and around corners, backing out of dead ends, trying this direction instead of that. Often I had to stop and rethink my strategy, squinting until some unobstructed path became clear and I could start to move the crayon again.

I kept my sights on the small chamber in the middle of the page and knew that being lost would not be in vain; wrong turns only improved my chances, showed me the one true path toward my reward. Even when trapped in the hallways of the maze, I felt an embracing safety.

Reaching the cheese had about it a triumph and finality I'd never experienced after coloring a picture or connecting the dots. If only I'd known a word like "inevitable," since that's how it felt to finally slip into the innermost room. I gripped the crayon, savored the place.

The lines of the next maze in the coloring book curved and rippled like waves on water. The object of this maze was to lead a hungry dog to his bone. Mouse to cheese, dog to bone—the premise quickly ceased to matter. It was the tricky, halting travel I was after, forging a passage, finding my way.

Later that day, as I walked through our living room, a maze revealed itself to me in the mahogany coffee table. I sat on the floor, fingered the wood grain, and found a winding avenue through it. The fabric of my parents' blanket was a pattern of climbing ivy and, from one end of the bed to the other, I traced the air between the tendrils. Soon, I didn't need to use a finger, mapping my path by sight. I moved through the veins of the marble sink, through the space between the paisleys on my mother's blouse. At the age of seven I changed forever, like the faithful who see Christ on the side of a barn or peering up from a corn tortilla. Everywhere I looked, a labyrinth meandered.

Soon, the mazes in coloring books, in the comic-strip section of the Sunday paper, or on the place mats of coffee shops that served "children's meals," became too easy. And so I began to make my own. I drew them on the cardboard rectangles that my father's dress shirts were folded around when they came back from the cleaner's. My frugal mother, hoarder of jelly jars and rubber bands, had saved a stack of them. She was happy to put the cardboard to use, if a bit mystified by my new obsession.

The best method was to start from the center and work outward with a sharpened pencil, creating layers of complication. I left a few gaps in every line, and after I'd gotten a feel for the architecture of the whole, I'd close off openings, reinforce walls, a slave sealing the pharaoh's tomb with himself inside it. My blind alleys were especially treacherous; I constructed them so

that, by the time one realized he'd gotten stuck, turning back would be an exquisite ordeal.

My hobby required a twofold concentration: carefully planning a maze while allowing myself the fresh pleasure of moving through it. Alone in my bedroom, sitting at my desk, I sometimes spent the better part of an afternoon on a single maze. I worked with the patience of a redwood growing rings. Drawing myself into corners, erasing a wall if all else failed, I fooled and baffled and freed myself.

Eventually, I used shelf paper, tearing off larger and larger sheets to accommodate my burgeoning ambition. Once, I brought a huge maze to my mother, who was drinking a cup of coffee in the kitchen. It wafted behind me like an ostentatious cape. I draped it over the table and challenged her to try it. She hadn't looked at it for more than a second before she refused. "You've got to be kidding," she said, blotting her lips with a paper napkin. "I'm lost enough as it is." When my father returned from work that night, he hefted his briefcase into the closet, his hat wet and drooping from the rain. "Later," he said (his code word for "never") when I waved the banner of my labyrinth before him.

It was inconceivable to me that someone wouldn't jump at the chance to enter a maze, wouldn't lapse into the trance it required, wouldn't sacrifice the time to find a solution. But mazes had a strange effect on my parents: they took one look at those tangled paths and seemed to wilt.

I was a late child, a "big surprise" as my mother liked to say; by the time I'd turned seven, my parents were trying to cut a swath through middle age. Their mortgage ballooned. The plumbing rusted. Old friends grew sick or moved away. The creases in their skin deepened, so complex a network of lines

that my mazes paled by comparison. Father's hair receded; Mother's grayed. "When you've lived as long as we have . . . " they'd say, which meant no surprises loomed in their future; it was repetition from here on out. The endless succession of burdens and concerns was enough to make anyone forgetful. Eggs were boiled until they turned brown, sprinklers left on till the lawn grew soggy, keys and glasses and watches misplaced. When I asked my parents about their past, they cocked their heads, stared into the distance, and often couldn't recall the details.

. . .

Thirty years later, I understand my parents' refusal. Why would anyone choose to get mired in a maze when the days encase us, loopy and confusing? Remembered events merge together, or fade away. Places and dates grow dubious, a jumble of guesswork and speculation. *What's-his-name* and *thingamajig* replace the bright particular. Recollecting the past becomes as unreliable as forecasting the future; you consult yourself with a certain trepidation and take your answer with a grain of salt. The friends you turn to for confirmation are just as muddled; they furrow their brows and look at you blankly. Of course, once in a while you find the tiny, pungent details poised on your tongue like a single bead of caviar. But more often than not, you settle for sloppy approximations—"I was visiting Texas or Colorado, in nineteen seventy-one or two"—and the anecdote rambles on regardless. When the face of a friend from childhood suddenly comes back to me, it's sad to think that, if a certain synapse hadn't fired just then, I may never have recalled that friend again. Sometimes I'm not sure if I've overheard a story in con-

versation, read it in a book, or if I'm the person to whom it happened; whose adventures, besides my own, are wedged in my memory? Then there are the things I've dreamed and mistaken as fact. When you've lived as long as I have, uncertainty is virtually indistinguishable from the truth, which as far as I know is never naked, but always wearing some disguise.

Mother, Father: I'm growing middle-aged, lost in the folds and bones of my body. It gets harder to remember the days when you were here. I suppose it was inevitable that, gazing down at this piece of paper, I'd feel your weary expressions on my face. What have things been like since you've been gone? Labyrinthine. The very sound of that word sums it up—as slippery as thought, as perplexing as the truth, as long and convoluted as a life.

Something from Nothing

After Brian has brushed his teeth, after he's swallowed a fistful of pills, after he's injected Nupigen into the fraction of fat he can pinch from his belly, he dons a pair of pajamas and says: "I'm ready to get plugged in." He means he's ready for me to connect him to a computerized infusion pump called a Flo-Gard. Every night for over a year, a rich, synthetic liquid called paranutrition has been pumped into his bloodstream, fattening every cell. Or so we keep hoping. Infusions were the last treatment left to slow his rapid weight-loss from AIDS.

Brian sits beside me at the edge of our bed, gritting his teeth as he rolls up his sleeve. He's worried that his PICC line—seven inches of flexible tubing that protrudes from the flesh at the crook of his arm—might catch in the fabric. I'd make a move to help him, but he insists on carrying out this part of the procedure himself, lifting and guiding the sleeve with his free hand, blue eyes alert to the slightest snag. These are perhaps the only

moments in a given day when he has the power to protect himself from pain. The moments don't last long.

When the full length of the PICC line unfurls, its loose end dangles over Brian's forearm. He's continued to grow alarmingly thin despite his nightly infusions, and so vascular that his once-submerged veins seem to rise in compliance with the doctors and nurses who extract his blood, a dark-red portent on which they base prognostications and an ever-changing regimen of drugs. Shelves in our kitchen are packed with plastic vials, bottles in every shape and size, foil gel-packs, transdermal patches, and a pill cutter dusted with chalky powder from slicing thousands of tablets in half. On the counter lies a spiral binder filled with Brian's handwritten notes—an archive of failed therapies complete with dates and annotations, schedules for taking his current medications, and emergency numbers to call just in case. The binder contains a persuasive account of his will to live. I've taken a leave from my job writing art criticism to finish a manuscript, but it dims in comparison to Brian's binder, its dense notations fueled by an urgency I can't and wouldn't try to match, its contents growing ever longer and more complex.

. . .

I first considered taking time off when Brian's primary physician began a gentle but insistent campaign for home infusions. "I have patients who've been able to benefit from paranutrition for years," the doctor told us during a consultation. Right then and there, I should have grasped the finality of his remark, the brick wall of it, but I willed myself to believe that his patients benefited from infusions until they were able to stop the treatment and sustain themselves by eating solid food.

Brian understood the implications from the start. One morning, as he was getting dressed for work, he informed me that he'd decided to take the doctor's advice. He asked if I'd be willing to learn how to administer the infusions.

"Absolutely," I said. "Anything."

"I'll probably be hooked up to an infusion pump every night for the rest of my life."

"You mean, 'for the rest of *our* lives.'"

"No," he said. "I mean the rest of mine."

I'd been sitting in bed, editing my review of a retrospective at LACMA, fiddling with its grammar and syntax, but parsing his remark was the greater challenge.

Brian was changing into a white dress shirt and tan pants, becoming a sartorial blank screen onto which his clients can project whoever they most need their psychotherapist to be. Dressing in those clothes goes a long way in helping him achieve the cool, analytical demeanor that both his occupation and illness require. "I've done some research," he continued, "and at least I can sleep through infusions. My only other choice is to be the guinea pig for an experimental gel that'll leave painful knots at the injection sites. And the knots won't go away. I wouldn't be able to sit at my desk or lie in bed without hurting. I wouldn't be able to rest. Ever." And then, perhaps mistaking my silence for acceptance, he announced that he was off to Nordstrom to get his shoes shined before work.

Brian's decision to have his shoes shined at that particular moment might strike some people as a flight from otherwise bleak and inescapable circumstances—and if so, so what?—but as his meticulous notebook shows, he isn't one to fool himself about the state of his health. If you ask him

how he is, he could (but wouldn't) give you an answer down to the platelet. It's not that he takes his illness lightly; he takes it gravely, but continues his routines to whatever extent his strength allows. For most of our twenty-year relationship, Brian has been in perpetual motion. Expending energy left him replenished. His favorite sport was crossing items off a list of things to do.

When I first met Brian at out local gym, his heartiness made me skeptical, but it turned out that he wasn't just the most genuinely cheerful person I've ever known, he's practically the *only* cheerful person I've ever known. None of my wonderfully complicated and unconventional friends would so much as consider doing "the wave" in a stadium full of people, for example, one of Brian's favorite things to do. Group behavior fills me with a discomfort I'm afraid to show for fear that I'll be seen as a spoiler, a nonbelonger, whereas Brian has always loved parades, political rallies, square dances, ice-skating rinks, and other gatherings in which large groups of people move in unison, subordinate parts to a single-mindedly jubilant whole.

Even after he became symptomatic, progressing from HIV to AIDS, he's rallied quickly after bouts of infection. No sooner do his fevers cool or white count subside than he volunteers to perform the kind of tasks that many people in the peak of health would try to put off, preferably forever. Once, newly recuperated from a bout of neuropathy that numbed his hands and feet, he climbed onto our pitched roof and, against my protests, swept an autumn's worth of leaves from the rain gutters. There are times I've seen him dumbstruck by despair, but despair burns inside him for only so long before it runs its course, restoring him to the ordinary.

But back to the day he asked me to administer the infusions. I was sitting on the bed, the draft of an art review in hand, and when I could finally bring myself to speak, to say something consoling or sympathetic about what was perhaps the last medical option available to prevent him from losing even more weight, this is what came out of my mouth: "There's a shoe shiner at Nordstrom's?"

"In the men's department," he said. He cinched his tie tightly enough to compensate for the shirt's roomy collar. He kissed me on the forehead and left the house.

Ever since he tested positive (early in our relationship we discovered we were a sero-divergent couple), Brian has endured medical procedures too numerous to count—too ghoulish to *want* to count—and has cultivated a dignified, if somewhat reticent, surrender when letting strangers palpate his glands, press their stethoscopes against his chest, and pierce his skin with needles. But as the day of the implant drew near, the prospect of having a catheter fed into in his arm caused an uncharacteristic spike in his anxiety, despite his doctor's assurances that the procedure would be painless and over in a flash.

Brian and I have always been a lucky couple in that one of us was usually steadfast (him) when the other was fretful (me), and this division of emotional labor suited us well. I'm good at fretting. Better than good. I'm a world-class fretter. I can fret with both hands tied behind my back. I come from a long line of professional fretters who would have no trouble making the association between, say, a drafty room and full-blown pneumonia. I bring to worry a far greater dedication than Brian ever could, and this, I'd like to think, has freed him up to get his bearings, dig in his heels, and remain resolute. With my considerable skill in this

area, I'd thus far been able to take at least some of the burden off Brian's shoulders, and he, in turn, gave me hope for the future by insisting that I worry too much. We'd managed, with this kind of delicate imbalance, to husband each other through several crises.

As the day of the appointment neared, I had to pick up his constitutional slack, so to speak, and I'm pleased to say that I met the challenge head-on, becoming a relatively levelheaded fellow who doled out the kind of comments—*Even if getting the implant hurts, which the doctor says it doesn't, it won't hurt for long*—that usually fell under Brian's purview.

Playing at having confidence (in other words, having false confidence) led me to believe that I might actually master, or at least achieve a basic grasp of, the necessary steps for giving an infusion. This came as very good news indeed, because if *I* had to receive an infusion, I'm the last person I'd choose to receive it from. I've never, thank goodness, been called upon to staunch a geyser of blood, splint a broken bone, or perform the Heimlich maneuver. Up to that point, my medical experience had been confined to the application of Band-Aids and bags of frozen peas. The fact that Brian asked me to give him infusions struck me as a flaw in his otherwise rational thinking. Worse, giving him infusions would make me, in a definitive and daily way, his caretaker, a word I despised for its notes of dependency and incapacitation. For more than two decades I'd assumed that it was *he* who took care of me, that *he* was the dependable one, the organized one, the one who got things done despite being HIV positive, while I spent days hunched over a desk, distracted by language to the point of . . . distraction. If I became the infuser and he the infusee, our time-tested roles would have to be reversed.

My "infusion training session" was scheduled days in

advance of the implant, and Brian decided to come along so he could get a better idea of how the treatment worked, and no doubt to see with his own two eyes that I'd learned the procedure forward and back. With her gold bifocals and tailored skirt, the instructor—I'll call her M—looked "pulled together" as Brian said of the well groomed and self-possessed, a pet expression that never failed to confirm my suspicion that, if a person wasn't held together by every means possible, they were bound to fall apart. I introduced myself and reached out to shake her hand.

"You're the partner?" asked M. Her scrutiny was as bright as a searchlight.

"That would be me!" I was too jaunty by half, but the other half couldn't do a thing about it.

"I'm the patient," said Brian, "which you probably could tell."

M opened her briefcase and handed us printed folders whose covers featured an illustration of what I thought was a kite on a string, but on closer examination turned out to be an IV bag trailing a tube. M noticed me squinting at the image. She closed her briefcase and switched off her cell phone. She sighed the sigh of a woman whose work was cut out for her. "You're prepared to be in charge?" she asked me.

"I realize I must look a little nervous, but please understand that I take this responsibility as seriously as anyone without medical experience can take it. Not that my not having medical experience will be a problem. What I'm saying is, *despite* my lack of medical experience, I'm ready and willing to learn everything there is to know about giving foolproof infusions."

"What do you mean by foolproof?" she asked.

Brian and I looked at each other.

"I guess I mean infusions that don't leak or come loose or whatever else can go wrong when someone does them."

"So you know about air bubbles?"

"I know what they are, if that's what you're asking."

"It only takes a few millimeters of air to kill a patient. A lethal bubble can slip through the tube and stop the patient's heart like that." She snapped her fingers. "The authorities have ways of determining if an air bubble has passed through the filtration system *on purpose*. I'm obligated by law, and by my own conscience, to make this danger clear to my clients."

I telepathically urged Brian to say something in my defense.

"Can I have a glass of water?" he asked.

I turned back to M. "I know you don't know me from Adam and that you're obligated by law and ethics, etcetera, and I respect you for professionalism, but believe me, there's no way I'm going to kill him on purpose!"

Her eyes widened.

"Not by accident, either!"

"He won't," said Brian, with a little less conviction than I would have wished.

"We've been together for over twenty years," I told M, realizing too late that a twenty-year relationship might seem to her like a reason *for* foul play instead of against it.

"I'm going to trust you," M told me. *Begrudgingly* doesn't do her tone justice; her trust had to be extracted like a tooth. "You must understand that I'm here not only to instruct, but to assess the suitability of the parties involved."

"Can I have a glass of water?" Brian asked again.

"Listen," I said to M, "I think it's safe to say that if we weren't

suitable to help each other through this, we would have found out by now."

M paused a moment, taking this in. "That's what I like to hear." She seemed pleased by my commitment in the face of opposition. "I feel much more confident now and I hope you do too."

"Relatively," I said, "but even under the best circumstances my confidence is clouded by doubt."

"Bernard," said Brian.

"She asked me," I said.

While M prepared her demonstration, laying out the PICC line and its attachments on a small table, I brought Brian a gulp-worth of water in one of those tiny pleated paper cups. He tossed it back and swallowed.

M rolled an IV pole closer. Perched atop it was the FloGard we'd be taking home with us. It emitted a shrill, repeated beep the second M plugged it into the wall. Brian and I winced. Amazingly, M went about her business unbothered. Although the dictionary defines a "beep" as a short burst of sound, that word is as wanting as a referent can get. *FloGard* is to *Beep* as *Air Horn* is to *Chirp*. Like a baby's wail, the sound stimulated an involuntary biological response, its pitch able to wrest the attention of anyone within fifty yards. How could a person think or read or relax while that thing was beeping? You certainly couldn't sleep through it, which was precisely the point; no state of repose, no deep elaborate dream, was safe from its many decibels. A sound like that could penetrate bone. One didn't need ears to hear it.

"The beep lets you know the machine is on," said M in a masterstroke of understatement. "During the night, it will also alert

you to clogs in the PICC line—we call them *occlusions*—and other malfunctions in the apparatus. We want the lumen to stay clear at all times…"

Brian wedged a question between beeps.

"*Lumen*," explained M, "is what we call the inside of the tube. Unusual movements can twist the line, which blocks the lumen and sets off the alarm. You mustn't bounce on the bed unless you absolutely have to."

Brian smiled wryly. "My bouncing days are over."

"I'll hold him down if he bounces," I said.

"You gentlemen won't think it's funny if you have to wake up ten times a night to turn off the alarm."

It was difficult for me to absorb what M was saying because every time a sentence left her mouth, a beep blew it to smithereens like a rifle shooting skeet. "The alarm could also go off if Brian gets up in the middle of the night to use the bathroom and accidentally disengages the safety clamp. Brian, make sure you grab the IV stand firmly in the center of the pole when you roll it with you, and always leave some slack in the line."

"I'll be able to get out of bed after I'm hooked up?"

She grabbed the IV pole and pushed it from side to side and then in a circle, showing Brian how easy it was to move the unit on its four swiveling wheels.

M pointed to a luminous green plus sign near the touch pad. "This light shows you that the battery is charged. It'll give you about two hours of reserve power after you unplug it. Just make sure you're always near an outlet."

Brian considered the prospect of having to be plugged into a wall socket at night—another limitation to rein him in.

M turned off the FloGard's alarm. What followed wasn't

silence so much as an agitated vacuum. It took her some time
to thumb through the thick folder Brian's doctor had sent her.
Brian had volunteered for the first trial of protease inhibitors at
UCLA in the mid-1980s, but his control group, given the highest
dosage, became resistant to the new drug instead of reaping its
benefits. This lead to an ever more complicated course of alter-
native drugs, many still in the testing stage. Even M must have
found it hard to believe that someone had ingested such large
quantities of medication over the years. Brian's life had been
lived by the milligram, the precise titration. And now we were
running out of drugs, and drug combinations, to prolong his life.

When M was finished, she removed her glasses to get a bet-
ter look at us, revealing a permanent furrow the bridge of her
glasses had hidden. "Twenty years," she said.

"What?" asked Brian.

"That's a long time to know you're infected. Longer than I've
lived in America. When I first came to the States, my parents
warned me that America was a place forsaken. I was told that
few people prayed to Allah. But it looked to me like people were
praying all the time, day and night. Of course, it wasn't the kind
of prayer I thought."

"What was it?" asked Brian.

"Cell phones," she said.

"You heard people praying over the phone?"

"This was before I had a cell myself," M continued. "I saw
men and women everywhere lifting their hands to their ears just
as I had growing up in Iran, and I thought, it's *qiyam*, the pos-
ture taken when one decides to pray. A sign of readiness. Soon
I understood my mistake, but I still like to see it as I used to:
prayer everywhere. Every one of these people is giving a sign

of readiness whether they believe in prayer or not. Call and answer, call and answer. How else can a man or a woman know God? We're making way for prayer even if what we're making is appointments."

She gathered herself up, adjusted her glasses, having a little trouble, it seemed, resuming her impartial role. "Brian," she said, "I don't mean to pry, but there's something I have to ask you before we begin. Is there a secret to your longevity?"

"Yes," he told her. "I'd rather not die."

. . .

By now I have the procedure down pat. I rock the refrigerated bag of paranutrition back and forth to break up the "particulate matter," then hang it from the top of the IV pole. I scrub my hands with germicidal soap and rinse them in the hottest water I can stand, then force my fingers into a pair of purple Safeskin examination gloves, clenching my fists a few times to loosen the fit. The gloves are numbing; when I touch Brian's outstretched arm, the touch conveys few sensory details, as if his body itself, and not the sensation in my fingertips, has grown fainter.

Thin as he is, it's hard for me to think of him as the host to a virus, and yet I know he's inhabited, yielding against his will to a microscopic force that makes him appear less and less like the young man I met more than two decades ago, his body once agile, thoughtless in its health, responsive to pleasure instead of pain. Tonight he wears a polar fleece jacket over a sweatshirt and thermal long johns beneath his jeans. A wool ski cap covers his head. Each foot is padded by several pairs of socks. All these layers give him a temporary density; he's robust from clothes. I'd probably find some comfort in his bulky appearance if it

weren't for the fact that it's summer in Los Angeles, the heater in our bedroom cranked up full-blast. Since he barely possesses any insulating fat, Brian shivers, cold to the bone.

. . .

When people ask Brian why he'd moved to Los Angeles from his tiny boyhood town in Canada, he routinely tells strangers that, after graduate school, he couldn't wait to flee the brutal winters. Climate was only a small part of the reason he immigrated.

From an early age, Brian considered himself at odds with small-town convention, despite his affection for the scale of provincial life, its consistency and politeness. He might never have thought of himself a budding renegade if it hadn't been for the plain, socially unacceptable fact that he and the town's paper boy engaged in sex nearly every day for six years, from the ages of ten to fifteen. Because a single route covered the entire town, the paperboy assumed the prestige and civic responsibility of a government official.

Once Paper Boy's rounds were complete, the news delivered, his bike lightened, he wheeled up to an abandoned barn on the outskirts of town, where Brian *just happened* to be passing by. The boys feigned surprise each time they crossed paths, as if brought there by accident rather than plan. *Wanting* to meet would make them homosexuals, whereas so-called chance encounters allowed them to remain nothing more unusual than two classmates who barely exchanged a glance at school. Never mind that their rendezvous was repeated day after day, week after week, year after year. The ritual of surprise—"Hey, aren't you in my class?" or "What're you doing here?"—served to erase

their previous meetings, a willed amnesia that delivered them from sin. Since their preferred method of reaching orgasm consisted of rubbing up against each other while fully clothed and ejaculating in their pants, Brian refers to their assignations as "frottage on tap." The two of them rolled around—where else but in the hay—and *kept* rolling. Perpetual motion prevented either from assuming the supine position, which would have cast that boy as the woman of the couple, or, more accurately given the longevity of their relationship, as the wife. No time to stop and hold the other's gaze. No time to reflect. The tacit rules didn't permit overtly homosexual acts—they refrained from touching the other's penis, nipples, testicles, ass. Specific predilections were diffused into a broad abstraction of contact. Neither did the rules permit overtly tender acts—kissing was out of the question, a caress of the cheek too fraught with feeling. Paper Boy insisted that what happened between them wasn't, strictly speaking, sex. Brian thoroughly agreed—a ploy to keep his lover coming back for more of what wasn't sex.

And so it continued, dependable, unwavering, a bond that, in very different circumstances, would go by the name of fidelity. Until the age of fifteen. It was Paper Boy's idea to go on a double date with two girls of his choosing, a boyish, artistically inclined girl for Brian, and a precocious, outgoing redhead for himself. Brian had never been on an official date, and the prospect of fraternizing with girls he'd never met, girls from another, larger town—prissy sophisticates, he'd assumed—made him apprehensive. Still worse was the idea of sharing this initiation with the boy whose companionship had been relegated to the sunless, dusty confines of a barn. Why make their friendship public now? What if their secret suddenly escaped like a bee from a jar?

When the night finally arrived, however, the girls' good manners and skill at small talk—a social currency that Brian appreciated even back then—put him at ease. Learner's permit hot in his pocket, Paper Boy borrowed his father's car and aimed the foursome toward the only Chinese restaurant within a fifty-mile radius. For much of the drive, he attempted to impress the girls with tales of his days on the paper route.

"You don't still deliver papers, do you?" the redhead asked.

Realizing he'd taken the wrong tack, Paper Boy shifted the spotlight to his Labrador Blackie, sure that stories of a loyal dog would soften them up. The girls listened politely, nodded in all the appropriate places, then said they each had a darling cat and that they identified themselves in no uncertain terms as "cat people," an affinity that stalled the conversation.

Rushing in to fill the gap, Brian inquired after their pets, whose names were Kitty-Sticks and Professor Jingle. He earned points with the girls by referring to the pets by name; most boys, they told him, were too embarrassed to say the names aloud and tried to change the subject. "Cowards!" scoffed the redhead. "Afraid of the feline species," said the other. That Brian had demonstrated his male prowess by uttering silly cat names came as a stunning surprise to say the least. Masculinity loosened its starched collar which, up until that moment, had restricted his breathing and pinched his neck. He went on to tantalize the girls with local gossip. He told them jokes without flubbing the punch lines. He grew emboldened to ask about their hairstyles and clothes with the ease of a boy who has nothing to lose. Soon the girls needed to remind themselves that a second boy had come on the date; too polite to ignore the driver of the car altogether, they tried to solicit his opinion about the recent popu-

larity of powder blue, the newest shade in women's fashion and home decor. Paper boy shrugged. "Don't know about that kind of stuff." He rolled down the widow and executed a hand signal with studied nonchalance. This merely forced the talkers to shout above the wind.

"I bet powder blue is hard to keep clean," said Brian.

"Try wearing pumps that color!" exclaimed the redhead.

Brian shook his head in commiseration.

Leafy trees flicked by in the headlights. "You're simpatico," observed Brian's date.

"He is," confirmed the redhead.

"No kidding," said the driver, an edge in his voice.

The girls seemed not to notice. Or not to want to. Their eyes glittered in the darkness of the car. Despite their maturity, they may have mistaken their sisterly regard toward Brian for the first stirrings of love. In any case, the night was a triumph for Brian, for he'd won the lion's share of attention from two amusing, worldly girls (as he'd come to think of them) without having to stiffen his wrists or dredge up a phony baritone every time he opened his mouth. The girls both planted a kiss on Brian's lips before shaking Paper boy's hand good night.

. . .

When I press Start, milky droplets are pumped through the FloGard's drip chamber, then along the PICC line, and finally through the shunt in Brian's arm. He lies back on a stack of pillows and closes his eyes. Nupigen stimulates the growth of white blood cells and this makes his bones sensate in a way he never thought possible; he can feel the marrow aching within them. Painkillers don't ease the discomfort so much as they

cause a foggy resignation that passes for repose. Still, he feels lucky that "the whole rigmarole," as he calls it, doesn't keep him from a good night's sleep. Most nights, he's out by eight o'clock and I slip into bed beside him. But the deeper Brian sinks toward sleep—his hands unclenching, jaw going lax—the more wary I become. During my waking hours, I think of myself as a reasonably protective person, but at night this instinct is magnified, even if he's breathing peacefully beside me. My hairs bristle and muscles tense at the slightest vibration. I could spring across the room if I had to. I could lift the bed and carry him to safety. I'm at the ready, though I don't know for what.

As I lie in bed and listen, sounds reach me with piercing clarity and in nearly tangible shapes and patterns. Hip-hop throbs from a driver's moon roof, its trail of rubbery bass notes bouncing off the asphalt. A helicopter passes overhead and rips the sky into tattered black rags. The infusion pump isn't loud, exactly, but in the process of generating each precisely measured drip, it repeatedly makes what the layperson would hear as a single sound, whereas the exhausted aficionado hears a bedeviling sequence of sounds. It begins with a metallic tick. Next comes a deepening hum as a single ivory bead expands at the top of the drip chamber, growing too heavy to support its own weight. And just before it falls, the pumping cycle starts all over again, its noise masking the inevitable *plink* or *plop*, or whatever word would best describe the impact.

I've lost track of the number of nights I've lain here and made a pact with myself to ignore the damn drip, only to go right on thinking about it to the exclusion of everything else. I can't be the only person on Earth who'd get a little fixated on a dripping bag of milky liquid suspended in the air beside

his bed. The droplets might as well be falling on my forehead; both thinking about them and trying *not* to think about them are a form of Chinese water torture. Every drop feeds and hydrates Brian. Every drop perpetuates a world in which he's alive and sleeping beside me. Every drop is deep enough to drown in.

I used to read for hours every night until I fell sleep. In the act of reading, I routinely met the writer halfway by allowing myself to be carried off by the forward momentum of his or her sentences, a voluntary surrender that, until Brian began infusions, was the very abandon I sought in books. Now the merest hint of immersion in a text, the slightest sense that I've lowered my guard, gives me a start; I must stay alert. I've developed a new and admittedly superstitious belief that I can't allow my attention to lapse, that I have to keep track of what happens to Brian, and therefore to us, *as* it's happening. The narrative instincts I've developed as a reader and a writer are now spent making sense of the present, however tentative and uncomprehending that sense might be. A narrative contains us, binds us to a single, ongoing story. Every night I review the day, selecting stray details, mulling them over as if to write them down, all the while knowing that the details remembered one day are destined to be forgotten the next, erased by a slew of new details that can't be foreseen—sudden nausea that will not stop, the angry, transient rash. Every night I attempt to save our place, as if in a book. We're drawing toward an end that's inevitable on one hand and impossible to imagine on the other, but until we get there—how and when will we get there?—I can't allow a lapse between scenes, can't lose the continuity. All the details have to add up, each effect tied to a probable cause,

each action in keeping with character. Any less will lead to incoherence.

I understand, intellectually at least, that my fear of losing track of the narrative fuels my desperate wish to control it. For the truth is, I don't want to nurse Brian. I don't want to make his illness easier to bear. What I want to do is save him. There's no way to say this without sounding deluded, or foolish, or like a man who's building a case for the depth of his love, or worse, to win pity for its imminent loss. But there's no other way to say it, either: I want to save him. Even though Brian has warned me that his body will soon belong to the virus, robbing him of the drive to live, the sheer futility of my wish makes it all the stronger. I can't ignore, or lessen, or shed it.

Even if I could give myself over to the parallel life of a book, the sound of the pump distracts me from language, goads me again and again into the present. Its churning disrupts the very air. Reminds me that it's late in every sense. Proves that the world will rattle on without us.

When I can't stand listening a moment longer, I get out of bed and go watch television in the next room. And just as I settle back and relax, just as vigilance loosens its grip, I notice that the sound coming from the TV is more vibrant and lifelike than ever before. How can I be expected to follow, say, the grizzly re-creation of an unsolved murder or close-ups of the latest plastic-surgery procedure when I'm busy pivoting my head at different angles to determine whether the TV's enhanced audio is due to the room's acoustics, the set itself, or my own ears?

Insomnia, it seems, is spending the night. A couple of my friends wouldn't mind a phone call even at this hour, but I don't want to wake them. Their kindness is a fund I can draw from

when I'll need it most, when "after" happens. And so I find myself guarding not only Brian's sleep, but my friends' sleep as well. This is an illusory duty, I know, but it lends a purpose to long and sleepless hours. I turn off the set and head back to bed.

Late at night, unable to concentrate on books or television, cut off from conversation, it's impossible to escape the vise of life-as-I-know-it and lose myself in another story. The only story I know is the one in which Brian is dying. Our twenty-year history has a beginning and a middle, of course, but they've been eclipsed by the sights and sounds of these numbered days. The past is an unimaginable condition in which we possessed a future. It's as if we'd met so we could be together when he dies, paid the mortgage so we could be together when he dies, sustained ourselves with food and love and hard work so we'd one day come to the realization that everything up to this point was a prologue. The story has started here, now, when time is finite.

. . .

Brian loses language one morning just after we wake up. We were having one of those groggy conversations that exist as a kind of domestic white noise in the lives of longtime couples; one is neither listening to, nor avoiding, the other. He meant to say that he'd be home early from work that afternoon—his disability policy allowed him to see three clients a week and, as frail as he was, he wanted to feel useful—but what came out of his mouth wasn't the word "home." Nor a synonym. Nor antonym. Nor word with a connotation of shelter. The wrong word—"brush"—simply falls into place, as hard and inarguable as a dropped rock.

Brian tries the word again. His brow furrows with effort and fear. He wills his lips to move in such a way that the word he'd intended might take shape. He marshals all he has—all his energy and intelligence—to push it out of his mouth. To rid himself of the need to say it.

"Oh!" I cry. If only it had been an *Oh* of understanding—*I see what you mean*—rather than an *Oh* of alarm.

And so his forgetting begins.

Tests confirm that the virus has crossed the blood/brain barrier, breaching the otherwise impassable junctions between brain cells.

Words go. Then phrases. Then reasons to speak.

Poised at the top of the staircase, he balks and teeters and his body seems to ask if a staircase is flat.

Then comes a night when he forgets how to undress for bed. The order of what's taken off and why. He rallies the motion of his slender bones and tugs at buttons, flustered and embarrassed when I walk into the bedroom. I sit at his feet and untie his laces. I remove his shoes, leaving the layers of thick athletic socks he requires for extra insulation in bed. He steadies himself by grabbing onto the IV pole when I can reach up to unbuckle his belt and pull his jeans toward his ankles. I say, "De-pantsing you is the only fun part of this whole thing."

"Right," he says, his skepticism mixed with pleasure. Our erotic life may be composed solely of innuendo, but complimenting a man whose body betrays him day after day has given me, if not the satisfaction of sex, then at least the satisfaction of discovering innuendo where none would ordinarily exist. I'm not simply praising him out of long habit. This is not appreciation for the man I *remember*. My ardor exists in the present tense,

though its object, and its terms of expression, have changed so dramatically that I have to remind myself that what I feel is different from pity, though there's pity in it, too. "Beauty plus pity," said Vladimir Nabokov, "that is the closest we can come to a definition of art. Where there is beauty there is pity, for beauty must die: beauty always dies, the manner dies with the matter, the world dies with the individual."

This quote is one of the talismans I hold close, reminding me that even death can be turned on the lathe of imagination and polished into a memorable phrase. I find myself depending on the words of others because I have so few of my own. If it weren't for their words, I'd have to settle for the platitudes that occur to me reflexively now, bringing the added defeat of having to resort to stale phrases because I don't have the wherewithal to invent my own. That Brian will die has become a fact so immense, I fear it will obliterate not only him, but the words I use to define our life together, and therefore the world as I know it. It's my death too, and the pact I've entered, though not as Shakespearean as vowing to die with him, is to follow him toward death as far as I can go.

Brian steps out of the denim one leg at a time, as if from a dark blue pool. Beneath his jeans, the waffled fabric of thermal long johns cling to legs so thin they hardly look capable of supporting his torso. After he lies flat I cover him up to his chin with an electric blanket, the dial set to High.

I used to wonder what I would do for sexual gratification if and when Brian became too ill. It never occurred to me that I'd be too depleted by his illness to want sex myself—the two of us united, finally, by eroticism's opposite: the explicit stages of physical disintegration that have taken place in our bedroom,

in our bed. There's an even greater, unexpected, sorrow than knowing he no longer desires me: knowing he desires no one at all. Yearning fails along with the body. The body, as it fails, yearns only for its health. And then, perhaps, not even that.

When I grab his jeans off the floor and begin to fold them, proportion goes awry. My hands appear huge against the denim waistband. Pant legs hang, thin as ribbons. Seeing my bafflement from across the room he says, "Nordstrom's. I had to buy pants in the boys' department."

Later that night, as I lie there and listen to bead after ivory bead falling through the drip chamber, Brian stirs awake and takes me in. For a moment there's nothing but the hum of the pump. Without question or preface he says, "This kind of thing is harder for the person who has to watch."

This kind of thing.

I say, not unkindly, "Do you have to be so decent?" By this time I've entered a new universe where I'm stung by his offers of comfort, which only remind me how much I'd need his presence to survive his death.

"Sorry," he says, and before I can weigh his intonation—is he apologizing for his decency or his illness?—he falls back asleep, whereas I remain awake for hours. In the time-lapse of my imagination, I picture him wasting away until he's little more than a strand of himself, as white and lifeless as a length of thread. This image visits me repeatedly while I hold a book and scan the same sentence over and over, unable to take it in. Literary representations of the world beyond this room are never as urgent as the world within it, a world where the air is close and overheated, dense with milky light, with emanations from our bowels and our lungs and the acrid odor of his body striving,

even at rest, to stay alive. The recurring image of Brian's diminishment is also, I'm ashamed to admit, a wish for his absence to be realized rather than impending, a wish for everything that has been protracted and incremental about his illness to be hastened, accomplished, over at last, the advent of his death transformed into something as ordinary as a loose thread, as easy for me to break free of. I listen to his breathing, firmly tethered to the last days of his life.

. . .

After Brian's death, I waited the requisite twelve months recommended by grief counselors before making any major decisions. And then I hastily sold our house and moved from place to place to place, but I stayed inside that room for years. Breathed its cubic feet of air. Exhaled its cubic feet of air and breathed them in again. To this day, I'd be willing to wager that, wherever I happen to find myself, I could pace off the boundaries of our former bedroom, accurate within an inch.

As Brian was dying, I searched his face for a final vestige of what was recognizably him, and the part of him I recognized was inseparable from his death. His muscles cramped and his body heaved, and I could have sworn he was writhing in reverse, the opposite of labor pains. Fists clenched, head thrown back, his body retracted who he had been, his bones and muscles taking it back. There were jagged, unscalable peaks of breath. His eyes grew opaque in a matter of hours, their depth slowly rising to the surface until there was nothing more than surface, each blue iris an unseeing skin. Before he was gone, I asked him to remember me. Asked aloud. For exactly as long as it took me to ask, I believed I was being rational, believed

my request could somehow be met. And then I lurched at my misunderstanding—I'd been lying beside him and I bolted upright—hoping he hadn't heard what I'd said, or if he had, could not understand me. I'd asked for the last thing he couldn't give. It was as if the words themselves had left him empty. As if the words themselves had undone us. The selfish, dismantling patter of those words. What was left to say after that?

In the years following Brian's death, I could barely read or write. It was as if I'd finally succumbed to the accumulated weights of the *Speech Regulator* I'd made in art school. My tongue went as still as the tongue I'd once seen affixed to a wall, collecting dust. I left my job as a reviewer and took another job that didn't require three thousand words per month. Didn't require that I look at art and expect the slightest consolation. I flatly refused to be consoled. Only my refusal was absolute. I settled into the petulance of grieving; I didn't have language and didn't want it. Let aphasia be contagious. Let the world be swallowed by silence. Let every page and every work of art revert to its inborn blankness.

. . .

If it was true that, in the aftermath of Brian's death, I thought of myself a man bereft, I slowly began to understand that I was, in equal measure, replete with grief, brimming with it. Grief became my provision, my hidden reserve. Even the most stubborn among grievers may begin to know the plentitude of loss rather than its emptiness. Memory is a form of visitation; who and what is gone assumes a presence, however brief, however one wishes it otherwise.

This revision of my mourner's outlook, of my widow's-

eye-view of the world, may have happened gradually, but my experience of it couldn't have seemed more sudden. I was scanning the magazine rack at my local supermarket—the supermarket, site of so much boyhood inspiration. I was about to do my grocery shopping, a necessary but vaguely embarrassing task in which my sorry state of bachelorhood was made clear, I feared, to all who glanced into my cart: the scant fresh produce, the boxes of individual servings, the frozen food glinting with crystals of ice, and one or two illicit foods—red licorice, barbecued chips—thrown in to compensate for the nights I spent in bed with my laptop, searching for dates with interesting, attractive men, or later those same nights when lonliness set in, for hook-ups with uninteresting men who were passably attractive by somebody's standards, if not by mine, and who didn't seem crazy or tweaked on meth.

It was just before 5 p.m. and the supermarket was crowded with commuters on their way home. Harried shoppers yanked at the handles of nested carts, prying them apart with civilized violence. Beside the magazine rack, a woman in a neon-pink tracksuit dumped bags of loose change into the Coinstar, her money tallied up. I was about to thumb through a recent issue of the magazine for which I'd once written art reviews when I noticed that someone had returned a copy of *Boating* magazine to the shelf, but had placed it upside down. On the cover was a luxury cruiser whose white fiberglass hull could have been a canopy suspended over the cabin. Higher still, a green, unbreathable body of water replaced the air. A figure on the deck waved toward the camera but, turned on his head, he appeared to be diving into the sky, about to break through its cloudless blue surface before he disappeared. I thought:

a boat seen upside down is capsized. A man on a boat seen upside down is abandoning ship, not waving hello to someone on shore, but waving good-bye. This visual inversion was as concise an embodiment of loss as anything I'd ever seen, an accidental elegy composed of a single image. I stood there and stared. A flood of visual possibility pressed in at me from all sides, just as it had back in my junior high school library when *Life* magazine had lain open before me, the shock of Pop on its glossy pages.

That night I searched the Internet for images of ships— tankers, cutlasses, sailboats, ferries, speedboats, dinghies. These keywords yielded everything from amateur oil paintings to shipbuilders' blueprints, from Polaroid snapshots to etchings in the archives of marine historical societies. I conducted my search without a single theory, a lapse that would have been inexcusable in art school. I did, however, set some rules for myself: (1) Works of fine art were dismissed out of hand; I wanted to immerse myself in the Internet's nearly infinite dross. (2) No image could be copyrighted; all of them had to readily accessible, and I avoided sites that sold stock downloads. (3) I aimed for Warhol's pre-postmodern tolerance, giving every image due consideration, whether they were hazy or high-resolution, illustrative or photographic, vintage or digital. I'd embarked on a search in the broadest, most existential sense, without precisely knowing why, or what it was I hoped to find. Wasn't it the artist's duty, I'd wondered as a boy, to make something from nothing for the rest of his life? I dragged dozens of JPEGS onto my desktop as though hoarding them after a famine.

If I tried to remain open-minded while gathering JPEGS,

selectivity kicked in when I finally deliberated over which ones to print. The glut of the Internet, I wanted to believe, could be winnowed down to a small evocative handful of images, which is to say that I gravitated toward pictures of ships I wanted to stare at long after my searching stopped. The three ships chosen from dozens were then printed out on sheets of typing paper, paper I'd bought for drafts of a book I hadn't worked on since Brian had died. When I turned the vessels upside down, the sea on which they sailed—placid or roiling, opaque or transparent—rose up to engulf them, about to bear down, as oceanic as grief itself. Yet grief was constrained to the size of a page. I could examine it from various angles, arrange it in different configurations, could play with it freely, even if my play was grave. "Both art and life," said artist Walter De Maria, "are a matter of life and death."

Back at the laptop, I entered associations with the word "capsize" into the search-field: *Shipwreck, maelstrom, drowning, flotsam.* Grid after grid of images appeared. It was the kind of instantaneous conjuring that had been, for me, conceptual art's greatest promise. I recalled Lyn Horton plumbing her thesaurus for the synonyms of "inconsequential," the sum of the English language held in her sights like a far horizon.

Associations rippled outward. I Googled *home aquariums* and was rewarded with a JPEG of swimming iridescent fish like a string of Japanese lanterns. *Sea monster* brought me to a murky undersea photograph of a just-discovered species of squid, their bodies as pale and diaphanous as the half-materialized ghosts in old spirit photographs, the ectoplasm of the long departed flowing out of a medium's mouth. Under *Deep sea diver,* two men in bulky, archaic diving suits posed

with their arms around each other before being lowered into the drink, connected to the living by nothing but the thin umbilicus of a shared air hose; behind the fogged oculus of their helmets were faces as vague as the faces of men I barely remembered from the first wave of AIDS, gone now for decades. *Vortex* led to a series of black-and-white spirals whose convolutions swept the eye inward, producing the kind of dizziness that Victorians called a "sinking spell." *Waterspout* brought me to hardware stores with their shining array of bronze and silver faucets. A glass of purified water looked transparent and prim and wholly contained, but I realized that, once it was printed and turned upside down, the contents would threaten to spill into a puddle whose shape depended, like a bucket of Jackson Pollock's paint, on gravity and chance.

A veteran insomniac, I spent the better part of a night arranging and rearranging a small handful of found images. They served as words in a vast language—the givens one must choose from if one hopes to speak—and I was convinced that, if I ordered them according to some instinctive syntax, they'd form the visual equivalent of a sentence. Not just any sentence; I was holding out for a sentence that seemed inevitable; change one word and you jettison sense. I invoked the names of poets I'd read and revered in college—Elizabeth Bishop, Sylvia Plath—and also the names of the great collagists—Kurt Schwitters, Max Ernst—with a timidity verging on superstition; as always, I wanted my mentors to oversee me and also to leave me to my own devices.

I didn't know then that I'd continue making art for years to come. I was picking up where I'd left off in college, but without

waving the banner of avant-gardism as fervently as I had back in the 1970s. That particular set of cutting-edge aesthetics, the very idea of an avant-garde, had aged along with everything else. In the living room of the third house I'd lived in since Brian's death, I sat on the floor, determined to stay there until some cohesive meaning emerged, a lament becoming visible like writing on a tie.

Elegy with Double Knot, 2011, 30" × 65"

The Insomniac Manifesto

S leep is the opiate of the masses, a retreat from the teeth grinding and ceaseless thinking that is our true calling as humans! What use is a body sprawled on cotton, as still as a statue? We who toss and turn each night, we sentries fretting in the moonlight say: Deep-breathers everywhere, awake! Rise from your beds, free yourself from the stranglehold of blankets, shed your flimsy bedclothes and don a scratchy woollen suit, chafing shoes and belts and watchbands, the glorious clothes of consciousness!

Dreams are nothing more than deception: you hold the winning lottery ticket, the dead one returns to your arms at last, the exam is passed with flying colors, the speech delivered even though you are nude. O, dozers and cat nappers and denizens of Nod, you must turn your backs on the illusory satisfactions of the dream life! Surrender yourself to churning worry, to indecision, to doubts as bright and numberless as stars!

Warm milk, bounding sheep, amber bottles of Halcyon—

where have they gotten you? Half your life squandered, time that would have been better spent regretting the past and dreading the future. Think of it (if you're not too groggy): you might have constructed, grain by monotonous, painstaking grain, a mountain out of a molehill.

You say you need your forty winks, to knit up the raveled sleeve of care? Go ahead and make excuses, each as thin as a well-worn sheet. A life where pale dawns are lost is no life at all! We the bleary-eyed, the perpetually restless, the not-for-a-moment-seduced-by-sleep, we tell you there's light in pots of black coffee, high adventure while pacing the floor. While others slumber, insensible, we urge you to make yourself irate by recalling old slights, to see the unstoppable progress of time by studying your face in the bathroom mirror, to embrace the terrors of kidnap, plane crash, and coronary by watching late-night TV.

You must make your pallets from brittle straw! You must fling your limbs at uncomfortable angles, each less conducive to sleep than the next! You must picture the mites, mandibles and all, who inhabit your mattress!

Listen! Rousing new tunes have replaced the quaint music of crickets, the mumbling of doves on a window ledge, the rain's drowsy, insistent whisper. Gunshots, sirens, car alarms. Raging dogs, squalling babies, couples fucking like wildebeests. Why ignore this wealth of noise for a meager lease on oblivion? What you hear is an anthem throbbing through the walls. Stand up, comrades. Look alive!

We must reconsider the meaning of sleep! We must think again. And again and again.

Credits

ART

Page 16: Baldessari, John. *Teaching a Plant the Alphabet,* 1972. Courtesy of John Baldessari.

Page 17: Wesselmann, Tom. *Still Life with Live TV #28,* 1964. © Estate of Tom Wesselmann / Licensed by VAGA, New York, NY. Photograph © Henri Dauman / Daumanpictures.com.

Page 18: Rauschenberg, Robert. *Clock.* Art © Robert Rauschenberg Foundation / Licensed by VAGA, New York, NY. Photograph © Henri Dauman / Daumanpictures.com.

Page 19: Oldenburg, Claes. *Stove with Meats,* 1962. Copyright 1962 Claes Oldenburg. Photograph © Henri Dauman / Dauman pictures.com.

Page 20: Rivera, Diego. *The Flower Carrier,* 1935. © 2014 Banco de México Diego Rivera Frida Kahlo Museums Trust, Mexico, D.F. / Artists Rights Society (ARS), New York.

Page 25 (left): Portrait of Jon Gnagy. "You are An Artist" NBC/NBC Universal/Getty Images.

Page 25 (center): Duchamp, Marcel. *L.H.O.O.Q.,* 1919. © Succession

Page 34: Hamilton, Richard. *Just what is it that makes today's homes so different, so appealing?*, 1956. © R. Hamilton. All Rights Reserved, DACS and ARS 2014.

Page 36: Oldenburg, Claes. *Soft Toilet,* 1966. Copyright 1966 Claes Oldenburg.

Page 40: Kienholz, Edward. *Back Seat Dodge '38,* 1964. Copyright Kienholz. Courtesy of L.A. Louver, Venice, CA.

Page 42: Kienholz, Edward. *The Beanery,* 1965. Copyright Kienholz. Courtesy of L.A. Louver, Venice, CA.

Page 48: Warhol, Andy. *Jackie — With Veil,* 1964. © 2014 The Andy Warhol Foundation for the Visual Arts, Inc. / Artists Rights Society (ARS), New York.

Page 49: Rosenquist, James. *Dishes,* 1964. Art © James Rosenquist / Licensed by VAGA, New York, NY.

Page 66: Rauschenberg, Robert. *Bed,* 1955. Art © Robert Rauschenberg Foundation / Licensed by VAGA, New York, NY.

Page 71: Acconci, Vito. *Following Piece,* 1969. © 2014 Vito Acconci / Artists Rights Society (ARS), New York.

Page 84: Kosuth, Joseph. *One and Three Chairs,* 1965. © 2014 Joseph Kosuth / Artists Rights Society (ARS), New York.

Page 101: Baldessari, John. *Quality Material,* 1966–68. Courtesy of John Baldessari.

Page 103: Lichtenstein, Roy. *Nurse,* 1964. © Estate of Roy Lichtenstein.

Page 130: Kuffler, Suzanne. *Mona Lisa "Description,"* 1973. Courtesy of Suzanne Kuffler.

Page 140 (left): Paramount Pictures, *Easy Come, Easy Go* (film still), 1967. Printed with permission.

Page 140 (right), 142 (center): Kaprow, Allan. *Household,* 1964. Courtesy Allan Kaprow Estate and Hauser & Wirth. Photo: © Sol Goldberg.

Page 142 (left): Kline, Franz. *Untitled,* 1957. © 2014 The Franz Kline Estate / Artists Rights Society (ARS), New York.

Page 142 (right): Lichtenstein, Roy. *Brushstrokes,* 1966–68. © Estate of Roy Lichtenstein.

Page 148 (left): Riefenstahl, Leni. *Triumph of the Will,* 1935, film still. Courtesy of Archives LRP.

Page 148 (right): Andre, Carl. *9 x 27 Napoli Rectangle,* 2010. Art © Carl Andre / Licensed by VAGA, New York, NY.

Page 152: Warhol, Andy. *Front and Back of Dollar Bills,* 1962. © 2014 The Andy Warhol Foundation for the Visual Arts, Inc. / Artists Rights Society (ARS), New York.

Page 167: Information, MoMA catalog cover. Digital Image © The Museum of Modern Art / Licensed by SCALA / Art Resource, NY

Page 189: Adams, China. *Blood Consumption: Heather Thomason,* 1999. Courtesy of China Adams.

Page 189: Adams, China. *Blood Consumption: Amy Stock-Drozd,* 1999. Courtesy of China Adams.

Page 189: Adams, China. *Blood Consumption,* 1999. Courtesy of China Adams.

Page 194: Quinn, Mark. *Self 2001 (refrigeration unit and canopy),* 2001. Photo: Stephen White. Courtesy: White Cube.

TEXT

Randall Jarrell, excerpt from "A Sick Child" from THE COMPLETE POEMS by Randall Jarrell. Copyright © 1969, renewed 1997 by Mary von S. Jarrell. Reprinted by permission of Farrar, Straus and Giroux, LLC and Faber and Faber Ltd.

Sylvia Plath, "Excerpt of five lines from "Cut" from ARIEL. Copyright © 1963 by Ted Hughes. Reprinted by permission of Harper-Collins and Faber and Faber Ltd.

Acknowledgments

This book is dedicated to a confederate of amazing and necessary people who have no idea that they constitute a group:

Steven Barclay, Jill Bialosky, Jill Ciment, Eliza Fischer, Amy Gerstler, Matthew Grover, Jeff Hammond, Sloan Harris, Bill Haugse, Heather Karpas, Tom Knechtel, Dinah Lenney, Brian Miller, Phranc, Mark Pinkosh, Kit Rachlis, Alice Sebold, Rebecca Schultz, Louise Steinman, George Stoll, Sallie Tisdale, Douglas Trazzare, and Benjamin Weissman